THE MEANING OF
MODERN SCULPTURE

by

R. H. WILENSKI

BEACON PRESS — BOSTON

First published in 1932 by Faber and Faber Ltd., London

First published as a Beacon Paperback in 1961 by
arrangement with the original publisher

Printed in the United States of America

Beacon Press books are published under the auspices
of the Unitarian Universalist Association

Second printing, April 1966

THIS BOOK IS
DEDICATED
TO
S. S.

PREFACE TO THE BEACON PRESS EDITION

Students under thirty in 1962 will read here a book, written before they were born, about the meaning of sculpture now being produced in Europe and America. Most of the sculptors, then maligned and misunderstood, whose creed I set out to defend and explain, are still working and are now widely recognized as eminent creative artists. Others, of consequence, have studied that creed and have developed it in various directions.

Much that was new and provocative when I wrote it is now taken for granted. Henry Moore, for example, was then unknown in America and almost unknown in London (where his first exhibition was held in 1928). Few people then realized the immense extension of sculptural knowledge brought about by what André Malraux has since called "The Museum without Walls" which I discussed in Part IV as "The Modern Sculptors' Education."

The prejudices described here as impediments to the understanding of modern sculpture were an intolerable nuisance in 1932. There are signs now that a Baroque Prejudice is replacing the Renaissance Prejudice. But the Greek Prejudice, at any rate, is still active. Professor E. H. Gombrich in his "Art and Illusion" (published in 1960) can still write: "The names of Myron, Phidias, Xeuxis and Apelles have retained their magic despite the fact that we do not know one work from their hands"; and it may well be 1992 before a professor will bring himself to say: "The names of Calamis, Myron, Pythag-

v

oras, Phidias, Polyclitus, Scopas and Lysippus have no magic for us because no works from their hands are known to be extant."

If I were writing the book now I should write it with more decorum, i.e., polite pomposity, but I should say most of the same things again. I hope that students of today and tomorrow will find it interesting and not uninstructive as a forward-looking "period piece."

R. H. Wilenski

Marlow, England

CONTENTS

Contents

Contents

Contents

Contents

Contents

Contents

ILLUSTRATIONS

Illustrations

Illustrations

PREFACE

Six years ago I published a general inquiry into the modern movement in the arts, together with some comments on various problems connected with its appreciation.[1] The present inquiry, which began as a lecture on modern sculpture delivered last year in the Victoria and Albert Museum, London, has become an inquiry into the modern sculptors' creed; and here again I have felt it necessary to comment on certain attitudes that affect appreciation.

Modern sculpture, as I understand it, is an aspect and a symbol of the living creative culture of our day; and, as such, it is concerned with redressing the balance after the empiricism of the nineteenth century.

I am conscious that in writing in 1932 of the sculpture symbolic of this culture I am in the position of a man writing in 1832 about the sculpture symbolic of the Romantic culture of the nineteenth century, which was concerned with redressing the balance of the eighteenth century, and which eventually culminated in the Romantic modelling of Rodin and Epstein. I am conscious, that is to say, that I am writing of the first stage in a cultural manifestation of which not even the middle, let alone the end, is yet apparent. But this, as I see it, makes my task peculiarly worth doing because, if I can assist the new culture at this stage by assisting in its comprehension, I am rendering service at the stage which is the most difficult for the sculptors and which demands from them the greatest sacrifices and the most continuous courage.

The plan which I have adopted in this inquiry is as follows:

In Part I, I have indicated very briefly my concept of modern sculpture as an aspect of contemporary culture.

[1] *The Modern Movement in Art*, by R. H. Wilenski. Faber and Faber.

Preface

In Part II, I have discussed the prevailing prejudices in regard to sculpture which impede the comprehension and therefore the appreciation of creative contemporary work. These prejudices—the Romantic prejudice, the Renaissance prejudice, and the Greek prejudice—are a solid phalanx which resists the establishment of the new sculptural values.

In my lecture I touched briefly on these prejudices. In examining them more closely in this inquiry I found that I had underestimated the obstructive character of the Greek prejudice and that I had not fully realised the sources of its power.

I know now that this prejudice, which consists in the notion that the Greeks achieved the final and only possible perfection in sculpture, derives its power from a world-wide organisation vitally concerned with its continuation.

I know now that most books on Greek sculpture and the Greek sculptors are nothing but emotive propaganda ; and that we do not recognise this propaganda as propaganda because we have all absorbed it in childhood and youth as part of our ordinary education.

The sections of this inquiry in which I discuss the Greek prejudice and its supporting propaganda do not, of course, claim to be a history of Greek sculpture, a history of the propaganda, and a history of the resulting prejudice. They are merely designed as indications of *the lines* on which the student must proceed if he wishes to convert a prejudice acquired in childhood and early youth into knowledge of the facts.

I know well that these sections of my inquiry will not prevent archaeologists and professors from continuing to write emotive twaddle about Greek sculpture and the Greek sculptors whose names they keep alive. But my notes will have justified their existence if they help a few people to recognise the twaddle as twaddle the next time it comes their way.

In Part III, I have recorded the first steps in the formulation of the modern sculptors' creed as I understand it.

The creed was not, of course, evolved in the methodical way in which I have set it down. It grew in more ragged formation and as a less orderly progression. But I think that my notes, taken as a whole, rightly indicate what the modern sculptors had in their minds from about 1905 to the beginning of the war.

In Part IV, I have tried to indicate the range of the modern sculptors' experience of sculpture which is, of course, much wider than the experience of any sculptors at any other time.

Here too, for convenience, I have suggested an orderly systematic study of the world's content of sculpture though, in fact, the modern sculptors' studies have been more casual and haphazard and have coincided in point of time with the gradual development of their creed.

I have moreover tried to make it clear that as the modern sculptors are original artists they are not concerned with theories of art history, or even with historical facts, but purely with the power of the sculpture studied to assist them in their own work.

In this section I have indicated, for example, what I take to be the modern sculptors' attitude to the remains of Greek sculpture, to Gothic sculpture, to Negro sculpture and so forth. I know well that each individual sculptor has reacted to some extent individually to each object, and reacted to it differently at different times because his reactions have been dictated by his own particular problems at the time. I also know, of course, that many of the sculptors are acquainted with many more objects than I am myself, and that as creative and professional sculptors they enjoy a brotherly contact—both aesthetic and technical—with the makers of the objects that is denied to everyone outside the 'shop'. Nevertheless I hope that they will find that my indications of the character of their education is right on general lines.

In Part V, I have indicated the more recent stages in the development of the modern sculptors' creed as I understand it; and if I have done my work properly the general statements should make it easier for some readers to understand the meaning of the sculptured objects which the modern sculptors have recently produced.

I have to thank a number of modern sculptors who have allowed me continually to see their works, who have provided me with many photographs, and who have paid me the compliment of talking to me about their attitudes and aims. If I have failed fully to understand and so fully to appreciate the effort as a whole the fault is not theirs but mine.

Preface

One word more. Some literary critics of *The Modern Movement in Art* have complained that it is written in a 'jargon'. Similar critics may possibly make the same complaint about this inquiry, which again, I fear, is most inelegantly written. But in the case of *The Modern Movement in Art* I have come to consider this criticism unimportant, firstly because people are still reading the book, and secondly because public appreciation of the artists, to whose works it was designed to call attention, has much increased in the intervening years. I indulge the hope that people will again forgive the inelegance of my writing for the sake of the interest of the art which I am discussing, and that in six years' time the sculptors, to whose works this essay is designed to call attention, will be more widely appreciated than they are to-day.

London, May 1932.

PART I
THE MODERN EFFORT IN SCULPTURE

PART I
THE MODERN EFFORT IN SCULPTURE

1. Scope of this inquiry

The efforts and achievements of the modern sculptors are misunderstood in many quarters at the present day.

The first purpose of this inquiry is to explain the character of those efforts and achievements. For this purpose I shall examine the development of the modern sculptors' creed; and I shall indicate the wide range of the sculptors' education.

My second purpose is to explain the obstacles to the appreciation of modern sculpture, in the hope that the explanation may help to remove them.

2. Popular sculpture not my affair

The sculptors with whose work I am here concerned are, generally speaking, not employed by modern society. The men who are given employment are sculptors of another kind—the kind described as 'popular' in my earlier inquiry.[1]

The popular sculptors, who work within familiar experience of sculpture, are employed in the modern world in three main ways. They are commissioned by architects to fill odd corners on buildings with ornaments or figures; they are commissioned by town councils and other bodies to make monuments for public places; and they are employed by individuals who want 'lifelike' portraits in marble or bronze.

Everyone is familiar with the sculpture produced in response to these commissions. It can be seen on public buildings and in the official art-shows everywhere each year. When completed it is put up or sent home as the case may be and then nobody

[1] Cf. *The Modern Movement in Art*, pp. 24 and 25.

thinks any more about it. Nobody looks at such sculpture a second time because it arouses no interest; and it arouses no interest because it does not enlarge experience.

This kind of sculpture is not the product of contemporary culture, as I understand it, but the backwash of obsolete cultures of the recent past; and in this inquiry I am not concerned with it at all.

3. Modern sculpture

The sculptors whose aims and work I am here discussing are 'original' artists in the sense in which I have defined the term in my earlier inquiry.[1]

These sculptors set out to enlarge experience by their work.

Very occasionally one of these original sculptors receives a commission to add sculpture to a building, or to erect a monument in a public place. When this happens the matter does not end with the fulfilment of the contract. The work enlarges experience and thereby impels the spectator to look at it a second time.

Except when these rare commissions happen the general public only sees the works of these original sculptors in small exhibitions in dealers' galleries or in the sculptors' studios. It cannot see them in the large official exhibitions because modern sculpture properly so called is generally excluded from those exhibitions.

I say 'modern sculpture properly so called' because the word 'modern' means 'of our own age' and, as I see it, the only contemporary sculpture which can properly be described as 'of our own age' is the sculpture which I am discussing. This sculpture, I submit, can be described as 'of our own age' because it is an aspect and a symbol of contemporary culture.

4. Modern culture

I have submitted elsewhere that a culture can be defined as an attitude of mind which determines values; that each age has its

[1] Cf. *The Modern Movement in Art*, pp. 26 and 27.

own culture evolved by the keenest brains and most courageous spirits in all fields while the blunt brains and feeble spirits remain content with obsolete cultures of the past; and that the outstanding feature of the culture of our own age seems to be a marked disposition to study first principles and general laws.[1]

A culture, as I understand it, is a form of service to a society by its most conscious and articulate section. In recent centuries cultures seem to have been habitually concerned with the relief of subconscious dissatisfactions that oppress the society of which they form a part.

In the nineteenth century men were afraid of the machine-ruled world which they were making. Nineteenth-century culture sought to relieve that dissatisfaction by stressing individualism; men's works, it was pointed out, were not uniform like the productions of machines, every man was different, and it was the *differences between men* that really mattered; hence the hero-worship of the nineteenth century, its notions of local freedoms ('The Englishman's home is his castle') and nationalist isolations; and hence also its Romantic-individualist-empirical art, the concept of the work of art as justified if it relieved the artist's personal neurosis, and the concept of the Bohemian as the typical artist.

In our own age men are still afraid of the machine-ruled world which they have fashioned; and their dissatisfaction amounts to despair because they know from their experience of the nineteenth century that individualism can do nothing to relieve their fear. Modern culture, as I understand it, is an effort of the finer brains and spirits to relieve this desperate dissatisfaction by repressing individualism, empiricism and local pretensions, and formulating concepts in which the inevitable fight against the machine-ruled world is conducted not by individuals or individual nations but by civilised mankind pooling brains and imagination in the hope that collective thought may lead to concerted action and thereby avert the disaster which is feared.

The keenest intellects in all fields to-day seem to have started with the assumption that the world must be visualised as one organism, that all men must work together for a common goal, and that the civilisation made empirically by man can only be

[1] *An Outline of French Painting* by R. H. Wilenski. Faber and Faber.

prevented from destroying man, if man obtains strength to control it through contact with the universal characters and principles of life which civilisation in its nature must inevitably defy.

This sounds high-falutin. But it is really simple. We all know that civilisation works against nature. We all fear that our civilisation will destroy us. We all know that individualism is powerless in the world to-day. We all realise that another kind of effort must be made. We all know that that effort can only be made by the cultural elements in our world, and that in fact it is being made by them.

It is of that effort that modern sculpture is an aspect and a symbol. The modern sculptors have lost faith in the nineteenth-century attitude. They no longer value contacts with local and individual manifestations of life; they seek comprehension of universal and constant characters and principles divined behind the individual manifestations. Their work is an aspect and a symbol of modern culture because they have relieved their personal neurosis by accepting the neurosis of the society of which they form a part, and because they conceive it their function to work for the relief of that; it is an aspect and a symbol of modern culture because it leads man to concern himself not with the civilisation empirically made by man but with springs and forms of life which that civilisation, as civilisation, has inevitably defied.[1]

[1] Cf. Part V. *passim*.

PART II
OPPOSITION TO THE EFFORT

PART II

OPPOSITION TO THE EFFORT

1. The vulgar Dean

We might expect the effort thus being made by the modern sculptors to be studied on all hands with respectful interest. But in fact we find that their works arouse resentment in many quarters and that the sculptors are frequently subjected to the vulgarest abuse.

Read, for example, this extract from *The Times* (London) of 16th March, 1932 :

'The Royal Institute of Painters in Water Colours celebrated their 123rd exhibition by a dinner held at the Institute, Piccadilly, last night. . . . The Dean of St. Paul's . . . asked what they were to say of modernist atrocities . . . of sculptures which seemed to be modelled on the mysterious statues found on Easter Island or the early efforts of the savages of West Africa? . . . He trusted that within the next ten years the productions of these artists would have been banished to the bathroom or even further (Laughter).'

Is it not extraordinary that a gentleman should thus refer to an aspect of contemporary culture? and that other gentlemen should approve of the reference?

What is the explanation?

It is, I think, quite simple.

The Dean had dined; he was in genial mood; he was out to please the members of the water-colour club who were his hosts at dinner; he knew that jeering at the contributions made by modern sculptors to modern culture was a favourite pastime with the members; he gave them an opportunity of releasing their inhibitions in this way.

That, I think, was that.[1]

[1] But cf. IV. 3. v. *d.*

2. The vulgar diners

But why do the members of this water-colour club find satisfaction in jeering at modern sculpture?

Because, being popular, and not original, artists they achieve no enlargement of experience by their own work and they are jealous of those who are really doing what they themselves pretend to be doing when they call themselves artists.

This jealousy, which is subconscious, lurks beneath the mind of *all popular artists*. It is a powerful complex, an emotional resentment which tones and colours all their ideas.

It makes them all vulgar after dinner.

3. Philistine resentment

But the vulgar Dean and the jealous popular artists are not the general public.

Why does the general public resent the modern sculptors' contributions to contemporary culture?

The answer that would be given by most modern sculptors themselves is simple:

'The general public', they would say, 'is a collection of Philistines. The Philistine is a man who is absolutely satisfied with his own familiar experience in all fields and obstinately convinced that any enlargement of that experience is unnecessary. He resents our sculpture because it is original and thus not within his familiar experience of sculptural art. Everyone is a Philistine who cannot feel respect and gratitude to the exceptional people who make efforts to establish new values, for the benefit of the general public, in all fields.'

This explanation, I think, is sound except in the initial assumption that the general public is a collection of Philistines.

Philistines in the modern world are less numerous than modern artists suppose. They are emphatic and vociferous but they are a minority of the population; they must be regarded as eccentrics or abnormalities, or simply as cranks; their resentment, therefore, is not a matter of general interest at all.

4. Average resentment

i. *The half-open door*

The ordinary man of average intelligence and average education in the modern world to-day is neither a Dean being pleasant after dinner nor a popular artist giving vent to jealousy, nor a Philistine ruled by abnormal conceit. He is a man with a marked disposition to be curious about contemporary culture and to treat the idea of the establishment of new values with a considerable measure of respect.

But there is ample evidence that such men also view the efforts of the modern sculptors with resentment.

How can this be explained?

The answer here is more complicated.

The ordinary man of average intelligence and average education does not keep the door of his mind closed to fresh experience; but he also does not keep it open; *he keeps it ajar*.

He is hospitable to new ideas but he does not keep entirely open house. He insists upon a right to choose the guests to be admitted across his threshold and a right to determine what clothes they shall wear when they come to his dinner. He takes stock of the callers at the door, and is ready to invite them to his table, but he makes it a condition that their appearance shall conform, in a reasonable measure, with the appearances of the members of his household and his other guests.

The average man is ready to accept an addition to his experience, but it must be an addition which somehow or other can be fitted in with the others already there. He is not disposed to turn out all his old friends for a newcomer or to build a new wing to his house for his accommodation.

In the case of most aspects of contemporary culture this system works quite well. The average man takes a look at the efforts

made by modern physicists, economists and so forth, decides that their appearance is much too complicated for his comprehension, and suggests that if they are covered with some simple well-tailored formula that will not be too conspicuous at his party he will be happy to invite them in. Some man of letters then cuts out the formula, the publisher makes the suit, claps it on to the effort, say, of Einstein, and in due course Einstein's effort thus disguised is admitted and mingles pleasantly with our friend's family and guests.

ii. 'Where did you get that hat . . .?'

But in the case of modern sculpture this system will not work. This particular effort is an effort in the field of form. It arrives at our friend's doorway as a man in extraordinary raiment who demands admission *on the strength of his clothes*. A visitor of this character cannot obviously be made presentable and remain recognisable at all. You cannot make a statuette of Epstein's *Genesis* that will disguise it as the same sort of thing as the *Medici Venus*; you cannot make a potted version of Henry Moore's *Mountains* (Pl. 24) that will put it on a social footing with the *Theseus* of the Parthenon Pediment; you cannot trim his *Mother and Child* (Pl. 8 *b*) in a way that would lead the average man to mistake it for a *Virgin and Child* by Desiderio da Settignano. Our friend has to agree to admit this visitor in his own clothes or else decide to send him away.

The dilemma is perplexing. He cannot bring himself to invite him to his table in those dreadful clothes. 'If I invite him', he reflects, 'he will come in those clothes—he has in fact refused to change them; and if I receive him in those clothes I accept them as the proper habit of a sculptor; if I do this, if I accept them as even tolerable, it will destroy the standard represented by the tailcoats and dinner jackets of all the sculptors who have been my guests for years, and it will spoil my satisfaction with my party'.

So he sends the fellow about his business with gentlemanly expressions of regret.

iii. Gate crashing

But he finds to his dismay *that he cannot forget him.* Because a work of original art once seen is never forgotten. The image of that disturbing apparition, of that astonishing dress suit, has remained with him to cast doubts on the final perfection of the dinner jackets and tailcoats.

The visitor, in other words, has forced his way in and spoilt the party.

The average intelligent man resents this intrusion.

And that, as far as it goes, is that.

5. The finality-complex

i. Configuration

In thus resenting the intrusion the average intelligent man is only yielding to the finality-complex which we must recognise as a powerful force.

Without entering the abstruse field of configuration-psychology we can, I think, presume the existence of a desire to conceive finalities. This desire drives us to seek concepts with a bottom, sides and a top, or with a beginning, a middle and end; it makes us ill at ease with indefinite concepts and with concepts of infinity; it makes us suffer from the realisation that we cannot understand life because we are inside it, and it leads us to imagine that we would understand life better if we could conceive it as something which we could walk all round and look down upon. This desire leads us to indulge in the illusion that we have achieved comprehension when we have reduced a concept of chaos to a concept with a shape, to reject the concept of a universe without form, to refuse to entertain the thought of a world without a beginning; and if it yields to the complex which has created the concept of human life prolonged after death it combats that concept of infinity by the idea that the prolongation is not really infinite but only long enough to complete the form of the particular life left incomplete at the time of death—to complete it for example, in one's own case, by reward for unrewarded virtue, and, in the case of other people, by punishment for unpunished sin.

The Philistine is really only a man with an abnormally strong finality-complex. His desire for the illusion of final comprehension is so strong that he atrophies his curiosity and restricts it to the narrowest possible field. As an Oxford undergraduate, if I remember rightly, might say, he 'sports his oak' against experience and smokes his pipe in peace.

14

The average intelligent man has the delicate and difficult task of satisfying his finality-complex, which is there to procure him illusions of comprehension, and of satisfying his curiosity at the same time. His problem is to arrive at concepts which are finality-forms but which are nevertheless so elastic that new experience can be fitted into them.

The process of fitting in a new experience always takes some time; the length of time depends on the power of the finality-form to resist the intruder.

The average man has a concept of the art of sculpture which is definitely a finality-form; and the process of fitting in the new experience of modern sculpture is a particularly hard one and is taking an especially long time (*a*) because, as I have already observed, the experience cannot be made presentable in order to render the adjustment easy and (*b*) because, as I shall show later, the finality-form is continually reinforced by an army of professional propagandists and is, therefore, peculiarly resistant.

The average man's concept of sculptural art is a finality-form which his education has introduced into his mind.

If we were told at school that the history of sculpture is the history of the human race our finality-complex would lead us to shrink at once from attempting to absorb it, even if such a history were available. But we are not told this at school. We are provided with an illusion of comprehension by means of a potted history of sculpture.

This potted history has a beginning, a middle and an end—the end being always about the year in which the teacher himself was born.

ii. Little Jack Horners

We thus start with a concept which represents the history of sculpture as something belonging to the past and as something with a complete and easily discernible form. This concept satisfies our finality-complex and we accept it. Like Little Jack Horners we grab at this prejudice pie.

iii. 'What a good boy am I'

Moreover as education is not organised for the bald imparting of information but more for the maintenance of a system of

(generally obsolete) values, the potted history always contains within itself a neat set of ready-made valuations. Our finality-complex is thus satisfied also in this field. We are provided with an illusion that we understand, not only the potted facts of the history of sculpture, but also the relative merits of the sculptures, and that our power to pick out the approved plums from the prejudice-pie demonstrates a merit in ourselves.

iv. *The approved plums*

In the case of the history of sculpture the average intelligent man, who has had no occasion to pursue the subject further, has little in his mind beyond the finality-form introduced in this way. He thinks of that history as a form of which the beginning was Greek sculpture, the middle the sculpture of the Italian Renaissance, and the end the Romantic sculpture of the nineteenth century as represented by Rodin; within this finality-form are the ready-made valuations which assume that Greek sculpture attained final perfection as 'ideal-naturalistic' sculpture, that Renaissance sculpture attained final perfection as religious and social sculpture, and that Rodin attained final perfection in expressive sculpture; and, attached to these assumptions, there is the assumption that all living sculptors should imitate the Greeks and aim at 'ideal-naturalistic' sculpture though they can never equal the Greek achievements in that field; and that, if they do not feel up to imitating vainly this perfection, they should imitate the sculpture of the Renaissance or the Romantic sculpture of Rodin.

The average man's concept of sculpture is thus a finality-form operating as a prejudice against modern sculpture which is placed outside the prejudice-pie both in point of time and in point of value.

6. The student's attitude

i. *Another type of spectator*

But there is another type of spectator—the student of sculpture.

The term 'student of sculpture' is generally used to cover a wide field. It is used of archaeologists, historians of sculpture, critics of sculpture, writers about sculpture, and sculptors themselves.

All these types write about sculpture, but none of them are 'students' in the sense in which I am about to use the term.

I shall define my 'student' in a moment. But first we must get clear about the 'students' of the other kinds.

ii. *Archaeologists*

Archaeologists are people whose business it is to examine objects of the past and documents relating thereto with real care and thoroughness and to record *without omissions and without comment* the knowledge thus obtained.

When they stick to their business, as they occasionally do, they are useful to historians and critics.

But they usually indulge in art criticism for which they are not equipped by their studies; they invent theories, and to strengthen them they divide facts which are all really of equal importance into 'important facts' (*i.e.* those which support their theory) and 'unimportant facts' (*i.e.* those which do not); and their 'unimportant facts' tend to be omitted altogether. Moreover, their standard of reliability in evidence is often inconsistent; if a type of evidence supports their theory they call it 'reliable' evidence; if it conflicts they call it 'unreliable'; and they will use both terms of the same type of evidence in the same book.[1]

[1] Cf. II. 9. viii. *j.*

I shall give examples of these lamentable procedures on the part of unreliable archaeologists when I discuss their propaganda in support of the Greek prejudice.

Here my point is that the archaeologist is not a student of sculpture in the sense in which I am about to use the word.

iii. *Historians of sculpture*

The business of the historian of sculpture is the co-ordination of the facts collected by the archaeologists. But in practice the historians usually concoct some simple finality-form for the satisfaction of their own and the readers' finality-complex. For this purpose they take the data provided by the unreliable archaeologists and make further selections of fact and further misrepresentations; and they invariably invade the province of the art critic for which they are not equipped by these procedures which they call studies.

I shall give examples of the misleading twaddle written by these historians of sculpture when I discuss their propaganda in support of the Greek prejudice.[1]

iv. *Critics of sculpture*

The business of the critic of sculpture is to discover and record values.

It is not given to humanity to discover absolute and permanent values.

All the critic can do is to discover relations of values and record those relations.

When archaeologists and historians of sculpture invade the province of the critic of sculpture they habitually take the valuations in the finality-form made by themselves and refer to it rhetorically as *the consensus of educated judgement* or *the accepted judgement of fine taste*. They then turn to contemporary culture and assess its value in relation to that standard. The result is a foregone conclusion. They say 'Here is a final complete form with final perfection inside it. Anything outside that form is a perverse deviation or an unnecessary excrescence. Let us look at the particular deviation or excrescence produced by

[1] Cf. II. 9. i. to v., and viii. *a* to *k*.

the sculptors of to-day'. They then look at modern sculpture, or pretend to look at it, and describe it as 'a perverse deviation from the standard cherished by all educated men' or 'an unnecessary excrescence that can be safely ignored by all people of fine taste'. They end, that is to say, where they began.

The critic of sculpture, whose work, in my view, is of most service, is the critic who starts with the assumption that the values in course of establishment by contemporary culture are the values of which the age has need. Such critics examine the sculpture of the past in relation to the sculpture produced by the new values; they reassess the prejudice-pie in order to assist the comprehension of contemporary culture.

But critics of this kind recognise, of course, that contemporary culture, like all cultures, is transitional; they do not pretend to be establishing any absolute and permanent values, they only claim to be discovering and recording a particular relation of values which, owing to the date of their existence, falls within the field of experience open to them. They know that the culture of their age will eventually become part of the prejudice-pie and that, if their grandsons are critics of sculpture, it will be their business to re-examine the pie, with this ingredient inside, in the light of the new culture of their particular age.

Criticism of this kind is of service *at the time* because, by indicating the nature of the adjustment necessary for the absorption of the new and necessary values, it assists the process of adjustment; and it is of service *later* because it records the nature and date of a particular addition to the ingredients of the prejudice-pie and thus assists the critics of the future in their work of reassessment.

We can thus lay it down, I think, that if the critic's studies of the sculpture of the past help his contemporaries to understand and so appreciate the original sculpture of their day he is a good and useful critic; if his studies of the sculpture of the past do not affect the comprehension and appreciation of the original sculpture of his day he is a critic of no consequence; if his studies of the sculpture of the past militate against the comprehension and appreciation of the original sculpture of his day he is a bad and harmful critic.

v. Writers about sculpture

By 'writers about sculpture' I mean people who examine their own reactions in front of works of sculpture and record them as though they were judgements based on a standard of absolute value.

This kind of writing is autobiography and the authors are only called 'students of sculpture' by courtesy.

vi. Sculptors

The business of the sculptor is to produce sculpture.

Many sculptors to-day invade the fields of the historian and the critic of sculpture.

If a sculptor is capable of contributing to contemporary sculpture by his sculpture then, when he writes about sculpture, he is of necessity a 'writer about sculpture' in the sense defined above.

If he is an original modern sculptor he is of necessity absorbed by the difficulty of his sculptural task. He turns to the sculpture of the past for assistance in his problems and for the reinforcement of his morale by contact with men who seem to him to have faced analogous problems before. A minor work may thus have tremendous value for him and a major work may have for him no value at all.[1] When a sculptor of this kind writes about sculpture he is really writing about himself. He is writing autobiography not criticism of sculpture. Such autobiography is much more interesting to the critic and the student of sculpture than any other kind of autobiography. But we miss the point of it unless we remember that it is autobiography.

When a sculptor, who is not an original sculptor but a popular sculptor, writes about sculpture his work is also autobiography. The autobiography in this case records the writer's attempt to rationalise his inability to contribute to contemporary culture. Such writings about sculpture are not of interest to critics or students of sculpture because they always consist of propaganda for the prejudice-pie; they are the authors' attempts to convince themselves and Jack Horner readers that their own sculpture has at least a negative value because, whatever its

[1] Cf. IV. i.

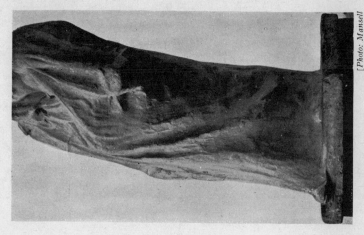

1b. RODIN: *Balzac* (detail)

Cf. II. 7. ii. and IV. 2. ii. and V. 5.

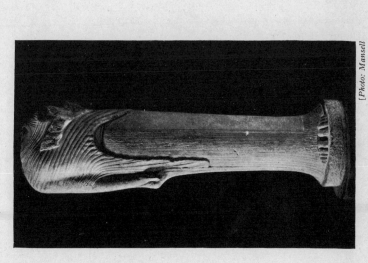

1a. The so-called *Hera from Samos*

(Louvre)

Cf. IV. 2. iv. d.

2b. In the 'Praxitelean' tradition
Wax and Indiarubber figure for
shop windows
(Messrs. Pollard & Co., London)

2a. Diomede with the Palladium
(Formerly Lansdowne Collection)
Cf. II. 9. f. 17-22.

limitations may be, it does not, at any rate, spoil anyone's satisfaction with the pie, or as they themselves would say, 'it contains no affront to the accepted standards of educated taste'.

vii. The student of sculpture

The man I have in mind when I refer to the 'student of sculpture' is our old friend the average intelligent man of average education who has reached the stage when modern sculpture has forced its way into his mind and who wants to make space so that it can remain there without causing embarrassment. I mean the man who is starting on a reassessment of his sculptural values in order to be able to participate in modern culture as represented by sculpture.

It is to students of this kind that this inquiry is addressed; and my first task, if I am to help them, must be the examination of the impediments to their appreciation of creative modern sculpture—the examination, that is to say, of the three prejudices in regard to sculpture which average education has placed inside their minds.

I shall begin with the Romantic prejudice which for various reasons has the smallest power.

7. The Romantic prejudice

i. *The three chairs*

The Romantic prejudice is the youngest component of the sculptural finality-form in the average intelligent spectator's mind. In its present form, so far as sculpture is concerned, it is simply the assumption that the works of Rodin, and other works like them, can be accepted without question as worthy companions to Renaissance sculpture and Greek sculpture.

The Romantic movement was well launched by 1830. When Rodin began to demand recognition about 1880 the student had already had half a century in which to get acclimatised to the Romantic point of view. Rodin's *Burghers of Calais* and *La Vieille Heaulmière* (Pl. 3*b*) gate-crashed between 1884 and 1890; and about 1900 Rodin's sculpture became a regular resident in the student's parlour where it now has its own particular chair.

But the Romantic prejudice remains a junior member. Its chair is a small one. The arm-chair is occupied by the Renaissance prejudice, and the sofa by the Greek.

ii. *Rodin's 'Balzac'*

In nineteenth-century sculpture Rodin was the typical and most original Romantic. His *Balzac* is the typical Romantic statue. It was produced in 1898 (seventy years after Delacroix's *Massacres de Scio*) when Rodin himself was just under sixty, and when his name was already widely known. It was commissioned by a Committee as a monument for a public place in Paris. The Committee refused it. But except in such Committees the Romantic movement had now won all its battles; the

22

average student had seen the point of it; and in Rodin's *Balzac* he recognised an important original work of this particular school.

Rodin's interest when he modelled the *Balzac* was concentrated in the head. Remove the head and we have nothing but a shapeless mess (Pl. 1*b*).

In thus concentrating his attention on a fragment Rodin obeyed the cardinal principles of Romantic art. I have discussed the essential character of that art in *The Modern Movement in Art*. Here I need only remind the reader that the creed of the Romantic movement held (*a*) that the artist should react to or imagine some emotive fragment of life and record his consequent emotion; (*b*) that the artist's emotion should be symbolised by his actual handling of material; and (*c*) that in order to symbolise his own concentration on a fragment he should fix a point of focus within the work and concentrate attention upon that.

As readers of my earlier inquiry will also remember, I pointed out there that in practice this creed generally meant (*a*) the concentration of interest on the face of a figure and a concern with the face's *expression*; and (*b*) the parade of impulsiveness, spontaneity or sentimentality in the actual handling.

In the field of sculpture these characteristics are exhibited in the *Balzac*.

iii. Rodin's 'La Vieille Heaulmière'

They are also exhibited in Rodin's *La Vieille Heaulmière* (Pl. 3*b*), the emaciated figure of the old helmet-maker whose body had been an object of desire in her youth. Rodin's work, modelled from an old woman of his day, corresponds to Villon's lines:

> 'Les epaules toutes bossues
> Mamelles, quoi! toutes retraites
> Telles les hanches que les tettes!
> Quant aux cuisses,
> Cuisses ne sont plus, mais cuisettes
> Grivelées comme saucisses!'

This statue exemplifies moreover the implication in the Romantic creed that beauty is that which has *emotive character*

so that beauty includes ugliness if that ugliness is emotionally expressive.

When the average student made room for this statue as part of his prejudice-concept of 'good' sculpture he made an adjustment the difficulty of which, now that the statue is an established part of the prejudice, he has completely forgotten.

iv. The propagandist protests

The admission of this statue, in fact, actually affected the position of the Greek prejudice on the sofa; and as late as 1913 we find Sir Charles Waldstein (afterwards Walston) protesting against this sacrilege when, in a lecture delivered to the students of the London Royal Academy, he said: '*I maintain, and emphatically maintain, that the production of such a statue is an artistic mistake*'. But in this connection we must remember that Sir Charles Waldstein (Litt. D., Ph.D., L.H.D., sometime Fellow and Lecturer of King's College, Cambridge, sometime Slade Professor of Fine Art, Reader in Classical Archaeology, Director of the Fitzwilliam Museum, Cambridge, Director of the American School of Archaeology, Athens) was one of the professional propagandists for Greek sculpture whose activities I shall examine later.[1]

v. Rodin's incomplete figures

It was the Romantic creed moreover which produced those fragmentary statues which form a characteristic part of Rodin's *œuvre*—in bronze the torsos and figures with incomplete limbs, and in marble the figures still adhering to or partly emerging from lumps of material hardly worked at all.

vi. Rodin—a modeller

It is also important to notice that in the field of sculpture the Romantic creed encouraged a decided preference for clay modelling (distinguished from carving) as the most suitable medium for the expression of the sculptor's emotion and the symbolisation of that emotion in the touch. I shall return to the

[1] Cf. II. 9. iii. to v. and viii. *a.* to *k.*

significance of this preference later. Here I need only remind the reader that Rodin never carved. He made all his works in clay. The marble versions of his statues were produced by marble workers whom he never even saw.[1]

vii. Summary

In admitting the works of Rodin as part of his finality-form of 'good' sculpture of the past the student thus admitted (*a*) the Romantic doctrines that art is nature seen or imagined through the artist's temperament, and that sculptural beauty is emotionally expressive character, (*b*) the Romantic preference for modelling (distinguished from carving) as the sculptor's most characteristic procedure, and (*c*) the Romantic view that the incomplete statue in bronze or marble is complete and satisfactory if the fragment records the artist's emotional reaction to a fragment of life.

viii. How the Elgin Marbles helped

It is further worthy of note that the adjustment required for the acceptance of the incomplete statue was actually facilitated by professional propaganda in support of the Greek prejudice. As we shall see later that propaganda in the nineteenth century exalted the Elgin Marbles as objects of sculptural perfection in their *incomplete* condition as acquired for the nation in 1816. Before the Elgin Marbles were established in the average spectator's finality-form of 'good' sculpture the finality-complex had always demanded that a statue should be complete. For this reason in Imperial Rome, in Renaissance Italy and up to the beginning of the nineteenth century, all fragments of so-called 'antique' statues had been rendered 'complete' by restorers.[2]

The only fragment of sculpture admitted as satisfactory before the period of the Elgin Marbles propaganda was the *Vatican Torso* which, for some reason that I have not been able to discover, was not restored in the Renaissance. The *Vatican Torso* was so exceptional in this respect that it was habitually referred to in sculptural literature for four hundred years as *The Torso*

[1] Cf. III. viii. *passim*.
[2] Cf. II. 9. vii. *f*. 3 and 13, and 19-21.

and we can even find it so referred to in the indices of books published within the last thirty years.[1]

The Elgin Marbles prejudice also contributed to appreciation of Romantic sculpture in another way. By accepting their roughness of surface (on the *Ilissus* for example) and the jagged broken edges to the drapery on the other figures, the spectators were admitting a new sculptural experience, because the surface of all antique figures, hitherto considered 'good' by the prejudice, had always been worked all over to an even smoothness by the restorers and the edges of all the drapery had always been made sharp, neat, and even. When the rough and varied surface of the Elgin Marbles became included in the Greek prejudice the door was open to the acceptance of the emotive handling of Romantic sculpture—the thumbed clay and uneven texture reproduced in bronze, and the passages in marbles that were not finished with the fine chiselling and smoothing processes but left quite roughly pointed out.

The professional propagandists for Greek sculpture in the nineteenth century would have been horrified if they had realised that by extolling the Elgin Marbles as sculptural perfection in their actual state they were helping the appreciation of the sculpture produced by the hated Romantic movement. But that, in fact, is what occurred. The appreciation of Rodin's sculptural fragments would have been quite impossible if the Elgin Marbles, like all 'antique' statues before them, had been known to the world only after the restorers had added arms and legs and heads, and smoothed all the surface of the flesh, and refashioned the drapery into nice neat edges.

The propagandists for the Elgin Marbles would have been still more horrified if they had realised that the taste which they

[1] Cf. the index of Professor B. G. Baldwin Brown's edition of *Vasari on Technique* (London, Dent, 1907).

Dr. Gisela Richter writes as follows of this torso: 'In the . . . "Belvedere Torso" we find . . . superbly realistic modelling and dramatic action conveyed by a decided twist of the body and the placing of the head at a completely different angle from the trunk'—though there is absolutely nothing to indicate how the head on this headless and neckless statue was placed. I shall have more to say later of the methods of this American propagandist for the Greek prejudice (cf. II. 9. iv. and vii. *b*., and II. 9. viii. *g*. and *h*).

26

were creating for a rough and varied surface was opening the door to the appreciation of the bronze portraits of Jacob Epstein in our day. But that also, in fact, is what has happened.

ix. *Epstein's portrait bronzes*

The average student has not yet made the adjustment necessary to understand Epstein's carvings in stone to which I shall refer later.[1] But he finds no difficulty in understanding his bronze portraits because they are Romantic in attitude and thus fall within the finality-form as altered by the admission of Rodin. Students recognise to-day that Epstein, when he makes his bronze portraits is doing the same kind of thing as was done by Rodin. They know indeed the nature of that activity from the lips of both sculptors themselves. Rodin said to M. Gsell, '*Il n'y a de laid dans l'Art que ce qui est sans caractère*',[2] and Epstein has said to Mr. Arnold Haskell, '*I try to express the character of what I am depicting*'.[3] Students to-day grant the sculptor the right to make statues from this standpoint, and when they contemplate the intensely individualised character in Epstein's bronze portraits, they realise that this kind of empirical modelling has never been more powerfully done and that the art of Romantic portraiture has reached a climax in these works (Pl. 3*a*).

The student to-day finds no difficulty in accepting Epstein's technique in these bronzes. He accepts the rough surface because he has already accepted it in the works of Rodin which in turn he had accepted because he had been taught to accept such surface in the Elgin Marbles.

The rough surface in Epstein's bronzes can be described in general terms as romantic-emotive handling. But there is nevertheless I think a difference in character between the surface of Rodin's bronzes and those of Epstein. Rodin's handling was deliberately emotive in the Romantic tradition. The parade of the varied surfaces in his case was partly a gesture of the same character as Delacroix's parade of his *brosse ivre*. In the case of Epstein, as we know from the book already quoted, the varied

[1] Cf. III. 2. viii. *j*.

[2] *L'Art*. Rodin and Gsell, p. 51.

[3] *The Sculptor Speaks*. Jacob Epstein to Arnold Haskell, p. 71.

surface derives partly from the artist's conscious desire to exhibit and stress the minor forms that give character to a face; but it also derives in part, I fancy, from a feeling that the surface is aesthetically intriguing in itself.

Epstein has studied the Elgin Marbles as an original artist; he has studied them that is to say for his own purposes. He experienced, I fancy, an aesthetic pleasure from their surface, which is the result of accidents and of the action of time in contact with stone. He has tried perhaps unconsciously to make clay models which, when cast in *bronze*, will provide the same pleasure from their surface that he derived from the surface of the *marbles* from the Parthenon pediments. This aesthetic element should, I think, be taken into account in contemplating the rough surface of Epstein's portrait bronzes (Pl. 3*a*) and the broken edges of the drapery in the bronze *Madonna and Child*.

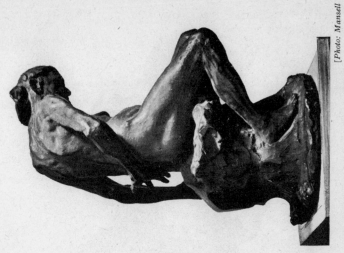

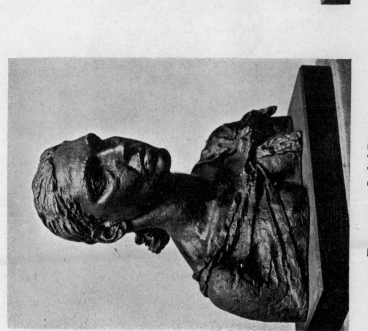

3b. RODIN: *La Vieille Heaulmière*
Cf. II. 7. iii. and v. 5.

3a. EPSTEIN: *Isabel Powys*
Cf. II. 7. ix.

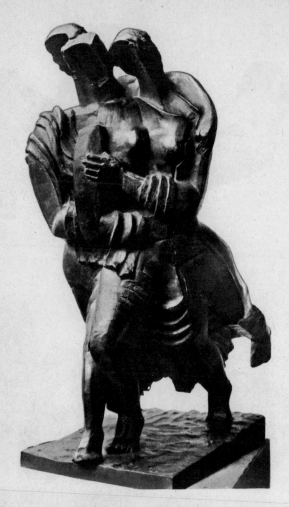

4. ZADKINE: *Menades*
Cf. IV. 2. iv., 3. ii.

8. The Renaissance prejudice

i. The prejudice

'*If a sculptor of the late Phidian school had been surrounded by the same types of face and costume as those among which the Italians lived he would have produced plastic works closely resembling those of the great Florentine masters.*'[1]

That, concisely put, is the Renaissance prejudice. The prejudice assumes that the Renaissance masters imitated the Greeks and did it so well that the Greeks themselves would have approved the imitation.

We have all absorbed this misrepresentation of Renaissance sculpture in our schooldays and we can only correct it by independent study.

ii. Renaissance sculpture

The facts of the matter as I understand them would seem to have been more as follows:

a. The rebirth of the Greek prejudice which gives its name to the period was not the characteristic culture of the age. It was an attitude mainly restricted to dilettanti and to pedants and one encouraged by antique dealers, archaeologists and other interested groups.[2]

b. The Renaissance sculptors were not acquainted with any original Greek sculpture. In the early Renaissance they were acquainted with Roman and Etruscan sarcophagi; later they were acquainted with statues by Greek sculptors of Roman Imperial times and reconcocted 'Graeco-Roman' statues such as we see to-day in the Vatican collection.[3]

[1] *Encyclopaedia Britannica*, 9th edition. Article 'Sculpture' by Professor J. H. Middleton.

[2] Cf. II. 8. iii., and II. 9. vii. *f.* 16. [3] Cf. II. 9. vii. *f.* 12-15.

c. Some academic sculptors in the Renaissance imitated the Vatican statues in order to obtain contact with the rich collectors' taste for the 'antique' and so extract some of their money. But these sculptors were popular, not original, in kind.[1]

d. The main mass of both secular and religious sculpture in the Renaissance imitated not antique sculpture but *contemporary Renaissance painting*.[2]

e. The outstanding original sculptors looked at the Roman and Etruscan sarcophagi and even at the Vatican statues and learned something from them for their own purposes at the moment. They looked at them, that is to say, not as victims of the contemporary propaganda for the Greek prejudice but from the quite different standpoint of the creative artist.[3]

f. The original sculpture of the Renaissance was part of the characteristic culture of the age as distinguished from the pseudo-culture of the 'antique' prejudice. The characteristic culture of the Renaissance was a new attitude of scientific curiosity and adventure. It was the scientific curiosity of the original Renaissance sculptors which drove them to their dexterous and ingenious solutions of technical problems; it was the spirit of scientific adventure that made them feel dissatisfied till they had produced a technical innovation and established a technical 'record' of some kind; Cellini flinging his household pots and pans into the melting pot to make the metal flow at the critical moment in casting his *Perseus* was a typical contributor to Renaissance culture.

Even the naturalism which we get in the ordinary workaday Renaissance portraits was part of this spirit of scientific curiosity which had cultural significance at the time. The Renaissance portrait-modellers made extensive use of death-masks and they also used plaster casts from life. In the Museum at Toulouse there is a set of sculptures from the Saint Sernin church where the faces, which are from death-masks, show the tongue between the half-open mouths and all the clothes are actual garments cast in some peculiar way. Scientific imitation of this kind had metaphysical value in the Renaissance, but the

[1] Cf. *The Modern Movement in Art, passim.*
[2] Cf. III. 2. viii. *g.*, and IV. 2. iii.
[3] II. 6. vi., and IV. 1. and 2. iii.

same thing has of course no such metaphysical value to-day because technical triumphs are now the functions of machines.

I have submitted earlier that in recent centuries culture has been habitually concerned with the relief of the subconscious dissatisfactions of the time.[1] As I understand it the true Renaissance culture, this attitude of scientific adventure, was an effort by the finer spirits to intensify the Gothic fire which the contemporary propagandists for the 'antique' prejudice were trying to put out.

Original Renaissance sculpture was a direct defiance of the contemporary prattle about the perfection of 'antique' sculpture. The original sculptors exhibit neurotic reactions to emotive fragments of life and a passionate empiricism in technique which not only intensified the Gothic attitude but forestalled the Romantic art of Rembrandt and of the nineteenth century.

g. It is also worth noting that the original sculpture of the Italian Renaissance in the fifteenth century was not specifically Italian in character; it was part of the international culture of the time. Donatello, the most typical fifteenth-century figure, was at once the greatest of the international Gothic sculptors and the ancestor of Rodin and Epstein.

It is not till we get to Michelangelo's work in the sixteenth century that we encounter sculpture that is no longer Gothic; and Michelangelo's attitude, as we shall see, was more like that of the original sculptors of our day.[2]

iii. *The die-hard dilettanti*

The 'antique' prejudice in the Renaissance was partly a fashionable snobbery encouraged by antique dealers, archaeologists and other interested groups, and partly a nationalist and reactionary attempt to resist the international development of Gothic culture as something foreign and dangerously alive. The word 'Gothic', to describe the non-Italian art of the period, was invented, as all the world knows, as a term of contempt by the Italians of the Renaissance; the propagandists for the Greek prejudice made such good use of it that it remained a term of contempt for three hundred years; and they began by persuad-

[1] Cf. I. 4. [2] Cf. III. 2. viii. *b*.

ing the contemporary Jack Horners that there was something fine and patriotic in admiring reconcocted antique statues and that the glories of ancient Rome were being revived by every Italian gentleman who dug in his garden and found half a marble torso or a fragment of a leg.[1]

The prejudice in the Renaissance was also partly an expression of the resentment of blunt minds and feeble spirits at living contemporary culture *as such*. The die-hard dilettanti were correctly described by a contemporary as those 'who admire the antique without criticism through a kind of jealousy toward the talent and industry of their own times.'[2]

iv. *Rodin, Donatello and Michelangelo*

The Renaissance prejudice in our own time has undergone some adjustment as the result of the admission of Rodin's Romantic sculpture to the prejudice-pie. Renaissance works hitherto regarded as attempts to emulate Greek perfection were seen to stand much closer to Rodin than to the statues in the Vatican collection. The 'expressionism' in Donatello's work was seen to be not the result of a failure to achieve the vacuous calm of the Vatican 'antiques' but the result of the attitude which we have learned to call Romantic; and students who had become acclimatised to Rodin's fragmentary bronzes and marble figures half emerging from roughly pointed masses of stone, began to ask themselves whether Michelangelo's unfinished statues from the Boboli gardens were not 'better' than his finished *David* in Florence and whether the naked old gentleman called *Day* on the tomb of Giuliano dei Medici was not 'better' because more vital and expressive than the naked old gentleman called *The Nile* in the Vatican or his brother called *The Tiber* in Paris.

But students have not been allowed to pursue such independent judgements undisturbed, because, as we shall see, the propagandists for the supremacy of the Greek prejudice are much too numerous and too strong.

[1] Cf. II. 9. vii. *f*. 13. [2] Cf. II. 9. vii. *f*. 16.

9. The Greek prejudice

i. The prejudice

The Greek prejudice assumes that a final perfection in the sculptor's art was achieved by the Greeks, and particularly by the Athenians in the fifth century before the Christian era; that the greatest Greek sculptors were called Myron, Phidias and Praxiteles; and that all right-minded contemporary sculptors should imitate the productions of those masters though all attempts to equal their perfection will of necessity be vain.

ii. Two facts

Now let us look at two facts.

a. The first fact is that the Greeks in the fifth and fourth century produced a number of clay modellers who acquired wide reputations in their day; Calamis, Myron, Pythagoras, Phidias, Polyclitus, Scopas, Praxiteles, and Lysippus are among the names of such sculptors recorded in the writings of the ancients.

b. The second fact is that *no works by these sculptors survive.*[1] All these sculptors modelled for bronze, and a thousand years ago all their bronzes had already been melted down by men who thought the metal more useful to them than these particular statues.[2]

[1] For the case of the so-called *Praxiteles Hermes* cf. II. 9. iv. *g.*

[2] The desire to melt down bronze statues for the metal was not confined to the barbarians of the Dark Ages. As the reader will remember, Hubert Le Sueur's equestrian bronze of Charles I (now in Trafalgar Square, London) was sold by Parliament during the Commonwealth to a brazier of Holborn to be melted down; the brazier took the money and sold knives and forks purporting to be made of the metal to Royalists; when the Restoration came he produced the statue intact.

In 1881 the Principal and Fellows of Brasenose College, Oxford, decided that they would rather have the value of the lead than the lead Renaissance statue in their front quadrangle; they accordingly sold it to a local plumber who melted it down.

iii. *Interested support of the prejudice*

The reputations of these sculptors would have disappeared as completely as their works if they had not been kept alive by propaganda emanating from interested supporters of the Greek prejudice.

The prejudice was born in ancient Roman times. It suffered temporary eclipse in the Middle Ages. It was reborn in the Renaissance and has flourished ever since. It derives its power from the support of powerful organisations whose existence depends in a large measure on its maintenance. This has been true all through its career. It is more true than ever to-day when the organisations interested in its maintenance are more numerous, more powerful, more widely distributed and more skilled in the concoction of propaganda than they have ever been before.

In Imperial Rome, in Italy in Renaissance times in the seventeenth and eighteenth centuries, and everywhere in our own day, dealers in antiques, restorers of antiques, academic sculptors imitating antiques, collectors of antiques, professional archaeologists and historians of Greek sculpture have been and are vitally concerned with the maintenance of this prejudice.

In the last hundred years, moreover, countless museum officials, university professors, and educational officers in every country of the civilised world have constituted other groups whose actual existence depends in a large measure on maintaining the legend of the final perfection of Greek sculpture.[1]

When the prejudice has shown signs of languishing it has always been given physic and nursed back to life by the interests dependent upon its continuation.

The physic has always taken the form of propaganda disguised as the history and appreciation of sculpture. Whole libraries of books have been written to maintain and increase the reputations of sculptors whose works the writers *have not seen*.

I will quote some characteristic specimens of this propaganda which occur in two recent and well-known histories of Greek sculpture—*The Sculpture and Sculptors of the Greeks*, by Gisela

[1] Cf. II. 9. vii. *f*. 25.

The Greek prejudice

M. A. Richter, Litt.D., Curator of the Department of Classical Art in the Metropolitan Museum of New York,[1] and *Handbook of Greek Sculpture*, by Ernest Arthur Gardner, Litt.D., late Fellow of Gonville and Caius College, Cambridge, formerly Director of the British School of Archaeology at Athens; Yates Professor of Archaeology in the University of London, etc., etc.[2]

To quotations from these two books I will add quotations from one or two others.

iv. Specimens of propaganda

a. Boosting Calamis

(No work by the hand of this artist (fifth century B.C.) is known to or presumed to exist. It is a thousand years or more since anyone has seen one.)

'*Calamis . . . was a worthy representative of Greek sculpture as it might have been but for the bolder conceptions and more severe tendencies that we see in his contemporaries . . .*'

PROFESSOR GARDNER

b. Boosting Myron

(No work by the hand of this artist (fifth century B.C.) is known to or even presumed to exist. It is a thousand years or more since anyone has seen one.)

'*The "Marsyas" . . . is a splendid composition, full of action and yet beautifully harmonious. Its rhythmical movement and sturdy modelling mark it as the conception of a great artist.*'[3]

DR. GISELA RICHTER

'*The distinguishing feature of Myron's work is the fulness of physical life and its varied sometimes even exaggerated expression in bronze. In him we see complete mastery over the material.*'[4]

PROFESSOR GARDNER

[1] New Haven, Yale University Press. London, Humphrey Milford. Oxford University Press, 1930.

[2] Macmillan, London, 1924.

[3] Cf. II. 9. vii. *f.* 24, and II. 9. viii. *g.*

[4] For comments on the various *Discobolus* statues in marble to which the propagandists attach the name of Myron cf. II. 9. vii. *f.* 24.

35

c. Boosting Pythagoras

(No work by the hand of this artist (fifth century B.C.) is known to or presumed to exist. It is a thousand years or more since anyone has seen one.)

'*One of the greatest and most original of Greek sculptors.*'

DR. GISELA RICHTER

d. Boosting Phidias

(No work by the hand of this artist (fifth century B.C.) is known to or presumed to exist. It is a thousand years or more since anyone has seen the colossal statues which he made with the aid of assistants some of whose names survive.

The Elgin Marbles are not by his hand. There is no evidence of any kind that they were even made from his models or designs. He was not the architect of the Parthenon.)[1]

'*Phidias the world's greatest sculptor.*'

T. G. TUCKER, Litt.D. (Camb.), Hon. Litt.D. (Dublin), Professor of Classical Philology in the University of Melbourne. *Life in Ancient Athens*.[2]

'*The works of Phidias here collected show us Greek art as it was in its brief poise of perfection . . . of Phidias the sculptor it may be said . . . that "there is a strange undercurrent of everlasting murmur about his name which means the deep consent of all great men that he is greater than they".*'

E. T. COOK. Handbook to the Greek and Roman Antiquities in the British Museum.

'*. . . We must imagine this colossal figure the Olympian Zeus . . . grandly conceived and carved in simple lines; gleaming with its gold and ivory, but the brightness tempered by the figures wrought in the drapery; the sceptre sparkling with precious stones; and the throne elaborately decorated—a combination of grandeur and richness.*'

DR. GISELA RICHTER

'*Phidias was the first to make ideal statues, that is to say . . . he took the type prescribed and consecrated by tradition as belonging to*

[1] Cf. II. 9. viii. *a.*, *b.*, *c.*, and *d.*

[2] Macmillan, London and New York, 1907.

36

this or that deity, filled it with a new life and a higher meaning, while inspired by the religious conceptions of those for whom he worked, but raising them above such notions as were commonly received; in fact we may almost put in his mouth the words of another who turned to a new and higher meaning an accepted element of Athenian religion, "Whom therefore ye ignorantly worship, him declare I unto you".'

<div align="right">PROFESSOR GARDNER</div>

'*Phidias, the designer of the Parthenon sculptures.*'

SIR CHARLES WALDSTEIN (afterwards WALSTON), Litt.D., Ph.D., L.H.D., sometime Fellow and Lecturer of King's College, Cambridge, Slade Professor of Fine Art, Reader in Classical Archaeology and Director of the Fitzwilliam Museum, Cambridge, Director of the American School of Archaeology, Athens, etc., etc.

e. Boosting Polyclitus

(No work by the hand of this artist (fifth century B.C.) is known to or presumed to exist. It is a thousand years or more since anyone has seen one. Polyclitus was the author of a treatise on the ideal proportions for the male human figure which he embodied in a statue of a youth bearing a spear (*Doryphorus*). The treatise like the statue no longer exists.)

'*His gifts of exquisite finish and harmonious composition naturally marked him out as a sculptor of athletes.*'

<div align="right">DR. GISELA RICHTER</div>

'*He excelled in the ideal representation of divine power and beauty . . . his wonderful technical skill . . . his great creative imagination.*'

<div align="right">PROFESSOR GARDNER</div>

'*As perfect a work as any victorious athlete by Polyclitus.*'

<div align="right">STANLEY CASSON</div>

f. Boosting Scopas

(No work by the hand of this artist (fourth century B.C.) is known to or even presumed to exist. It is four hundred years since anyone has seen one.

<div align="center">37</div>

The Mausoleum at Halicarnassus on which there was some work by the hand of or from the designs of Scopas was damaged by an earthquake in the twelfth century, used by the Knights of Malta as material for constructing a castle in the thirteenth century, and further destroyed by the Turks in 1522. Not even the propagandists claim that any of the fragments from Halicarnassus in the British Museum can be presumed to be his work.[1] An incomplete marble helmeted head (found in pieces at Tegea, stuck together by restorers, and now in the National Museum, Athens), is absurdly presumed by the propagandists to represent the bronze style of Scopas because Pausanias says that he was *architect* of the Temple of Athena at Tegea.)

'He excels above all in the rendering of passionate and excited emotion, in the vivid expression, in every line of face and body, of an overmastering impulse from within.'

PROFESSOR GARDNER

g. Boosting Praxiteles

(Up to 8th May, 1877, no work by the hand of this artist (presumed to have lived in the fourth century B.C.) was known to or presumed to exist. It was then a thousand years or more since anyone had seen one. On that date an incomplete marble figure was excavated on the site of the Heraeum at Olympia where Pausanias about eighteen hundred years ago recorded that he saw 'a marble Hermes carrying the child Dionysus the work of Praxiteles'. As the excavated statue was part of a male figure carrying an infant, this statue was presumed to be the one which the informant of Pausanias presumed to have been made by Praxiteles four hundred years earlier. The right arm and both legs below the knee and one of the feet of the Hermes were missing; the left arm of the child was also missing. The legs and foot of Hermes and the arm of the child have been restored presumably by the restorers of the Olympia Museum. Dr. Richter's photograph of this statue includes the restorations. The presumption that the excavated portions of this statue are by the hand of Praxiteles has recently shown a tendency to give place to a presumption that they are the work of a Roman

[1] Cf. II. 9. viii. *h*.

38

'copyist' or of studio assistants who made this marble copy from the original bronze.[1])

The following is a specimen of the propaganda boosting Praxiteles *before* the discovery of the *Hermes*:

'Praxiteles excelled in the highest graces of youth and beauty.'
JOHN FLAXMAN, R.A., *c.* 1812

The following are specimens of propaganda boosting Praxiteles *after* the discovery of the single incomplete work assumed to be original:

'His works all show an artistic restraint.'
PROFESSOR GARDNER

'The genius of Praxiteles may be compared with that of Raphael. Their works are imbued with a serene and sober grace and appeal by their very radiance and loveliness.'
DR. GISELA RICHTER

h. Boosting Lysippus

(No work by the hand of this artist (fourth century B.C.) is known to or presumed to exist. It is a thousand years or more since anyone has seen one. Till the end of the nineteenth century the propagandists wrote twaddle about the style and genius of Lysippus based without any justification on a marble statue of an athlete scraping himself (Apoxyomenus) in the Vatican. Since the discovery at Delphi of a marble called Agias, *which is quite different in style*, and presumed to be a 'copy' of a work by Lysippus, they have been occupied in attempting to explain the difference.)

'A master of ideal portraiture in which all his technical skill in detail was employed to glorify the individual character of his subject.'
PROFESSOR GARDNER

[1] Pliny (cf. II. 9. v.) states that Praxiteles worked not only in bronze but also in marble; but this does not necessarily mean of course that Praxiteles cast the bronze or carved the marble himself. It probably means that he was a clay modeller (like Rodin) whose models were both cast in bronze and copied in marble by his assistants, as distinguished from the fifth-century modellers and Lysippus whose models were only cast in bronze (cf. II. 7. vi., and II. 9. v., and III. 2. viii.).

The Greek prejudice

*'The last great original sculptor of Greece. . . . A great composer.
. . . A genius.'*

DR. GISELA RICHTER[1]

v. *What the propagandists know*

The propagandists know from the writings of ancient authors
certain facts and opinions about some of the works of these
sculptors. They know, for example, from the writings of the
elder Pliny that all the famous Greek sculptors of the fifth cen-
tury modelled in clay for bronze. Pliny, a Roman compiler of an
Encyclopaedia in the first century A.D., gives a list of the most
celebrated Greek sculptors, the titles of some of their famous
works, some comments upon them and a statement of the
materials in which they were made.

The propagandists also know something from a kind of
'Baedeker' written by Pausanias, a Greek of Asia Minor. In the
middle of the second century A.D. Pausanias travelled in Greece
and made notes of the sculptures which then remained there and
of the information given him about them by the local guides.[2]

There are also references to and some descriptions of famous
Greek statues in the works of Lucian, a Syrian Greek who wrote
in the second century A.D.; and odd scraps of information ob-
tainable from other documents and from inscriptions.[3]

Certain possibly antique coins bear images of statues upon
them which are presumed to resemble certain celebrated Greek
statues. There is, for example, a coin (Bibliothèque nationale,

[1] Dr. Richter's book bears at the head of the Preface the following
quotation from Plato: *Epistles*, vii. 341c.

'There is no way of putting it into words like other studies, but after
much communion and constant intercourse with the thing itself, suddenly,
like a light kindled from a leaping fire, it is born within the soul and
henceforth *nourishes itself*.'

The italics are mine.

[2] Cf. II. 9. vii. *f*. 1.

[3] 'Were he [Pausanias] and Pliny excluded, a scanty pamphlet
would contain all that remained of our literary authorities for the
history of sculpture.' PROFESSOR GARDNER

The description of the history of the remains of Greek sculpture as
the history of sculpture is characteristic of the propagandists' methods.
Modern sculptors have a different concept of the history of sculpture
(cf. Part IV. *passim*).

Paris) with an image of a nude female figure presumed to have some relation to the *Aphrodite* made for the Cnidians by Praxiteles.[1] Another (in the Museo archaeologico, Florence) bears an image presumed to be related to the colossal *Zeus* in gold and ivory made by Phidias for the Temple of Zeus at Olympia; and a third (British Museum) bears an image presumed to be related to his *Athene Parthenos* in Athens.

The propagandists' eulogies of the styles of the celebrated Greek sculptors are, in the main, rhetorical rehashes of compilations made about two thousand years ago by authors who were then writing about sculptors who had lived four or five hundred years earlier; to the scraps of information derived from these compilations the propagandists add what they are pleased to call 'the evidence of coins' and try to persuade us that they have a complete and accurate impression of the appearance of a non-existent forty-foot statue from a half-effaced image on a possibly faked coin the size of a sixpence.[2]

vi. 'What then are all these objects'?

'But what', the reader may ask here, 'are all these objects which fill the European and American museums and collections? What are the Vatican Marbles, the Louvre Marbles, the Townley Marbles, the Lansdowne Marbles, the Elgin Marbles in the British Museum, the Aegina fragments in Munich, the Olympia fragments at Olympia, and the whole mass of sculpture continually written about by the historians of Greek sculpture?'

The answer must be a long one, but I must repeat before embarking upon it that there is not a single object (unless you chose to accept the *Hermes and the Infant Dionysus* at Olympia) which has any real claim to be an original by, or an accurate replica of any object made by, Myron, Phidias, Polyclitus, Scopas, Praxiteles, Lysippus, or any of the other Greek

[1] Cf. II. 9 vii. *e*. 2, and II. 9. vii. *f*. 24.

[2] They also talk of the 'evidence of gems' on which Nollekens, who saw antique gems being made by the dozen, had a useful word to say (cf. II. 9. vii. *f*. 18).

For restorations 'on the evidence of coins' cf. II. 9. vii. *f*. 24 and 30.

For the 'evidence of copies' cf. II. 9. vii. *f*. 1-24.

sculptors whose praises are so loudly and persistently sung by the propagandists.

vii. What the objects are

a. The difficulty of finding out

It is difficult to discover what these objects really are. To be able to state what they are we should have to be acquainted (*a*) with the whole Greek production of sculpture from 650 B.C. onwards, (*b*) with the attitudes, motives and procedures of the sculptors and (*c*) with the use made of their productions by contemporary life. To say what the objects really are we should require a complete knowledge of the *real appearance* of the Greek sculptures at the time when they were made and a complete knowledge of their *real character* as part of a living culture at the time or as part of the backwash of the obsolete culture of their day.[1]

Unfortunately in regard to (*a*) we do not know, as noted, the appearance of the works of the celebrated sculptors, and in regard to (*b*) when we try to visualise the succeeding cultures of ancient Greece at the various periods we are at once confronted with another mass of propaganda emanating from the same interested quarters—propaganda this time which conspires to persuade us that the Greeks and especially the Athenians of the fifth century achieved a perfection in life that no Christian nation can ever hope to equal.

We have all imbibed this propaganda in our childhood; it forms the basis of our general concept of Greek life and civilisation; and to correct it we have to make a definite effort because the propaganda is not only encountered in schoolboy literature but also in standard compilations designed for adult men and women.

b. The legend of Greek life

Here are two quotations taken at random from the vast libraries of this type of propaganda.

'*Service to the state in time of peace and war, the cultivation of the body and the mind by athletics, music, poetry, mathematics, and philosophy, relaxation in games, the theatre and processions, and a reverent worship of the supernatural—these made up the chief*

[1] Cf. IV. 2. iv. *c*. 4.

activities of an Athenian citizen. It is a radiant picture which Athens presents to us of a full and rounded life, perhaps the sanest that man has evolved . . .'

<div align="right">DR. GISELA RICHTER (op. cit.)</div>

'The Athenians were just sane and wholesome pagans with clear heads and true tastes.'

<div align="right">PROFESSOR TUCKER (op. cit.)</div>

I have always found it hard to accept the suggestion that the normal springs of action in ancient Greece were so entirely different from the springs of action in all other times and places, and that the Athenians of the age of Pericles knew nothing of the greeds for power and money, the natural and unnatural vices, the mean motives, the brutalities and hypocrisies which have always abounded in the Christian world. Dr. Richter and Professor Tucker must know that the picture which they draw in the words quoted is, in the nature of things, likely to be a false one; they also know it to be false from the evidence of their own studies; indeed if we read in their entirety the two books from which these quotations come we realise at once that the authors' real conclusions from the facts which they themselves record must be entirely different.

These writers and a thousand other propagandists know a great many things about life in ancient Athens which they obscure or conceal because they conflict with their desire to suggest that the Greeks produced a final perfection in sculpture because they had attained to a final perfection in life.

c. The legend of the fair city

There is also a conspiracy to persuade us that the Athenians produced final perfection in sculpture and had 'clear heads and true tastes' because they lived in a city which was beautifully disposed, and clean and clear. But the propagandists know that Athens and its inhabitants were filthy because the city was always short of water, that the streets were miserable unpaved lanes, that the majority of the houses were mean, that there was no sanitation, and that the 'sane and wholesome pagans' splodging through the mud in unlighted streets at night thought themselves lucky if they did not receive a shower bath of household garbage on their heads.

<div align="center">43</div>

The propagandists in a word have tried to persuade us that fifth-century Athens was a kind of Oxford peopled by Oxfordian types—the Oxford don (a middle-aged gentleman and scholar who fought in the last war) and the Oxford undergraduate (a younger gentleman and scholar, who hopes to fight in the next one); but they know that, as fifth-century Athens was a commercial and pleasure city attached to a Mediterranean port, it was probably much more like Marseilles.

d. The belief in sculpture

If it is thus hard to work through the propaganda to a credible concept of fifth-century Athens of which much is ascertainable, it is still harder to reach a credible concept of Greek cultures of the periods of which the propagandists themselves know next to nothing.

But it does seem quite clear that the Greeks, both in Greece and the Hellenised regions, believed in sculpture. For some reason or reasons, for five or six hundred years, they seem to have thought it desirable and necessary to produce it. From 650 B.C. the production seems to have been continuous. For five or six hundred years the Greeks looked to sculpture for some purposes in their adjustments to life. Sculpture quite evidently fulfilled for them some needs and provided them with gratifications of some kinds.

e. What the Greeks produced

1. Votive offerings and funeral reliefs. From the beginning of the period the Greeks seem to have believed that funeral or ancestor statues would serve some desirable purpose; their sculptors fashioned such statues in imitation of the figures on Egyptian tombs—upright naked figures with the arms hanging down and the hands fixed to the loins.[1]

When the Greeks began to build temples they seem to have thought that some magic purpose would be served by dedicating their funeral or ancestor statues as votive offerings at the sanctuaries; and they deposited statues as votive offerings at all times and everywhere.

[1] We find the same attitude in negro sculpture where the figures have been interpreted as magic ancestor figures with their hands fixed to their loins whence the progeny issued. (Cf. IV. 3. v.)

In the middle of the second century B.C. the temple sanctuaries, which abounded, were all packed with votive statues dating from different times. The statues were made of wood, bronze, marble and other materials. The marbles seem always to have been painted. The bronzes often had ivory and enamel eyes.

The Greeks seem also to have believed that relief sculptures on tombstones would serve some desirable end. The Athenians made sculptured tombstones until the end of the fourth century when they were forbidden by law to make them any longer.[1]

2. *Magic images, cult idols and war memorials.* The Greeks also used sculpture for magic images, cult idols and war memorials.

In the fifth century they evidently thought of their gods and goddesses as abnormally large men and women; Phidias was paid to make a giant *Zeus* forty feet high for the Temple of Zeus at Olympia and two giant *Athenas* for Athens. The size of the *Aphrodite,* which the inhabitants of Cnidus paid Praxiteles to make for them, is not known; we know, however, from ancient writers that the figure was completely naked and that it excited amorous passions in young men.[2]

It is possible that in the fourth century all the idols connected with the cult of Aphrodite and Apollo were statues with a similar sex appeal.

The war memorials were sometimes cult idols fabricated with metal taken from the enemy; and there would seem to be some ground for supposing that they were sometimes in the form of a young woman with wings on her back and a trumpet in her hand.[3]

The magic images, cult idols and war memorials were made of wood, bronze, gold and ivory, marble and other materials. Two of the giants by Phidias were made of gold and ivory; the third was bronze. The Cnidian *Aphrodite* by Praxiteles was in marble. The marbles were painted.

[1] Decree of Demetrios of Phaleron (c. 317). Cf. Richter, op. cit., p. 101 (1929 edition).

[2] Cf. II. 9. vii. *f.* 24.

[3] Cf. II. 9. vii. *f.* 30 for the concoction known as the *Victory from Samothrace.*

In the middle of the second century B.C. there were still thousands of magic images and cult idols of various degrees of antiquity and many war memorials in Greece and the Hellenised regions.

3. Statues with sex appeal. The Greeks of the fourth and later centuries made naked and draped statues of beautiful boys and pretty girls which were not used as cult idols but collected as objects of substitute-gratification by contemporary dilettanti.

The character aimed at in these statues has been described by Ezra Pound as the character of 'caressibility'.

In the fourth century a sculptor called Lysistratus was famous for his use of plaster casts from life. Casting from life was also practised by the modeller of the *Delphi Charioteer*, and the modellers of the drapery on some of the pedimental figures from the Parthenon and of the drapery in the *Hermes and Infant Dionysus*, ascribed to Praxiteles, obviously dipped real drapery in clay and cast that.[1]

When these statues were made in marble they were painted.

In the middle of the second century B.C. there still existed numbers of Greek statues and statuettes with sex appeal. They were made of bronze, painted marble, terra-cotta and other materials.

4. Sculpture on buildings. From early in the period Greek sculptors and masons seem to have been employed to add reliefs with figures to temples and other monuments. Processions of figures were placed on friezes; figure compositions were squashed into pediments and other places; here and there odd figures in the round were stuck upon the buildings. Sculptors and masons were paid to do this as long as temples and other monuments were erected in Greece and the Hellenic lands.

The sculpture on Greek buildings was of terra-cotta, marble or stone. It was all painted.

It is difficult to imagine why the Greeks thought a figure subject desirable for a frieze like that on the Parthenon which was placed in a position where nobody could distinguish the figures even when their outlines were reinforced with painting.

[1] Cf. IV. 2. iv. *c.* 2. and 4. For the Renaissance use of death-masks and casts from life cf. II. 8. ii.

It is harder still to guess why figure compositions were thought suitable for pediments. But the sculptors had to do what they were told and they grouped figures into the awkward shapes as best they could.[1]

At the beginning of the Christian era hundreds of Greek temples and monuments with their sculptural additions of various dates were still standing in Greece and the Hellenic lands. It is always assumed that it was never found necessary to restore any of the sculptures and that even sculptures put up five hundred years before the Christian era remained unrestored until they were finally broken and buried to await rediscovery by the excavators of the nineteenth century. This has always seemed to me an optimistic assumption.[2]

5. *Statues of athletes.* From somewhere about the middle of the sixth century the Greeks seem to have begun to make heroes of their athletes, and to call upon sculptors to make bronze statues in their honour. It was customary to dedicate statues in the sanctuary at Olympia to victors in the Olympian games; when a man had been a conqueror three times the statue dedicated was his portrait.

Most of the sculptors who were famous in the fifth century made statues of such heroes. Thus Pythagoras was commissioned to make a bronze in honour of a wrestler hero, one Leontiscus, whose speciality was skill in breaking his opponents' fingers; and a statue excavated at Delphi was erected, the inscription tells us, to honour a wrestler who 'killed the strongest man of the Etruscans.'

These athletes were depicted naked.

It is assumed that, as marble was cheap in Greece, marble versions of the most popular of original bronze statues of athletes by the famous fifth-century artists were sometimes made by marble workers and put up in different places. If this indeed happened we must remember that such marbles were not copies but hybrid translations.[3]

[1] Cf. IV. 2. iv.

[2] Cf. II. 9. viii. *a.* for the theory that the pedimental sculptures from the Parthenon are restorations of the time of Hadrian.

[3] Cf. III. 2. viii. *c.* and *d.*

47

In the middle of the second century B.C. there were numerous Greek statues of athletes in existence, and they may have included some of the original bronzes by the celebrated modellers of the fifth century.

6. Miscellaneous statues and statuettes. Greek sculptors were employed at various times to produce portrait propaganda statues of popular statesmen, dramatists and other public characters. At certain times rich private individuals seem also to have paid modellers to make their portraits, and to make genre statues and statuettes of peasants and so forth which they placed with their naked and draped statues of handsome gods and pretty goddesses, and of beautiful boys and pretty girls, in their houses and gardens.

The genre sculpture seems to have included statuettes of animals. The Greeks seem always to have derived some satisfaction from the sculpture of animals. Lions, horses, dogs, and cats occurred in the figure compositions which they stuck on to their buildings, and also on their tombstones. It is recorded that Myron made statues of a bull, a cow and a dog.

In the middle of the second century B.C. numerous examples of Greek genre sculpture still existed.

7. A vast conglomeration. These centuries of continuous Greek belief in sculpture as of use for the satisfaction of different needs thus produced a vast conglomeration of *most varied* sculpture. There was sculpture produced by sculptors who were justly famous and by famous sculptors who were humbugs; by obscure sculptors who were intelligent and obscure sculptors who were fools; there was sculpture made by original artists, popular artists, good craftsmen and hack masons. In the middle of the second century B.C. the buildings and monuments still had their sculptured additions and every temple sanctuary, every public square, every rich man's garden and vestibule had its forest of bronze and painted marble ninepins.[1]

[1] But, of course, you must not put it this way if you are a propagandist for the Greek prejudice. You must write as Professor Gardner writes: 'Every local shrine had statues to show such as would now be among the choicest treasures of any great museum . . .' and continue in this emotive strain.

f. What happened

1. Theft and destruction. Then all this sculpture was stolen or destroyed.

The Romans swarmed into the Hellenic world, and began to knock the buildings about in warfare and to carry off the nine-pins as loot.

Professor Gardner himself provides us with the beginning of the story:

'The first Greek cities to suffer the loss of their artistic treasures, carried off as plunder to decorate the triumph of a victorious Roman general and then to be set up by him at Rome, were those of Southern Italy and Sicily. When Syracuse and Capua and Tarentum fell into the hands of Rome, though Hannibal was still in Italy, the terror of his victories was waning; and, in the confidence of ultimate success, the Romans began to decorate their city with the spoils of the Greek colonies. The great Roman victories that soon followed in Macedonia and in Asia Minor each added to the artistic plunder, and a whole day in the triumph of the general was given to the mere procession of captured statues. It is said that M. Fulvius Nobilior carried off from Ambracia no less than 785 statues in bronze and 230 in marble; and these had doubtless been already accumulated there by Pyrrhus. The triumphs of Flamininus, of Scipio Asiaticus, and of Aemilius Paulus were as rich in sculpture. But so far Greece itself was, at least by a political fiction, regarded as independent, and its central shrines were spared. A new epoch begins with the sack of Corinth by Mummius in 146 B.C., and the reduction of Greece to a Roman province. From this time forward even the most sacred centres of Greek religion—Athens and Olympia and Delphi—were not only open to plunder by generals like Sulla, who respected no place or person, but also to the more quiet and gradual robbery of Roman proconsuls, who carried off the most famous works of Greek masters, either to enrich their own private collections, or to set up in public buildings at Rome, and so to win the favour of the people. . . . In Imperial times the shrines of Greece were again and again denuded of their choicest treasures . . . Nero is said to have carried off 500 bronze statues from Delphi alone. In the great fire at Rome

countless works of art must have perished; and he sent envoys to ransack Greece in order to fill up the gaps.'[1]

This process continued after the foundation of the Eastern Empire; and numerous Greek statues were taken to Constantinople.

Of the thousands of ninepins thus transferred *as loot* from Greek to Roman ownership the Romans selected a few which satisfied their own psychological needs and melted down or broke up the rest. The statues selected for preservation seem to have been mainly the statues with sex appeal; the Romans seem to have reacted especially to the character of 'caressibility' in the bronze and painted marble statues of beautiful boys and pretty girls.

2. Roman Collections. The Romans referred to the ninepins which they selected for preservation as their 'collections of Greek sculpture'. It soon became the mark of a Roman gentleman to have a collection of this kind, and Roman gentlemen maintaining the might of Rome in official positions in the outposts of the empire stole the local ninepins, especially if they were ninepins with sex appeal, to demonstrate their taste.

3. Restoration. Many of the ninepins were, of course, damaged in the processes of loot and transport, and the Roman collectors had them assembled and the missing parts 'restored'. The business of the restorer was to stick together fragments, to add heads, arms or legs so as to produce complete figures to suit the taste of the collectors. The character and degree of sex appeal required depended on the particular collector.

4. Copies and fakes. In these conditions the dealer in antiques made inevitably his appearance. He acquired Greek or pseudo-Greek statues, put his restorer to work to turn them into beautiful-youth or pretty-girl ninepins and sold them to the collectors.

5. 'Give it a name, boy' (i). The Roman collectors liked to call their beautiful-boy ninepins 'Apollo' or 'Mercury' and their

[1] But this does not prevent the Professor from telling us in another passage that when Pausanias travelled in the next century 'all the shrines of Greece still contained almost intact their innumerable treasures of art.'

pretty-girl ninepins 'Venus'. The name of a god or goddess on the base made the statue seem respectable.

In having their statues restored they therefore ordered the appropriate attributes of the god or goddess to be added.

The dealers' restorers proceeded in the same way; and the dealer, of course, often added the first name of a famous Greek sculptor that came into his head, because the second name on the label enabled him to charge more money.

6. *Roman sculpture.* Meanwhile the Romans were producing a mass of sculpture of their own. This production was of two main classes, (*a*) academic popular sculpture, (*b*) original sculpture.

The first class was the work of sculptors who made statues in imitation of the restored or faked Greek ninepins and so obtained contact with the rich collectors' idea of 'good' sculpture and won from them both respect and money.

The second class was the work of more robust sculptors who left the ninepins on one side and made vigorous portraits and vigorous sculpture on sarcophagi and on the triumphal arches and other monuments which the Romans erected all over the empire.

7. *The prejudice launched.* But no Roman gentleman of taste put contemporary Roman sculpture on the same plane as his Greek or pseudo-Greek or partly Greek ninepins. The academic *pasticheurs*, they would have said, were after all only trying to imitate the final perfection of Greek sculpture to which they could never hope to attain, and the others were only face modellers and architects' masons, and tombstone makers.[1]

The Greek prejudice in other words was already launched; and the dealers in antiques, restorers of antiques, academic sculptors imitating antiques, the archaeologists and professors were already organising to support it.

[1] Their attitude in fact was exactly that of the eighteenth-century English gentlemen to contemporary English painting. One could have one's face and one's wife's face painted by a native artist but one's saloons must be adorned with Italian, pseudo-Italian or partly Italian pictures.

8. A new conglomeration. In the end the Roman Empire display-
ed a conglomeration of statues as vast as that of ancient Greece.
There was considerably more sculpture on monuments and
buildings and there were even denser forests of ninepins in the
public places and in the gardens and vestibules of the houses of
the rich.

9. 'If Pausanias, reborn . . .' If Pausanias, reborn at the end of
the fourth century A.D., had toured the Hellenic world, he
would have looked in vain there for the ninepins recorded in
his notebooks and he would have found only a proportion of the
mason's sculptures added to the temples and monuments be-
cause by that time the barbarians had already overrun Meosia,
Thrace and Macedonia and sacked Athens, Argos, Sparta and
resacked Corinth.

But if he had toured Italy and visited Constantinople he would
have found whole forests of new ninepins.

10. Destruction of the ninepins. It was now Italy's turn to be de-
vastated by the barbarians. Rome was sacked and resacked and
the conquerors looked on the ninepins as so much metal and
stone to be melted or pounded down or kicked into the gutter.

Many ninepins moreover were destroyed in times of peace.
The material of ancient buildings was used in the construction
of churches; a great deal of the sculpture was destroyed as the
remains of heathen idolatry and a great deal was refashioned
into cult images of the Christian faith.

This happened everywhere. In Constantinople there was a
considerable production of Christian cult images in the early
centuries; a giant statue of Christ surmounted the door of the
Emperor's palace; and ninepins which had come from pagan
Greece were refashioned into Saints.[1]

Then in 730 Leo the Isaurian launched a compaign of icono-
clasm which lasted for a hundred years; and by the middle of the

[1] The refashioning of Greek and Roman sculpture into Christian
sculpture must have taken place on a much larger scale than is com-
monly supposed. It would obviously be quite easy, for example, to
convert the relief which can still be seen on the Roman Triumphal
Arch at Carpentras (Vaucluse, France) into a 'Byzantine' crucifix with
an emperor and empress on either side. (Cf. IV. 3. i.)

ninth century we can take it that Constantinople had practically no ninepins at all.[1]

11. The end. Flaxman began his lectures on Greek sculpture to the Royal Academy students (from which I have already quoted[2]) with the following sentence:

'When we consider the gradual ravages of time and the more compendious destruction of war ... that Persepolis, Alexandria, Elis, Eleusis, Delphos and Athens are discovered by ruins almost unintelligible ... that Rome ... has suffered sevenfold conflagration, that fourteen thousand exquisite works of Greek and Etruscan sculpture which decorated this metropolis of the world in her meridian splendour, were ... utterly destroyed or overwhelmed by Gothic ignorance or iconoclastic fury ... when we recollect ... the general and undistinguishing Turkish and northern devastations ... from such a train of reflections and such a widely extended scene of ruin we might be induced to suppose that all the nobler monuments of ancient genius ... were lost for ever ...'

We may, indeed, be induced to this supposition in regard to the works of the famous Greek sculptors. We can indeed suppose that in the tenth century *there was no longer a single original bronze statue by any of the famous Greek sculptors of the fifth*

[1] The iconoclast campaign was primarily directed against sculptured idols and by analogy against mosaics and paintings which were more numerous because sculpture was always considered more idolatrous than painting by the early Christians. Even as late as the High Renaissance we get a Greek priest refusing to accept a religious picture by Titian, to whom he wrote 'your scandalous figures quite stand out from the canvas; they are as bad as a group of statues.' The Council of Constantine Copronymus (754) forbade images in *private* houses as well as in public buildings. It is recorded that the decree was relentlessly carried out and it would be absurd to suppose that when all religious images were destroyed in private houses a nice discrimination was exercised by the mob or the police between images properly described as religious, and images (*i.e.* ninepins from Greece) preserved as loot or works of art. When the Jews revolted against the Romans they began by sacking the house of Antipas at Tiberias *because it contained a collection of sculpture*. If you acquire a taste for it, breaking up statues, like breaking windows, or chopping off human heads, is great fun. When you get into your stride you just *go on*.

[2] Cf. II. 9. iv. *f.*

century in existence; that they had all been utterly and finally destroyed.

In the tenth century there was still some masons' sculpture on Greek and Hellenic buildings visible. But as far as statues were concerned, in the Hellenic lands there were only fragments of miscellaneous works in marble buried beneath ruins, and in Italy, also buried, there were only fragments in marble of the Roman reconstructions, copies and fakes.

That is the real end of the history of Greek sculpture in the round.

As a result *we do not know what the bronze, gold and ivory, and painted marble statues made by the celebrated Greek sculptors looked like; and we never shall know what they looked like.*[1]

12. Freedom from the prejudice. The Middle Ages produced a vast quantity of sculpture of their own. The free growth of Romanesque and Gothic sculpture was possible *because the sculptors were not persecuted with the Greek ninepin prejudice.* The Romanesque and Gothic sculptors were acquainted with the remains of ancient Roman sculpture on the surviving monuments or fragments of monuments in their own lands and they incorporated this experience in their work. But they were not persecuted by the incubus of the prejudice; they were not persecuted with the legend of the final perfection of non-existent works by Myron, Phidias and so forth.

This freedom from the incubus lasted all through the Middle Ages. Even as late as the beginning of the fifteenth century the Christian sculptors were still relatively free; when the secretary of Pope Eugenius IV (1431–1447) toured Rome itself to record the number of 'antique' statues then visible, he could find no more than six.

13. Reconcocting the concocted ninepins. In the Italian Renaissance, as everyone knows, the gentry once more sought the substitute-gratification provided by beautiful-boy and pretty-girl statues.

Some Italian gentleman digging in his garden came on some fragments of a marble statue of this kind concocted for a Roman gentleman in Imperial times. He dug farther and found other fragments. Other gentlemen followed suit. It was soon the

[1] For the so-called 'copies' cf. II. 9. vii. *f.* 24 and II. 9. viii. *g.*

fashion to dig and find, and to call in a restorer to stick the pieces together and to add heads and legs and arms to these remains of statues concocted by the Imperial restorers.

Vasari writes as follows of the Renaissance restorations. The statues found, he says:

'were imperfect, some wanting a head and others arms while others again were legless and all were in some way mutilated. Nevertheless the architect [of Cardinal della Valle] managed everything excellently well for he got good sculptors to make again everything that was wanting and this led to other lords doing the same thing ... this was done ... by all Rome. And in truth these antiques restored in this fashion have a much more pleasing effect than those mutilated torsos and limbs without a head and suchlike fragments.'[1]

It is important to remember that none of the Renaissance restorers and fakers had ever seen any of the original bronzes by the famous Greek sculptors of the fifth and fourth centuries, *or had any reason to suppose that they could imagine what these statues had looked like.*

And now the antique dealer reappears. If you were a fashionable man of taste, and you could find no fragments in your garden, you had to buy them, and the antique dealer with his own restorers was there to supply your need. Sometimes he sold you a genuine antique fragment completed in his workshop, sometimes he sold you a complete fake, and sometimes he sold you as antique a work by a contemporary sculptor which you would have refused to look at if you had known the truth.[2]

14. The Renaissance collections. All the Renaissance collections—the Sassi, Farnese, Ferrara, Medici, Borghese, and so forth—had reconcocted ninepins of this kind.

15. The Vatican collection. Most of the ninepins in the Vatican collection are the same kind of thing, a few are later reconcoctions

[1] There is a tradition that Michelangelo himself restored one antique statue. But what is more certain is that he habitually refused to do so and handed the silly jobs to his pupils or studio assistants. To one of these, Fra Giovanni Agnolo Montorsoli, the Pope allotted a workshop in the Belvedere for the purpose.

[2] Cf. II. 9. vii. *f.* 16.

purchased later; some come from the Winckelmann-Jenkins-Cavaceppi-Hamilton-Nollekens combine that I am about to describe.[1]

16. The incubus returns. By the end of the fifteenth century the incubus had returned; the Greek prejudice had again triumphed and its triumph was again supported by the same types of interested groups.

There were robust and original Italian sculptors in the Renaissance but the average Italian collector regarded their productions as vastly inferior to the reconcocted antique statues.

How could Donatello or Michelangelo presume to compare their own productions with the final perfection of Greek sculpture in the noblemen's collections and in the galleries of the Vatican? Moreover the contemporary ninepins were obviously *repulsive*. What could be more *hideous* than the grimacing faces of Donatello's *Zuccone* and *Poggio* in Florence? What could be less Greek and less ideal that the emaciated limbs of his *St. John the Baptist* and his *Magdalene*? What could be coarser and clumsier and less like the *Apollo Belvedere* than the sculpture by that madman Michelangelo? The dealer who sold one of his works as an antique was a swindling scoundrel and the Cardinal was quite right to reclaim his money.[2]

17. An international traffic. In the seventeenth and eighteenth centuries the powerful groups interested in the maintenance of the prejudice perfected the organisation of their forces. Markets were sought abroad. Charles I of England was induced to buy about fifty ninepins; Richelieu and Mazarin were induced to buy others; Colbert imported whole shiploads for Louis XIV; and some English noblemen were also buyers in the seventeenth century.

In the eighteenth century propaganda to support this international trade was organised on an international basis. The son

[1] Cf. II. 9. vii. *f*. 18, and 19, 20, 21.

[2] This episode is related by Condivi who wrote a life of Michelangelo in the master's lifetime, and referred with scorn to the collectors who 'admire antiquity without criticism through a kind of jealousy toward the talents and industry of their own times' (cf. II. 8. *passim*).

of a German shoemaker, Johann Winckelmann, who became a Roman Catholic in order to get a job as librarian to a Cardinal, launched a campaign to call attention to the glories of the reconcocted ninepins in the Italian collections. His books, translated into various languages, became international best-sellers. His propaganda was so successful, particularly in England, that all the new-rich English gentlemen at the end of the century thought it essential to go to Italy and look at these embodiments of the final perfection of sculpture and if possible to procure some examples for their homes.

18. The innocents abroad. When the English gentlemen arrived in Italy they found the prejudice-supporters waiting for them in a phalanx. Winckelmann had allied himself with the swindling dealer Jenkins, the restorer Cavaceppi, and an excavator called Gavin Hamilton. When their lordships arrived they were received by Winckelmann (now librarian of the famous collector Cardinal Albani) and under his guidance they were taken rapidly round the Vatican and other collections and allowed to stay long enough to whet their interest but not long enough to tire them—(Lord Baltimore's visit to the Borghese gallery occupied exactly ten minutes). Then they were handed over to Jenkins and Hamilton who could produce gems by the ton and statues by the score emanating, they said, from excavations on the site of Hadrian's Villa and elsewhere. By this time the innocent's personal taste had been discovered. If he had expressed a preference for beautiful-boy ninepins the latest treasure unearthed tended to be a 'Mercury' or an 'Apollo'; if he had a taste for pretty-girl ninepins the discovery was more likely to be a 'Venus'.

As no English gentleman would have dreamed of putting a broken or incomplete statue in his mansion the ninepins sold to their lordships were always quite complete. Cavaceppi's name as a notorious reconcocter of these ninepins has been preserved to us; the English sculptor Nollekens, who was in Rome at this period, was also in the Winckelmann-Jenkins-Hamilton-Cavaceppi gang and earned his living by reconcocting 'antique' statues and dealing in them; and there were many minor combines of the same kind. Some of the reconcocted statues began

as fragments of a Renaissance or a Roman concoction. Others were completely fakes. As Michaelis puts it in his famous book: 'sometimes an old appearance was given to new works by an artificial roughening of the surface or by the use of chemicals. Sometimes insignificant old fragments were restored with more or less skill, that is to say turned into apparent completeness by arbitrary additions; and in this way otherwise worthless specimens were made salable.'[1]

It would seem impossible to exaggerate the faked-up character of the so-called antique masterpieces sold to English gentlemen in the eighteenth century. An eyewitness quoted by Michaelis states that he had seen statues sawn in half and turned into reliefs and figures sawn off reliefs and faked into statues in the round.

Nollekens in his later years spoke openly of this traffic.

'I got all the first and the best of my money by putting antiques together. Hamilton and I and Jenkins used to go shares in what we bought; and as I had to match the pieces as well as I could and clean 'em I had the best part of the profits. Gavin Hamilton was a good fellow but as for Jenkins he followed the trade of supplying the foreign visitors with Intaglios and Cameos made by his own people, that he kept in a part of the ruins of the Coliseum fitted up for 'em to work in slyly by themselves. I saw 'em at work though and Jenkins gave a whole handful of 'em to me to say nothing about the matter to anybody else but myself. Bless your heart! he sold 'em as fast as he made 'em.'[2]

This should be kept in mind when the archaeologists talk of 'the evidence of coins and gems.'[3]

19. Reconcoctions of reconcoctions of concoctions, copies or fakes. All the famous collections of antique marbles in the English mansions were formed in this or a similar manner and consist of these eighteenth-century reconcoctions, copies, or fakes of Renaissance reconcoctions, copies or fakes of Roman concoctions, copies or fakes of miscellaneous Greek sculpture. At best

[1] *Ancient Marbles in Great Britain* by Adolf Michaelis. English translation. Cambridge, 1882.

[2] *Nollekens and His Times* by J. T. Smith.

[3] Cf. II. 9. v.

they are eighteenth-century reconcoctions, copies or fakes of Roman concoctions, copies or fakes.

And it is important to remember that none of the eighteenth-century reconcocters had ever seen an original work by any of the celebrated Greek sculptors of the fifth and fourth centuries *or had any ground for supposing that they could guess what they had looked like.*

20. The Townley and Lansdowne Marbles. The Townley Marbles, now in the British Museum, are ninepins of this kind.

The statues in the famous collection known as the *Lansdowne Marbles,* dispersed at Christie's two years ago, were the same.

21. 'Diomede with the Palladium.' The following is the letter which Gavin Hamilton wrote to the first Lord Lansdowne to herald the arrival in England of one of these reconcoctions which he called *Diomede with the Palladium* (Pl. 2a).

ROME,
25th March, 1776.

'I have never mentioned to your Lordship one of the finest things I have ever had in my possession. . . . It is a Diomede carrying off the Palladium. *Your Lordship when in Rome mentioned to me particularly subjects of this sort as interesting to you.* . . . The legs and arms are modern but restored in perfect harmony with the rest. He holds the Palladium in one hand while he defends himself with the right holding a dagger. Your Lordship will ask me why I suppose this statue to be a Diomede. I answer "because it would be in the last degree absurd to suppose it anything else. . . ." Every view of it is fine. . . . With regard to the price I have put it only at £200. . . . My principal motive is to increase your collection with something new and uncommon.'[1]

22. Reynolds on sculpture. It was such ninepins in these eighteenth-century collections and in the Vatican galleries that Reynolds had in mind when in his Discourse on Sculpture he informed his students at the Royal Academy that sculpture had 'but one style' and when he encouraged them to original creation by the assurance that the boundaries of the sculptor's

[1] The italics are mine.

art had long been fixed and that all endeavours would be vain which hoped to equal the perfection of antique sculpture.

23. In the 'Praxitelean' tradition. It was presumably these same concoctions that a group of academic artists had in mind when they greeted with spontaneous applause a slide of a pretty-girl ninepin (Pl. 2*b*) made of wax and indiarubber, that I threw recently upon the screen in the course of a lecture on modern sculpture which I had the honour recently to deliver before them.

The statue was one of many such manufactured by Messrs. Pollard & Co. for shop windows.

24. 'Give it a name, boy' (ii).

i. Dishonest procedures. The interested supporters of the Greek prejudice in the eighteenth century knew of Myron, Phidias, Polyclitus, Praxiteles, Lysippus and the other Greek sculptors from the same sources that are available to-day,[1] and the dealers in order to make more money instructed their restorers to *make their concoctions correspond to the fragmentary descriptions of works by the celebrated Greek sculptors.*

A fragment of a crouching youth would be restored on one day as *Diomede with the Palladium* (Pl. 2*a*) and sold, as we have seen, as such to Lord Lansdowne; and on another day a similar marble torso would be made into a figure which followed Lucian's description of the bronze *Discobolus* by Myron.

It is very important to remember that the statue restored in the second way is *as much a concoction* as the first and that it is a more impudent concoction because it pretends to a greater market value by the use of a famous name.

The labels on all the so-called 'Graeco-Roman' statues in collections and museums are absolutely valueless; when they describe the works as 'copies' of a statue by Myron, Polyclitus, Scopas, Phidias, Praxiteles or Lysippus they are deliberate frauds, because no restorer, not even a papal restorer in the Vatican in the Renaissance, or Nollekens, or the gifted Cavaceppi (traditionally responsible for *Diomede with the Palladium*) can build a fragment into a '*copy*' of an original that he has *never seen*.

[1] Cf. II. 9. v.

The Greek prejudice

In Flaxman's day the archaeologists and historians of Greek sculpture were divided into two camps, some maintaining that the marble *Apollo Belvedere* in the Vatican was an original by Calamis (who worked in bronze) and others that it was a 'copy' of a work by Phidias. The archaeologists and historians of sculpture of to-day put the names of the famous Greek sculptors and the titles of their most famous works on reconcocted statues in just the same spirit, and indeed with less excuse, because they have better reason to know that the labels are false.

It is important to remember that when Professor Gardner writes: 'The *Apollo Citharoedus*, singing, and in long drapery, which was set up by Augustus in the Palatine temple at Rome, was also a work of Scopas; and a copy of it may be recognised, by the help of coins, in the *Apollo Citharoedus* in the Vatican, which shows the character of the inspired musician, though the execution has lost all the vigour of Scopas'—he knows no more of the *Apollo Citharoedus* by Scopas than—as Michelangelo might have said—'my maidservant'.[1]

We read in Professor Furtwängler's *Masterpieces of Greek Sculpture*[2] as follows:

'All of course depends on a right discrimination between what is derived from the original and what is added by the copyist. This point will always be a rich mine of error in inquiries of this kind . . .'

'A rich mine of error' indeed—seeing that the originals no longer exist.

For a hundred years after Winckelmann propagandists engaged in boosting the 'perfection' of the athletes by Polyclitus (as Mr. Stanley Casson is engaged to-day[3]) wrote of the marble Farnese *Diadumenus* (now in the British Museum) as a 'copy' of the bronze *Diadumenus* by Polyclitus. In 1862 when *a quite different* marble *Diadumenus* was produced from Vaison they transferred the word 'copy' with equal enthusiasm to that; now the 'best copy' is yet another object found at Delos. To-morrow

[1] Cf. III. 2. viii. *b*. For Zadkine's fantasia on the *Apollo Citharoedus* theme cf. IV. 2. iv. *b*. ii.

[2] English translation, Heinemann, London, 1895.

[3] Cf. II. 9. iv. *e*.

the 'perfection' of the *Diadumenus* by Polyclitus will be exemplified by something else.

In the same way there are various marble objects which, the propagandists tell us, exemplify Myron's 'complete mastery' of bronze and reproduce his *Discobolus*. Dr. Richter shows a 'composite reconstruction'[1] of Myron's *Discobolus* for our admiration. The torso of this concoction is quite different from the modelling in the *Discobolus* torso in the Terme Museum (Rome) and in the torso of the *Diomede with the Palladium* (Pl. 2). But which of the three, if any, is a 'good' 'copy' *nobody can say* because nobody knows what the bronze original was like.[2]

In some museums one even finds the concocted ninepins, and casts from them, described as *by* Praxiteles, or Myron or Polyclitus. Thus in the Vatican there is a label reading '*Venere Gnidia di Prassitele*' on a Venus ninepin which the propagandists describe 'on the evidence of a coin' as a 'copy' of the naked Aphrodite, so exciting to young men, which Praxiteles made for the Cnidians. The lower parts of the Vatican concoction, which has, of course, 'restored' head, arms, etc., is covered with tin drapery, painted the colour of marble, added under papal instructions on grounds of morality; and the drapery has served as a model for sculptors who believed it their function to imitate the final perfection of such works by the Greek masters.[3]

ii. Sir John's 'Britannia and the Colonies'. Let us imagine (*absit omen*) that a series of catastrophes results in the complete destruction of all English statues made in the last hundred years;

[1] Cf. II. 9. viii. *g*.

[2] The meaning of the word 'good', if the objects are considered not as 'copies' but on their merits, depends, of course, on your concept of the art of sculpture. I, personally, should call both the Vaison *Diadumenus* and Dr. Richter's composite *Discobolus* thoroughly bad. But I should not argue from that opinion that Polyclitus and Myron were bad sculptors, because I have never seen their work. The meaning of the word 'good' as used by the propagandists has, however, reference not to the sculptural merits of the objects judged by *any* sculptural standards but to the relation of the object to the propagandist's own notion of the *style* of the sculptor of whose work the object is presumed to be a copy (cf. II. 9. viii. *f*. and *g*.).

[3] Cf. II. 9. v. and II. 9. vii. *e*. 2. and 3., and IV. 2. iv. *b*.

that the bronzes are all melted down and the marbles broken to pieces and promiscuously buried.

Let us assume that all Epstein's works have thus perished; that his bronze *Madonna and Child* has been melted down; and that a marble copy of it, made by a pupil *without the aid of any modern reproductive machinery*, has been broken in pieces and eventually buried. Let us imagine that in the year A.D. 4000 fragments of a statue of a seated woman with an upright child between her legs is excavated somewhere; that literary records survive describing a *Britannia and the Colonies* by Sir John Twoshoes, R.A., as 'a woman with an upright child between her legs'; let us imagine that the excavated fragments when assembled, with bits let in, etc., only produce a group without heads or legs below the knees. Let us then imagine the restorers, the dealers and the propagandists for the British prejudice at work on the concoction; let us visualise the 'reconstruction' by Professor 'A' of 'the great Academician, Sir John Twoshoes' masterpiece, the world-famous *Britannia and the Colonies*,' completed by the brilliant and convincing ideas of Professor 'B' who inserted a trident in the hand of the child 'to explain the awkward position of the arm' and added the helmet on Britannia's head and the shield by her knee on the 'evidence of a penny' . . .[1]

And with this image in our minds let us leave the so-called 'copies' of 'perfect' works by Myron, Polyclitus and the rest of them, and turn our attention to objects of another kind.

25. Fragments from Greece. All the so-called 'Greek' and 'Graeco-Roman' statues concocted between the middle of the sixteenth century and the beginning of the nineteenth were produced in Italy. In the nineteenth century the international traffic was reinforced by a traffic in fragments of sculptured masonry excavated from the soil of Greece.

The collectors now were no longer private individuals but museums; and they remain so at the present time. Every object acquired by one of these purchasers in Europe or America is immediately converted into a propaganda-object in support of the Greek prejudice because it is in the interests of the organisation

[1] Cf. II. 9. v., and II. 9. viii. *g*.

which has acquired it, and which is paid to preserve it, to pretend that the object acquired and preserved is an important work of art.

This phase in the international traffic began in 1810 when Lord Elgin offered to the British Government, for the British Museum, the numerous fragments from the Parthenon which the Turks had allowed him to remove, and the new traffic was launched when the Government actually bought them six years later for £35,000.[1]

Since then the sites of numerous other temples and monuments have been excavated and the museums of Europe and America have acquired as a result (a) numerous fragments of sculpture presumed to have been executed by Greek masons for the friezes and pediments and so forth between 600 B.C. and the destruction of the temples at various dates; and (b) a few fragments, of various and uncertain dates, of votive ninepins which were originally in the sanctuaries and which by some accident or other had not been stolen or completely destroyed but had become buried beneath them or in their vicinity.

26. The dealers follow suit. The international dealers were not slow to perceive that the installation of these fragments from Greece in the world's museums, where they were supported in each case by local propaganda, would destroy the market in the reconcocted Graeco-Roman ninepins; and that the demand would be instead for more fragments of sculptured masonry and of figures in similar styles. They realised also that the new 'discoveries' must not be complete figures, because the Elgin Marbles (as already noted) had created a taste for the incomplete figure.[2]

Since 1816 the discoveries of Greek sculpture which have appeared in the international antique trade have shown a tendency to be (a) objects in a style resembling some objects excavated in Greece, (b) incomplete figures—consisting sometimes of a number of fragments which could be stuck together by the museum restorers in the shape most admired at the moment.[3]

27. The influence of the Elgin Marbles. The success of the Elgin Marbles as the result of propaganda shamelessly describing

[1] A figure equivalent to £100,000 or more in present money.
[2] Cf. II. 7. viii. [3] Cf. II. 9. vii. *f.* 28 and 30, and II. 9. viii. *h.*

them as works by Phidias, to which I shall refer later,[1] meant the establishment of the notion that the finest Greek sculpture consisted of fragments of figures, over life-size, with heavy torsos, large limbs and clinging naturalistic drapery.

The taste having been created for fragmentary statues on this scale, draped in this way, other such objects began to appear in the international market—(the reader will recall Gavin Hamilton's '*Your Lordship mentioned to me particularly subjects of this sort as interesting to you*').[2]

28. The Venus de Milo. Everyone is familiar with the present appearance of the *Aphrodite from Melos* in the Louvre.

This object as we see it to-day is a concoction of several fragments and *different kinds of marble* stuck together by the restorers of the Louvre. The top part of the torso is one piece, the lower part is another, the head and the right hip are fragments in themselves.[3]

The history of this statue is not given either by Professor Gardner or by Dr. Gisela Richter.

The *Encyclopaedia Britannica* (9th, 11th and last editions, *i.e.* 1875-1932) informs us that in 1820 the French navigator and traveller Dumont d'Urville while engaged in a survey of the Mediterranean 'was fortunate enough *to recognise the Venus of Milo* in a Greek statue recently unearthed'. The learned writer was evidently an ideal Jack Horner who assumed that there was a Greek master-sculptor called Milo whose other masterpieces (about which he himself alas! was a little vague) were so familiar to Dumont d'Urville that he could recognise a further example anywhere when he saw it.

There is also a legend spread by the propagandists that the statue, as we know it, was found in a subterranean cave or grotto by the sea where, as Professor Gardner puts it, 'she must have

[1] Cf. II. 9. viii. *b*. and *c*. and *d*. [2] Cf. II. 9 vii. *f*. 21.

[3] As all the statues and fragments which are described as examples or 'copies' of Greek sculpture consist of pieces stuck together, the propagandists tell us that the Greeks made their marble statues in a number of pieces and that they were never so happy as when they were making one hip in one kind of marble and the other in another and sticking on a head that was made of a third kind.

I see no reason to accept this palpably ridiculous assumption.

been hidden by some ancient worshipper to save her from destruction'.

It is however clear that the destruction had already taken place when fragments of a figure and its plinth were brought to the notice of Dumont d'Urville in the Island of Melos in the spring of 1820. The fragments were then in some kind of niche or kiln beneath the surface of some cultivated land some distance from the sea. The celebrated archaeologist Salomon Reinach has described the place as a disused limestone-burner's kiln or workshop (*magasin de chaux-fournier*); Professor Furtwängler has described it as a kind of shrine. A fragment of the plinth *contained the signature of the sculptor in lettering of the first or second century* B.C.

These fragments were bought by an agent of the Marquis de Rivière, French Ambassador in Constantinople. On 24th May, 1820, they were shipped to Paris, where M. de Rivière arranged to have them concocted into a statue which he could present to the King. Naturally one could not present a King with the work of a sculptor of the Hellenistic period whose name was previously unknown. The statue had to be—to quote Furtwängler —'a unique and unrivalled treasure, the work of Phidias or Praxiteles'. The portion of the plinth bearing the signature was therefore conveniently '*lost*'.

In the Louvre the statue was assembled, to quote Furtwängler again, 'clandestinely and hastily', in the form in which we know it to this day, and presented to the King as a masterpiece by Phidias or Praxiteles.

In November of 1820 a pair of arms, from the same place as the other fragments, were offered for sale to the Marquis de Rivière; but the taste of the moment preferred the statue incomplete and the arms were not acquired.

If the same fragments had been assembled for a King or an English lord about fifty years earlier it is, I submit, only reasonable to suppose that the result would have been (*a*) a complete figure and (*b*) a figure much less massive, less Elgin Marble-ish, and much more 'Graeco-Roman' in its form.

I understand that travellers in the Island of Melos are habitually shown a grotto by the sea in which, the guides tell them, the Venus of Milo was discovered.

29. The influence of the 'Nereids'. The so-called *Nereids* in the British Museum were excavated at Xanthos by a British naval expedition in 1842. These forward-moving figures with clinging draperies represented fragments of girls who were evidently younger, more sprightly and more 'caressible', when complete, than the *Venus de Milo* or the matrons of the Parthenon pediment; they were a great success with a public anxious to reconcile the new taste for the *Iris* of the Elgin Marbles with the old taste for the pretty-girl ninepins of the Graeco-Roman school; and it soon became evident that there was room in the world's museums for more fragments of the *Nereid* type.

30. The 'Victory from Samothrace'. All visitors to the Louvre are familiar with the so-called *Victory from Samothrace* which exhibits Elgin Marble + *Nereid* characteristics. The history of this concoction is as follows:

In 1863 a French gentleman arrived in Paris with fragments of a statue which had been sold to him in the Island of Samothrace. As we see the *Victory from Samothrace* to-day it is a forward-moving figure with clinging draperies. The torso consists of *one hundred and eighteen pieces* stuck together after the arrival of the figure in Paris; the right breast, the left wing and the draped legs are other pieces; the left half of the breast and the right wing are in plaster. The fragment of a galley on which the figure stands arrived in France some twenty years later.

The concocters of this statue had the Parthenon *Iris* and the *Nereids* to guide them; they also had a coin representing 'une Victoire semblable'.[1]

[1] The concoction of a statue from a hundred and thirty pieces in this way is not, of course, a procedure comparable to solving a jig-saw puzzle as the layman might suppose. To get something comparable you must (*a*) take a marble pyramid, (*b*) break it into a hundred and seventy pieces, (*c*) shake the pieces in a bag till the edges of the pieces are well chipped, (*d*) throw away forty pieces at random, (*e*) give the remaining hundred and thirty pieces to a sculptor and tell him that they are 'part of a geometrical figure', (*f*) see what he produces as a 'reconstruction', (*g*) compare and measure his production with the original of which you have kept a replica, (*h*) do the same thing a hundred times and compare the hundred different 'reconstructions', (*i*) do it once more when someone has told the reconstructor that you are particularly fond of *cubes*.

If this concoction had been concocted a hundred years earlier it is, I submit, only reasonable to suppose that we should know it in quite other and more Graeco-Roman shape.[1]

31. The later discoveries. Museums in recent years have shown a desire to acquire Greek statues of the so-called 'archaic' character; and as it is now becoming generally realised that the originals of all the most famous fifth-century Greek statues were bronzes, there is also a demand for life-size Greek statues in bronze.[2]

It is worthy of note that most of the sensational discoveries of Greek sculpture offered in the international market in recent years have been either 'archaic' in character or else bronzes rescued from a river or the sea.[3]

[1] The *Victory* on a base signed Paeonius, in the Olympia Museum, which is also *Iris-Nereid* in character, was excavated on the site of the Temple of Zeus at Olympia on 21st December, 1875; the base with the signature had been found near it on the preceding day.

For Zadkine's fantasia on the Paeonius *Victory* and the *Iris-Nereid* tradition generally cf. Pl. 5*a* and IV. 2. iv. *c*. 3.

For Professor Gardner and Dr. Richter's concealment of the facts about the *Victory from Samothrace* cf. II. 9. viii. *h*.

[2] The market for antique bronze *statuettes*, real and faked, is of longer standing (cf. II. 9. viii. 1).

[3] Fragments of a life-size naked male figure in bronze appeared in 1900 from the remains of a wreck (dating according to Professor Gardner from the early part of the first century B.C., and according to others 'from the time of Christ') off the coast of Cerigotto (Antikythera). A Monsieur André, according to the catalogue of the Athens Museum, 'artiste français des plus habiles', was put to work to stick the fragments together. When he had used up all the pieces the belly and part of the thorax were still a void. M. André filled the space with a belly and a thorax characteristic of—well the propagandists have not yet decided whether to call it the superb style of Praxiteles, Lysippus or Euphranor. The object resulting from the *habilité* of M. André can be seen in the National Museum at Athens. Of this object Professor Gardner reproduces a photograph which he labels 'Bronze statue found off Cerigotto'. In his text he says: 'The way in which the statue has been restored so as to conceal the losses is open to criticism', and then lest we fail to be thrilled by the object he adds: 'But there is no ground for the assertion that the restoration has obscured or confused the style'.

The bronze known as the *Delphi Charioteer* now in the Delphic Museum was excavated by the French at Delphi in 1896 (cf. IV. 2. iv. *c*. 4).

32. Summary. The preceding paragraphs (II. 9. *vii. f. 1-31*) indicate *the lines* on which the student must work if he wants to answer the questions : 'What are all these objects in the galleries and museums? Where is the Greek sculpture that the propagandists call upon us to admire?'

He will arrive at the best results if he starts by assuming that nobody knows what the works by the celebrated Greek sculptors looked like, and by remembering that fragments of antique statues have habitually been much encouraged by restorers to assume the form which the Greek prejudice at the moment has chanced to regard as the final perfection of the sculptor's art.

We must now return to the propagandists and see how they have done their work since the Elgin Marbles began to undermine the taste for the so-called 'Graeco-Roman' ninepins.

viii. Reorganising the prejudice

a. Payne Knight and the Elgin Marbles

The Elgin Marbles as is well known did not enter the Greek prejudice-pie without a great deal of difficulty.

Richard Payne Knight, a collector of antique bronzes and a most intelligent person (though he bought some of his bronzes, now in the British Museum, from Jenkins[1]) pointed out that the Elgin Marbles were obviously the work of many different persons, that they were probably all the work of artisans, and that they could throw little light or no light on the art of Phidias. He also reminded the learned world that a Pausanias of the seventeenth century, a German student named Spon, had examined the pedimental sculptures in position and had recognised in the two central figures of the Western pediment portraits of the Emperor Hadrian and his consort Sabina.

Payne Knight's comments were much more to the point than victims of subsequent prejudice-propaganda would suppose.

It is not inconceivable that the pedimental sculptures are Roman Imperial and not Greek work. The Romans were very vigorous stone-masons when they were not concocting beautiful-boy and pretty-girl ninepins for the collectors. The assumption that the sculptures in the Parthenon pediment remained unharmed and unrestored for two thousand years on a building

[1] Cf. II. 9. vii. *f.* 18 and 19.

which was alternately a Roman Temple, a Latin Church, a Greek Church and a Mosque—is a very large one. Indeed we know that the central group of the Eastern pediment was destroyed to make an apse when the temple became a Latin Church. To assume that the pediments were restored in the time of Hadrian is no wilder than to suppose that they were then intact, particularly when we remember that Hadrian had a passion for building and restoring, that he toured the empire accompanied by a small army of architects, sculptors and artisans, that Athens was 'the favoured scene of his architectural labours', that he added a new quarter to the city, and that he finished the temple of the Olympian Zeus. Spon at any rate *saw* the two central figures of the Western pediment which no one has seen since they were utterly destroyed a few years later when the Graeco-Venetian forces bombed the Parthenon in 1687;[1] and as for the subject of the sculptures in the Western pediment the remaining fragments might of course be part of anything.

If we assume that the Elgin pedimental sculptures are the remains of the sculptures stuck into the pediments in the time of Pericles then Payne Knight's account of them not only corresponds to what we know of them but also represents the whole of our real knowledge.

All we *really* know about the Parthenon and its sculptures (which, we are told by the propagandists, were the results of the Athenian hunger for beauty) is as follows.

b. Building the Parthenon

In the middle of the fifth century the Athenians had made peace with their enemies and they had control of all the funds provided by their allies for future protection against Persia. They also had large revenues from their mines and other resources. But they were suffering from a crisis of post-war unemployment. There was, that is to say, plenty of money but no work. In these circumstances Pericles proposed a vast building programme, which included the Parthenon, as an experiment in state socialism. The scheme, as Plutarch tells us in his *Life of*

[1] The Venetian general, a member of the noble house of Morosini, tried to steal the central group; but the ropes broke and the figures were smashed to pieces.

Pericles, was designed to make practically all the state wage-earners; it was to absorb all the industries and crafts—'each craft with an army of unskilled labourers working as tools'; and with the labour required for transport of materials it was calculated to provide state employment for persons of every age and capacity. The sculptures on the Parthenon occupied an army of workmen in this way for some fifteen years. They are obviously the production of a number of different craftsmen working from clay models and drawings by a number of different artists.

That is all we know about the making of the Parthenon and the sculptures upon it—except that the name of the architect was Ictinus, and that marble and other materials were transported to Athens for the building and sculptures on certain dates.

c. 'Where does Phidias come in?'

Here the reader may ask, 'And where does Phidias come in?' The answer is that he does not come in. He has been dragged in by the propagandists.

The name of Phidias was not associated in antiquity with the sculptures on the Parthenon. No Greek or Latin writer says that they were by Phidias or made after his models or designs. They were of so little interest to Pausanias (who described the sculptures on the Temple of Zeus at Olympia in detail and gave the names of the designers[1]) that he merely noted the subjects of the pediments as the 'Birth of Athena' and 'The contest of Poseidon with Athena for the land', and mentions *no* name of the designer. No other ancient author describes the Parthenon pediments at all.

The name of Phidias in antiquity was associated with the giant cult images (to which I have already referred[2]), two of which were statues of Athena, one of gold and ivory for the Parthenon and the other of bronze erected on the Acropolis between the Erechtheum and the Propylaea.

But Plutarch, in the same *Life of Pericles*, states that Phidias was a friend of Pericles who made him his 'controller and overseer' (*moderator et spectator*) in the building operations. *That is*

[1] Cf. II. 9. viii. *j*. [2] Cf. II. 9. vii. *e*. 2.

the sole authority for connecting the name of Phidias with the Parthenon.

All we really know is that Phidias on account of his reputation as a maker of bronze, and gold and ivory, giants, and on account of his friendship with Pericles, was given the honorary post of Minister of Fine Arts or Director of Public Works in the whole building scheme. There is no evidence that he had anything to do with the sculptures of the Parthenon, except perhaps to sign his Department's approval of the designs; there is no evidence that he designed sculpture for that or any other building *or that he was capable* of so doing; and there is no evidence that any of several styles of design that occur in the frieze, the metopes and the fragments from the pediments of the Parthenon has any relation to the style of his male and female giants in bronze or ivory and gold.

d. 'Give it a name, boy' (iii.)

The propagandists dragged in the name of Phidias for two reasons.

The first was the same reason that the names of Myron, Polyclitus, Praxiteles and Lysippus had been stuck on the concocted ninepins, *i.e.* in order to make the objects seem more valuable.

The British Government had bought these fragments of sculpture for the British Museum for the equivalent of £100,000 in present money. The Committee which recommended the purchase had to justify the expenditure, and in its report to the Government it started the new propaganda by describing the Elgin Marbles as 'monuments which surpass the richest treasures of Florence, of Rome or of Paris . . . the most perfect models of beauty and the most useful exercises of taste'. But that was not enough; the ninepins most boosted by the propagandists for the Greek prejudice, as it then existed, had names of famous Greek sculptors attached to them; the name of Praxiteles had been attached to a *Venus* in the Vatican;[1] the names of Calamis and Phidias had been attached to the *Apollo Belvedere*[2] and so forth; hang it all, these new 'perfect models of beauty', bought for so much money, must be attached to *someone*; and to whom more appropriately than to Phidias, the most famous of all

[1] Cf. II. 9. vii. *f.* 24.　　　　　[2] Cf. II. 9. vii. *f.* 24.

Greek sculptors in antiquity, and one who was not only alive when the Parthenon was built but actually Director of Public Works?

That was the first reason that the name of Phidias was dragged in.

The second reason was that the international propaganda organisation for boosting the Graeco-Roman reconcoctions was placed in an awkward position by the Elgin Marbles, which were now being forced into the Greek prejudice-pie by the propagandists of the British Museum. Unless the new propaganda could be assimilated to the old propaganda exalting the names and non-existent works of the so-called fifth-century masters, the accepted concept of the 'Graeco-Roman' ninepins as the sole and final 'perfect models of beauty and the most useful exercises of taste' would obviously be destroyed. In the hope of averting that catastrophe the international propagandists described the Parthenon sculptures as the work of Phidias and trusted that the Jack Horners would enjoy the old prejudice-pie with the addition of this new plum. The Committee of the House of Commons when interrogating witnesses before recommending the purchase of the Elgin Marbles had asked them, among other questions, 'Suppose the Townley Marbles to be valued at £20,000, what might you estimate these at?'[1] 'As compared with the *Apollo Belvedere* in what rank do you hold the Elgin Marble known as *Theseus*?' and 'Does the *Theseus* partake of as much ideal beauty as the *Apollo Belvedere*?' The propagandists replied to such questions: 'These marbles are works by Phidias, a great Greek sculptor like the sculptors of the Townley Marbles and the *Apollo Belvedere*. They can *therefore* be held to have an ideal beauty of the same kind as the Townley Marbles and the *Apollo Belvedere*; indeed they may be said to have even more ideal beauty and cash value than the other marbles because Phidias was the most famous and *therefore* the greatest of Greek sculptors'.[2]

[1] For the Townley Marbles cf. II. 9. vii. *f*. 18-21.

[2] There was a humorous moment when the Committee asked Nollekens: 'Do you consider part of the value of the Townley Collection to have depended upon the cost and labour incurred in restoring them'? And Nollekens replied: 'As for restoring them, that must have cost a good deal of money'—as he well knew, seeing that a good deal of it had gone into his own pocket (cf. II. 9. vii. *f*. 18).

e. *The propagandists in difficulty*

If the situation had remained static this modification of the prejudice-form would have worked quite well. But unfortunately for the propagandists, the excavations at Aegina, Olympia, Delphi and elsewhere in Greece and the Hellenic regions (which went on all through the nineteenth century) produced in the end such a variety of objects, and many so different from the Graeco-Roman ninepins on the one hand and the Elgin Marbles on the other, that the Jack Horners began to suspect that even such vague words as 'ideality' or 'beauty' were not vague enough to act as the common denominators of so miscellaneous an array.

In other words the finality-form of the propaganda was eventually found insufficient to satisfy the finality-complex of the Jack Horners; and the propagandists had to set to work to find a new formula that would suggest a common final perfection of the sculptor's art equally exemplified by the *Farnese Hercules* (National Museum, Naples), the *Apollo Belvedere* (Vatican, Rome), the *Diomede with the Palladium* (Pl. 2a), the *Venus de Milo* (Louvre), the *Cat-and-dog-fight relief* (National Museum, Athens), the *Elgin Marbles* (British Museum), the fragments of the Aegina pediments (Glyptothek, Munich), the so-called *Apollo from Sounion* (National Museum, Athens), and the so-called *Hera from Samos* (Louvre)—to take examples at random.

The task was obviously difficult. But it had to be done to keep up the prejudice; and it was important for the archaeologists and the educational authorities that *they themselves* should find the formula because their position depended on the assumption by the prejudice-holders that they could look to archaeologists and professors for the formulation of the standard of perfection in the sculptor's art.

f. *The Rise-and-Fall formula*

In this emergency the propagandists invented the Rise-and-Fall formula as a new basis for the prejudice.

According to this Rise-and-Fall formula Greek sculpture before the fifth century was an incompetent struggling to achieve an 'ideal-naturalistic' representation of the human form which is perfect sculptural art; Greek sculpture of the fifth and fourth

centuries was this perfect 'ideal-naturalistic' representation of the human form and therefore perfect sculptural art; and Greek sculpture afterwards, as there was nothing further to achieve in sculpture, decayed and died from a surfeit of its own powers.

In this purely fictional account of Greek sculpture the unity necessary for an easily absorbed finality-form was achieved by the personification of the activity. The archaeologists and educational authorities, that is to say, proceeded on the system of the popular press. They invented a *Romantic Career of Greek Sculpture*; with shoulder-headings: '*Childish Struggles, Manly Triumph* and *Senile Decay*.'

Into this formula of their own invention they now fitted the famous names, the so-called 'copies' of their non-existent works, and the objects produced in the nineteenth century by excavation and from the other sources referred to above.[1]

This Rise-and-Fall formula is particularly pernicious *because it pretends to be a complete description of the different 'styles' of the so-called masters and the other sculptors of the various periods and to contain within itself a complete and final system of sculptural values*. A new library of nonsense has been written to support this formula; and all the recent books are illustrated with photographs to help out the fiction in the text.

g. What the propagandists tell us

In these books the so-called 'archaic' objects are said to be 'good' or 'less good' as they approximate or fail to approximate to the 'best' of the Elgin Marbles 'brief poise of perfection';[2] the reconcocted ninepins are said to be 'good' copies or 'less good' copies according as, in the imagination of the propagandists, they approximate to, or differ from, the styles which the propagandists have invented for the unknown works of the famous Greek sculptors; and 'reconstructions' *made by the authors or other propagandists* are generally referred to, with astonishing effrontery, as the 'best' 'copies' of all.

The procedure in regard to the 'reconstructions' is as follows. Some propagandist has a composite cast made of the head of one reconcoction, of the torso of another, legs from a third, and of odd bits made round the corner the day before yesterday, and the

[1] Cf. II. 9. vii. *f*. 25-31. [2] Cf. II. 9. iv. *d*.

other propagandists insert photographs of this in their books and write: 'We can form the best idea of the master So-and-so's style from the brilliant reconstruction by Professor So-and-so of his masterpiece, the world-famous So-and-so'.[1]

In the same way, in dealing with the fragments of sculpture from buildings, the propagandists discourse of the 'exquisite balance' and 'harmony of line' of the composition when *they are judging that composition from a brother propagandist's 'reconstruction'*. All the recent histories of Greek sculpture contain photographs of such 'reconstructions' of the Aegina, the Olympia and other pediments, and the authors write of them as though they are discussing the originals; furthermore one propagandist will discourse of the beauty of composition in a pediment and illustrate it with a reconstruction by Professor 'A' and another will use the same phrases and illustrate it with a quite different reconstruction by Professor 'B'.

h. What they leave out

But the propagandists are careful not to weaken their emotive harangues with plain *descriptions of each object as it actually exists*. They do not begin, as they should, with full and precise statements of when, where and in what circumstances each object was discovered, *of the number of pieces it is made of, and of when and by whom the pieces were put together*.

To give but two examples.

a. Both Professor Gardner and Dr. Gisela Richter reproduce photographs of the *Victory from Samothrace* as we know it in the Louvre. Professor Gardner describes it as 'a typical work of the beginning of the Hellenistic age'. Dr. Richter's propaganda reads: 'One of the most powerful renderings of movement in the history of art . . . which shows on the one hand the transparency of the late fifth-century style as well as the dramatic effect of sweeping folds, on the other the concentration of heavy masses

[1] Cf. II. 9. vii. *f*. 24. ii. Mr. A. W. Lawrence, who is much more honest than most historians of Greek sculpture, nevertheless writes of the gold and ivory *Athena Parthenos* by Phidias as follows: 'Only a coloured restoration can offer a true idea of the statue's appearance'.

Professor Sieveking's 'restoration' of Myron's *Athena and Marsyas*, reproduced in Dr. Gisela Richter's book, is a prize piece of tomfoolery of this kind (cf. II. 9. iv. *b*.).

characteristic of the middle of the fourth; but the whole further complicated by a greater variation of direction'. But neither Dr. Gardner nor Dr. Richter states the facts about the concoction of this statue in the nineteenth century which I have set down above.[1]

b. In discussing the so-called *Mausolus* and *Artemisia* from the Mausoleum at Halicarnassus both Dr. Richter and Professor Gardner reproduce the *Mausolus* as at present restored in the British Museum, and Professor Gardner labels his photograph 'Portrait of Mausolus'. Neither, however, mentions that the figure was put together by the Museum restorers about 1860 *from sixty-five fragments*, that this restoration was subsequently reconstructed, that the fragments as always were joined by passages of the restorers' invention and that these inventions included *half the head*. Professor Gardner calls this 'a fine example of fourth-century portraiture'. Dr. Richter reproduces the *Artemisia* with both arms, the whole face, the right knee and surrounding drapery invented by restorers, and says nothing about the restorations.

i. An abuse of power

Completely unwarranted assessments of values based on the Rise-and-Fall formula occur even in official guide books to museums and in notices displayed in the museums themselves. In the official *Guide to the Greek and Roman Antiquities in the British Museum*, for example, the uninstructed are told that the early Greek sculptors were 'struggling with imperfect knowledge and incomplete mastery of the mechanical difficulties'; and in the Archaic Room of the British Museum there is a notice displayed in which the uninstructed are enjoined to 'contrast the shapelessness of B. 271 [presumed to be the earliest of the series of votive figures from the Sacred Way of Branchidae] with the vigorous but exaggerated anatomy of B. 280 [presumed to be the latest of the series]'. The notice does not say—as it should—that from the standpoint of modern culture, as represented by the original modern sculptors, the earlier figures from this series (Pl. 6a)[2] are not *shapeless*, but works which now have the meaning of their *shape* and no other meaning. It leads the

[1] Cf. II. 9. vii. *f.* 30. [2] This reproduces B. 278.

uninstructed to assume that the sculptor who made the early monuments did not know and could not achieve the business of sculpture, a view which leads to the conclusion that the modern sculptors who are dedicating their lives to fashioning works with similar meaning are equally ignorant of the nature of their art and equally incompetent in execution.

j. A new dilemma

The propagandists have always played a pretty little comedy of differing, discreetly and politely, on minor points among themselves. But on the whole they have maintained a solid front against the common enemy—the creative spirit in contemporary sculpture which at all times the propaganda has opposed.

In recent years, however, they have once more felt that the finality-form of the Greek prejudice must be adjusted. It has become evident to them that the victims of their propaganda have become a little dissatisfied with the Elgin Marbles as representing the 'brief poise of perfection' in sculpture. They have perceived a distinct tendency, even among their allies the academic sculptors, to look with peculiar favour at the straight folds of the garment worn by the *Delphi Charioteer*; and to regard the vacuous fragments of the pediments found at Olympia as 'partaking of more ideal beauty' not only than the *Apollo Belvedere* but even than fragments from the pediments of the Parthenon.[1]

The more die-hard propagandists early set their faces against this heresy. Sir Charles Waldstein (afterwards Walston), who in 1913 had protested against the disturbance of the prejudice-pie by the inclusion of Rodin, as I have noted earlier,[2] protested in 1921 against the disturbance caused by the new appreciation of the Olympia fragments, which, he pointed out, might lead the appreciators to forget that the Olympia fragments only 'mark a phase in the upward movement . . . which leads to a climax of perfection as represented by the Parthenon'.[3]

But this readjustment of the prejudice has nevertheless taken

[1] For the *Delphi Charioteer* and the Olympia fragments cf. IV. 2. iv. *c.* 4.

[2] Cf. II. 7. iv. [3] *Alcamenes*, Sir Charles Walston, 1921.

place and we now have propagandists who have enthroned the Olympia fragments as the climax, and placed the Parthenon fragments (and Phidias of course with them) as the beginning of the decadence in a new 'Rise-and-Fall' finality-form.

Thus Mr. Stanley Casson writes boldly of the Olympia fragments as 'the flower of all Greek sculpture' and tells us that 'the master sculptors of Olympia revolutionised all art ... Phidias adopted and adapted their inventions'.

There was a moment when this readjustment was rather disconcerting for the propagandists.

It will be recalled that the only fragment of a statue presumed to be an original by any Greek master—the *Hermes and the Infant Dionysus*—is presumed to be so and to be by Praxiteles because Pausanias saw it above ground in much the same place and described it as 'by Praxiteles'. Now Pausanias *also saw* the Olympia pediments on the building beneath which they were found; he described them and said that those of the West Pediment were 'by Alcamenes'.

In the old propaganda formula the unknown work of Alcamenes was always assumed to be like the Elgin Marbles but not quite so good because Alcamenes was mentioned by ancient writers as a *follower, pupil and contemporary of Phidias*. When the fragments of the West Pediment were excavated the subject was found to be as described by Pausanias but the sculptures to be not at all like the propagandists' notion of proper post-Phidian productions. They therefore solved the difficulty by saying in this case that *the evidence of Pausanias could not possibly be accepted*, that their own Rise-and-Fall theory of the development of Greek sculpture must stand, and that the Olympia sculptures in the West Pediment were by somebody else who was not a pupil of Phidias, who had never seen the Parthenon pediments and who lived some time before.

It was thus that they paved the way for Mr. Casson's invention of Olympian 'master sculptors' of marble pedimental compositions who produced 'the flower of all Greek sculpture' and taught Phidias his business of making gold and ivory giants in the round.[1]

[1] For the influence of the Olympia fragments on contemporary Academic sculpture cf. IV. 2. iv. 4.

79

k. *Everyone satisfied*

The Rise-and-Fall formula thus readjusted is the finality-form of the Greek prejudice at the present time.

It satisfies, at the moment, both the victims of the propaganda and the propagandists themselves. The victims' finality-complex is satisfied because the final standard of perfection which it demands is given a fixed point—which is now the Olympian and no longer the Parthenon fragments; and the personification of the activity allows the Jack Horners to project themselves into the progression and follow the alleged early struggles, the alleged mature perfection, and the alleged senile decline of Greek sculpture as though he were assisting at a play. It also satisfies the finality-complex of the propagandists who have glimpsed, in concocting it, something of the formal artists' rapture in the organisation of finite shape.

So everyone is satisfied.

l. *Except the creative sculptors*

Everyone, that is to say, except the creative sculptors of our day, who, like the creative sculptors of all other ages, regard the Greek prejudice as an incubus and the propaganda to support it as what it is and always has been—a bundle of nonsense invented for their own purposes by archaeologists and professors who, as Condivi put it, admire antiquity 'through a kind of jealousy toward the talents and industry of their own times', who are as incapable as anyone else of establishing standards of perfection in sculpture, who cannot distinguish the work of a creative sculptor from hack masonry, academic *pastiches* and concocted ninepins, and who assume if it suits their purpose that there is no difference between the work of a master and the works of his pupils.[1]

Everyone, that is to say, is satisfied with the present form of the Greek prejudice, except the creative sculptors who demand the right to look at Greek sculpture with their own eyes, in the light of their own knowledge, and for the purpose of their own creative work.

[1] Professor Gardner, for example, writes of Pasiteles: 'It is hardly to be supposed that his own work differed in its essential nature from that of his pupils'.

PART III
THE MODERN SCULPTORS' CREED (i)

PART III

THE MODERN SCULPTORS' CREED (i)

1. Refusing the pie

To understand the sculpture produced by the creative modern sculptors the student must begin (*a*) by realising that his own settled concepts of sculpture are in the nature of a prejudice-pie of the kind which we have just been examining, and (*b*) that the modern sculptors began their sculptural studies by rejecting that pie and refusing for their part to be Little Jack Horners.

The modern sculptors have had many more opportunities of acquiring experience of the sculpture of past ages and distant places than any sculptors ever had before. I shall discuss the range of their sculptural experience in Part IV. Here my point is that, in the light of that extended experience, they have recognised the real nature of the prejudice-pie and have realised that a concept of sculpture which would embody their own experience of that activity would bear the same relation in scale to that pie as the Coliseum bears to an ordinary apple tart.[1]

We must also remember that as original artists, concerned with the enlargement of experience, they could not accept *any* finality-form concept of their activity. They could not believe in themselves as original artists and at the same time believe that the art of sculpture belonged entirely to the past or that there were any final absolute standards of perfection in that art which had already been so triumphantly achieved that any further sculptural activity must of necessity consist in imitation.

They refused the prejudice-pie, that is to say, because they denied the cooks' right to make a pie at all, because the pie

[1]Their view is thus very different from that of Professor Gardner, who refers to the propagandists' Rise-and-Fall formula for Greek sculpture as the '*history of sculpture*'. Cf. II. 9. v.

offered was a ridiculously small pie, and because no pie of any size and any origin could be of use to them in their own creative work.

For the purpose of that creative work they began by assuming, for the moment, that no one had ever made sculpture before and that it was their own task to discover the nature of the activity in which they were about to be engaged.

They began, that is to say, at the beginning.

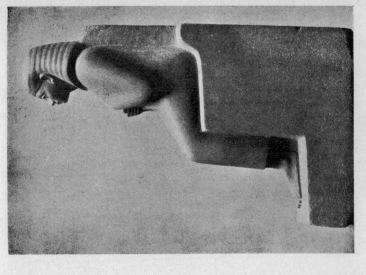

5b. Egyptian carving. *Chertihotep*
(*c.* 1950 B.C.) Berlin
(From Fechheimer's *La Sculpture Egyptienne*)
Cf. IV. 3. ii.

5a. BARBARA HEPWORTH: *Musician*
Cf. IV. 3. ii.

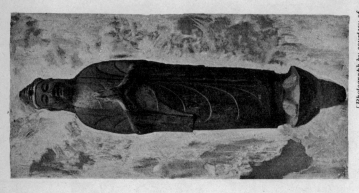

[Photograph by courtesy of
the 'Burlington Magazine']

6b. Tang figure (618-907 A.D.)
Cf. IV. 3. iii.

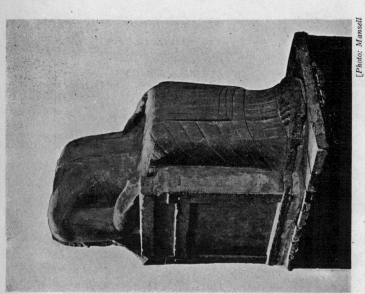

[Photo: Mansell]

6a. Votive statue from the Sacred Way at
Branchidae (c. 550 B.C.)
British Museum

2. A fresh start

i. 'What do we mean by "sculpture"?'

They began by asking themselves the question: 'What do we mean by sculpture?'

As they were original and not popular artists the accent in the question was on the '*we*'.

But as their attitude was part of the general attitude of contemporary culture they sought an answer which would not only guide them in their own production but which would also eventually be found to cover the whole range of sculptural production available to their experience. As twentieth-century thinkers they felt, rightly or wrongly, impelled to seek one all-embracing concept of the activity called sculpture.[1]

The first definition therefore had to be extremely wide.

ii. The first definition

What they arrived at was this:

'*Sculpture is the conversion of any mass of matter without formal meaning into a mass that has been given formal meaning as the result of human will.*'

As will be observed this definition covers many types of sculptural production.

It covers

a. sculpture with a magic purpose, sculpture with a religious purpose, sculpture with a propaganda purpose, sculpture with a narrative purpose;

b. sculpture which owes part of its appearance to the will of persons other than the sculptor,

c. sculpture which owes its appearance entirely to the sculptor's will.

It admits *though it does not demand* the representation of

[1] Cf. I. 4.

physical objects (human beings, animals, trees, etc.) and concrete things.

iii. The fashioning of form

But the accent in the definition is on the word 'formal'.

The modern sculptors began with the concept of an activity consisting in the fashioning of form.

According to this concept the only *sculptural* meaning of the object fashioned is the meaning of its form.

The work may have other meanings. It may, for example, have the meaning residing in its power to evoke some religious, patriotic or erotic response in the spectator; it may have the meaning resulting from its resemblance to a physical object or a concrete thing. But such meanings are regarded as *non-sculptural*. They may reside in a work which has sculptural meaning as well; and they may be present in a work that has no sculptural meaning at all.

Furthermore, according to this concept, a work which has sculptural meaning *need have no other*.

It is this last assumption which is the key to the comprehension of the *basis* of modern sculpture.

The sculptors who were determined to begin at the beginning began by forcing their own concept to its essential basis. They began by attempting to fashion form in stone and clay which would have the only kind of meaning which they deemed essential; and in the early stages they admitted no other meaning of any kind.

The modern sculptors have built their whole effort on this foundation. As they have advanced in their studies they have continually allowed themselves more latitude, and they have admitted other types of meaning into their productions. But they have never departed from this foundation concept of essential sculpture. They have made it more definite and richer but they have never built on any other base.

iv. The sphere, the cube and the cylinder

This restriction of their function by the modern sculptors led immediately to another.

By a process of elimination the sculptors had arrived at a

concept of the essential character of the sculptural activity as the creation of formal meaning. They proceeded to eliminate further and to restrict their concept of formal meaning to formal meaning of the simplest and most fundamental kind.

They thought of sculpture as the art of fashioning objects with three-dimensional meaning. They did not think of themselves as the servants of architects or of their art as the art of adding ornaments to buildings. They thought of themselves as architects of sculptures in the round; and their first concern was to discover the simplest type of three-dimensional meaning. That type they found in the sphere, the cube and the cylinder; and they sought to fashion statues which could be apprehended in the way that the sphere, the cube and the cylinder are apprehended.

Their second definition, therefore, read as follows:

'*Essential sculpture is sculpture which has the same kind of meaning as the sphere, the cube and the cylinder.*'

And in the early stages they rigorously restricted their studies to this field.

v. Plato on geometric form

It may, I think, be interesting to recall here the following passage in the *Philebus*, which represents Plato's aesthetic attitude in the later stages of his studies.

In the *Philebus* Socrates says:

'I do not mean by beauty of form such beauty as that of animals or pictures which the many would suppose to be my meaning; but, says the argument, understand me to mean straight lines and circles, and the plane or solid figures which are formed out of them by turning-lathes and rulers and measurers of angles; for these I affirm to be not only relatively beautiful, like other things, but they are eternally and absolutely beautiful . . . if arithmetic, mensuration, and weighing be taken away from any art that which remains will not be much . . . the rest will be only conjecture, and the better use of the senses which is given by experience and practice, in addition to a certain power of guessing, which is commonly called art, which is perfected by attention and pains. . . .' [1]

[1] Jowett's translation.

We have here a concept of beauty of form deliberately dissociated from representational meaning.

If we bring the passage into direct relation with modern sculpture it would read as follows:

'By beauty of form in sculpture I do not mean statues which have the meaning of beautiful bodies; I mean sculpture which has the meaning of geometrical forms.

'A work of sculpture in the construction of which the architectural activity has not predominated is a poor thing; it is only an empirical approximation, the production of an imitative eye and a hand trained in an art school.' [1]

vi. Ruskin on sculpture

It may also be appropriate to remind the reader at this point that both the modern sculptors' initial creed and their initial concept of essential sculptural form were foreshadowed by Ruskin sixty years ago.

Ruskin defined sculpture as 'the reduction of any shapeless mass of solid matter into an intended shape' and at his lectures in Oxford in 1870 he displayed a *crystal sphere* as the essential type of sculptural form.

Ruskin in fact worked hard at the problems connected with formal meaning which he called 'abstract' meaning as distinguished from representational meaning. He was driven to tackle these problems in relation to sculpture because he found it impossible to evade them in the course of his architectural studies; and he came to the conclusion that in sculpture on buildings the abstract qualities should dominate the representational.

Thus in the *Seven Lamps of Architecture* we read:

'Perfect sculpture must be a part of the severest architecture . . . the first office of that sculpture is not to represent the things it imitates but to gather out of them those arrangements of form which shall be pleasing to the eye in their intended places'; and 'It is a safe manner . . . to design all things at first in severe abstraction. . . .'

In *The Stones of Venice* we read:

'The purest architectural abstractions . . . are the deep and

[1] Cf. V. 2.

laborious thoughts of the greatest men', and 'What then *is* noble abstraction? It is taking first the essential elements of the thing to be represented, then the rest in order of importance, and using any expedient to impress what we want upon the mind, without caring about the mere literal accuracy of such expedient.' [1]

In *The Stones of Venice*, moreover, Ruskin refers to 'the assuredly intended and resolute abstraction of the Ninevite and Egyptian sculpture', and he tells us that 'the men who cut those granite lions in the Egyptian room of the British Museum, and who carved the calm faces of the Ninevite Kings, knew much more, both of lions and Kings, than they chose to express'; but he adds 'the Ninevite and Egyptian [systems] are altogether opposed to modern habits of thought and action; they are sculptures evidently executed under absolute authorities, physical and mental, such as cannot at present exist'.

I shall refer later to the modern sculptors' study of Assyrian and Egyptian sculpture; [2] here I need only pause to note (i) that though Ruskin was clearly right in observing that Assyrian and Egyptian sculpture was 'executed under absolute authorities, physical and mental' and right in stating that the systems upon which the Assyrian and Egyptian sculptors worked 'were altogether opposed' to the habits of thought and action in his own day (*i.e.* the individualist nineteenth century), he was naturally unable to know that twentieth-century culture would feel itself called upon to redress the balance after nineteenth-century individualism, or to foresee that all the most original twentieth-century sculptors would impose *upon themselves* a discipline as absolute as that imposed upon the Assyrian and Egyptian sculptors by their masters.

We must also remember that sculpture in Ruskin's mind was always sculpture on buildings. He was not interested in sculpture in the round, and he paid little attention to its problems. He evaded discussion of Royal Academy sculpture in his *Academy Notes* of 1857 by writing: 'I ought not to speak of Sculpture because I have little pleasure in it when unconnected

[1] This was the procedure of the negro sculptors as we shall see later (cf. IV. 3. v.).

[2] Cf. IV. 3. ii.

with architecture: so that I only go into the Sculpture room to look at my friends' works. . . '

We can well understand that for a man who could think of the sphere as the essential type of free sculpture, *i.e.* of sculpture in the round, it was a little difficult to find anything of interest in the sculpture-room of the Royal Academy in his day.[1]

vii. *Formal relations*

a. The theory

The modern sculptors, however, did not think of sculpture primarily as sculpture on buildings. Their concept did not *exclude* such sculpture, and they were willing, if called upon, to fashion it; but they held that such sculpture should be part of the building in fact as well as in name, and should be carved by the hand of the sculptor himself as far as possible *in situ*.[2]

In working out their own concept of sculpture they had primarily in their minds the creation of free sculpture in the round, the fashioning of a three-dimensional object, existing by itself on the strength of its own meaning in space; they desired not so much to contribute to works of architecture as to fashion objects that would be *works of architecture in themselves*.

It was indeed to this concept of their art that the modern sculptors soon arrived.

As they studied the formal characters of the sphere, the cube and the cylinder they realised that we do not experience even these elementary forms as single forms without constituents; that the form of the sphere is apparent to our perception as a series of interacting formal movements and that the form of the cube or the cylinder is apparent in the same way. They realised, that is to say, that the meaning of sculptural form, in their concept, was the formal meaning of architecture itself.[3]

This connotation gave a more precise meaning to the initial concept and at the same time extended the sculptor's horizon, because it placed him on a level with the architect, whose work, as distinguished from the work of the builder, is the organisation of formal relations.

[1] For English popular academic sculpture in the middle of the nine-teenth century cf. IV. 2. iv. *b*.

[2] Cf. III. 2. viii. *c*. [3] Cf. *The Modern Movement in Art*, pp. 8, 9 and 10.

The concept thus enriched was summarised by the sculptor Gaudier (who was killed in the war) in a manifesto published by Wyndham Lewis in *Blast* in June 1914:

In that profession of faith Gaudier said:

'*Sculptural feeling is the appreciation of masses in relation.*'

'*Sculptural ability is the defining of those masses by planes.*'

Here, clearly, was a wide field for experiment and research.

b. Brancusi and Gaudier

The pioneer experiments and researches were made quite early in the present century by the Roumanian sculptor Brancusi who is still living.

Brancusi started to explore geometry, the science which deals with relations of magnitude; he set out to fashion objects with the permanent universal meaning of the geometric symbols as distinguished from meanings that are local and topical. He made sculptures which had meaning only in their shapes—spirals which held the spectator fascinated, ovoids in stone or brass which created an uncanny sensation of permanence and finality by the sheer interplay of their constituent forms. He turned his back completely upon naturalism. His only utterance with which I am acquainted is: '*Je ne veux pas faire du bifteck*'—an attitude towards beauty of form which was precisely that of Socrates in the *Philebus*.[1]

Gaudier made explorations in the same field in the years before the war. He experimented with the geometrisation of his visual experience and also with geometrical combinations based on natural structure. I shall return to the difference between these two types of geometrisation when, in Part V, I discuss the later developments of the modern sculptors' creed. Here I need only indicate that Gaudier was working at both types of geometrisation about 1913 and that his *Brass Toy* (Pl. 13*b*) is an example of the first type and his *Formalised drawings* (Pl. 14*b*) are examples of the second.[2]

[1] Cf. III. 2. v.

[2] These plates come from Ezra Pound's *Gaudier-Brzeska* (Heinemann, 1915), which remains the most useful book on Gaudier as an artist in spite of the recent dramatisation of his private life by an author who never met him. Pound knew Gaudier intimately, bought his works in his lifetime, and made other people buy them to keep the sculptor from starvation.

The *Brass Toy* (Pl. 13*b*) is a geometrisation of a visual impression of a man in a lounge suit with his hand in his trousers pocket. It was not modelled in clay and cast in brass but cut from a piece of solid brass as an architectural object of which every surface contributed to the object's meaning as form. Gaudier called this object, which is six inches high, a 'Toy', but I can conceive a culture in which he might have been ordered to make it forty feet high as a cult idol to be worshipped and feared. I can conceive a whole people, who had never seen a man in a lounge suit with his hand in his pocket, trembling before this huge and sinister form and trusting to its power to save them from wild beasts or floods or pestilence; because there is an impressive and alarming meaning in the object's actual form which does not depend on its relation to the artist's jumping-off point—his visual impression of a man in a lounge suit with his hand in his pocket. Moreover if the object is enlarged in scale this impressive and alarming meaning would, I think, proportionately increase. This seems to be a characteristic of geometric art and I shall submit an explanation later.[1]

viii. Modelling and carving

a. The preference for carving

The modern sculptors at this stage showed a decided preference for carving as distinguished from modelling; most of them still exhibit this preference; many suggest that modelling and carving are different activities and that modelling is inferior in kind; and some hold the view that the invention of hollow casting in bronze was nothing less than a disaster for the art of sculpture.[2]

Studio discussions on this matter always contain references to Michelangelo's pronouncement on the difference between sculpture and painting, in the course of which he referred to carving as 'sculpture' and to modelling as an activity similar to painting.

[1] Cf. V. 5.

[2] Hollow casting in bronze is believed to have been invented in Egypt. It was certainly in use there from about 800 B.C. onwards (cf. IV. 3. ii.).

7. EPSTEIN: *Night*
On Underground Building, Westminster
Cf. IV. 3. iii. *c.*

8a. Sumerian carving called *Portrait of Gudea*
(Neck by Leon Underwood)
Cf. IV. 2. iv.

8b. MOORE: *Mother and Child*
Cf. IV. 2. iv. d.

Michelangelo's pronouncement was a letter written in 1549 when he was seventy-four. The gist of the letter was intended for publication in a symposium containing replies by a number of artists to the question: 'Which art is of higher rank, Sculpture or Painting?' [1]

The question was sent out by Benedetto Varchi, an historian of Florence and an art critic, who seems, in the case of Michelangelo at any rate, to have accompanied the question by an essay of his own on the subject and by selections from the replies received from other artists.

b. *Michelangelo on sculpture*

This is what Michelangelo wrote in reply:

Messer Benedetto.—Perchè e' paia pure che io abbia ricevuto, come ò, il vostro Libretto, risponderò qualche cosa a quel che e' mi domanda, benche ignorantemente. Io dico che la pittura mi pare più tenuta buona, quanto più va verso il rilievo, et il rilievo più tenuto cattivo, quanto più va verso la pittura: et però a me soleva parere che la scultura fussi la lanterna della pittura, et che dall' una all' altra fussi quella differenza ch' è dal sole alla luna. Ora, poi che io ò letto nel vostro Libretto, dove dite, che, parlando filosoficamente, quelle cose che ànno un medesimo fine, sono una medesima cosa; sono mutato d' oppinione: et dico, che se maggiore iudicio et difficultà, impedimento et fatica non fa maggiore nobilità; che la pittura et scultura è una medesima cosa; et perchè elle fussi tenuta cosi, non doverrebbe ogni pittore far manco di scultura che di pittura; e' l simile, lo scultore di pittura che di scultura. Io intendo scultura, quella che si fa per forza di levare: quella che si fa per via di porre, è simile alla pittura: basta, che venendo l' una e l' altra da una medesima intelligenza, cioè scultura et pittura, si può far fare loro una buona pace insieme, et lasciar tante dispute; perchè vi va più tempo, che a far le figure. Colui che scrisse che la pittura era più nobile della scultura, s' egli avessi cosi bene inteso l' altre cose ch' egli ha scritte, le

[1] The question in the original Italian asked which art was 'più nobile'—the significance of 'nobile' being, I take it, simply 'of high rank' without any of the associated connotations attaching to the English use of 'nobility' in discussions about art

àrebbe meglio scritte la mia fante. Infinite cose, et non più dette, ci sarebbe da dire di simili scienze; ma, come ho detto, vorrebbono troppo tempo, et io n' ho poco, perchè non solo son vechio, ma quasi nel numero de' morti: però priego mi abbiate per iscusato. E a voi mi racomando et vi ringrazio quanto so et posso del troppo onore che mi fate, et non conveniente a me.

VOSTRO MICHELAGNIOLO BUONARROTI IN ROMA.

The opinion which Michelangelo thus 'ignorantly' offers is the following:

'I say that painting seems to me to be held better the nearer it approaches relief and relief to be held worse the nearer it approaches painting; and further it used to seem to me that sculpture was the lamp of painting and that there was the same difference between the two as between the sun and the moon. Now, since I have been reading the contents of your pamphlet in which you say that, philosophically speaking, things which have the same end are one and the same thing, I have changed my opinion; and I say that unless greater judgement and difficulty, obstacles and toil, constitute a higher rank then painting and sculpture are one and the same thing; and since this is held no painter ought to make less account of sculpture than of painting and similarly no sculptor less of painting than of sculpture. I mean by sculpture that which is done by taking off; that which is done by putting on is similar to painting. It is enough that both sculpture and painting coming from one understanding can be allowed to make a happy peace together and leave these so numerous discussions on one side—since more time goes in them than in making figures. [As for the other subjects written about by] the man who wrote that painting is of higher rank than sculpture, if his understanding of them is about the same as his understanding of this matter, they could have been better written about by my maidservant. There are countless things that have not yet been said which could be said of similar sciences; but, as I have said, they would require too much time and I have but little because I am not only old but almost among the number of the dead. Therefore I beg you to have me excused. I give you my compliments and

94

thank you to the best of my ability for the too great honour which you do me which is more than I deserve.' [1]

Michelangelo's view was thus that *theoretically* sculpture (by which he meant direct carving) and painting (to which he assimilated clay modelling) are one and the same activity when the artists are aiming at the same kind of meaning and are equipped with the same species of understanding.

But though *theoretically*, or perhaps I should say metaphysically, Michelangelo regarded all three activities, carving, modelling and painting as one, he points out that *in practice* carving requires both more judgement and more physical labour than the other operations.

In studio discussions among modern sculptors another reference by Michelangelo to carving is also very often quoted.

This second reference is contained in the celebrated sonnet beginning

> 'Non ha l' ottimo artista alcun concetto
> Ch' un marmo solo in se non circonscriva.'

'The finest artist has no concept which the marble alone does not contain within itself.'

Here we have the notion of the statue imprisoned in the stone and *extracted* from it by the sculptor; and this notion of *collaboration* with the substance is also present in the modern artists' creed.[2]

c. *What 'direct carving' means*

If we are to understand Michelangelo's attitude to carving, and that of the original sculptors of to-day, we must realise that in Michelangelo's mind and in the minds of the modern sculptors the word 'carving' has a restricted meaning.

By a carved work Michelangelo meant a work carved entirely

[1] The tone of respect in which the aged master here addresses an art critic may surprise the artists of to-day who will probably suggest that he was pulling the art critic's leg. But there is another explanation. Varchi had described Michelangelo in a lecture, shortly before this letter was written, as 'the unique painter, the singular sculptor, the most perfect architect, the most excellent poet and a lover of the most divinest'. Michelangelo was possibly disposed to feel some measure of genuine respect for his discernment as an art critic.

[2] Cf. III. 2. viii. *f*.

by the sculptor himself. He himself carved his own statues directly into marble, generally without the aid of any preliminary model except a small sketch in wax or clay.[1]

In the minds of the modern sculptors carvings on buildings are not properly called architectural sculpture unless they are made part of the building in fact as well as in name by the procedure of direct carving on the building itself, as distinguished from the attachment to the building of sculpture copied elsewhere from clay models.

This attitude approves, for example, the procedure of the English sculptor Eric Kennington, who has recently carved a series of reliefs of over life-size figures in brick on the brick façade of the new Shakespeare Memorial Theatre at Stratford-upon-Avon, and carved them with his own hand *in situ* without preliminary clay models or any preliminary work except drawings on sheets of paper a little bigger than a postcard; and it also approves the procedure of Epstein who carved the *Day* and *Night* figures on the Underground Building, Broadway, Westminster, entirely with his own hand and largely *in situ*.[2]

In the case of free sculpture in the round the modern sculptors hold that the carving should be done from start to finish by the sculptor himself and that it is most likely to have sculptural significance if the sculptor has worked without a full-size clay model.

We are apt to forget that only a very small proportion of the world's content of marble sculpture is 'direct carving' of this kind. The vast majority of statues in the round and a very large proportion of the sculptures on buildings have not been designed and carved by the same hand. In most cases the preliminary clay models alone have been the work of the sculptor; the subsequent marbles have been produced by marble workers who were generally merely assistants, operatives or stonemasons.

[1] According to Cellini it was only in the later years of his life that Michelangelo sometimes made a full-size clay model as a preliminary guide for his carving. Michelangelo did not think of himself as a modeller but as a carver (cf. III. 2. viii. *j*.). He carved the *David* from a small sketch.

[2] Cf. III. 2. viii. *j*., and IV. 3. iii. *c*.

Carvings produced by marble workers from sculptors' clay models have always been either (a) translations into marble of the clay original or (b) accurate copies in marble of such originals.

In times when the science of 'pointing' was rudimentary the translation by other hands was of necessity very free; in modern times, since the procedures have been developed, the marble is no longer a translation but an accurate copy mechanically produced.[1]

d. Mr. Rossi's mate

Now it is obvious that in the case of a freely translated clay model the appearance of a marble statue is largely due to the alterations made by the marble worker, and that the result is hybrid—partly the result of the sculptor's 'putting on' concept in the clay model and partly of the marble worker's 'taking off' concept in the translated version.

Scarcely more than a hundred years ago sculptors' clay models (or plaster casts from them, since marbles are habitually made from casts) were still very freely translated in this way. In 1823 Lord Egremont bought the clay model (or a plaster cast from it) of a seated female figure by the sculptor Nollekens, and the sculptor's biographer tells us that he engaged Mr. Rossi, the Academician, to execute it in marble, with strict injunctions that no alteration whatever, 'not even an improvement upon the model', should be attempted. This injunction was evidently unusual, because the biographer continues:

'In giving this order his lordship was in my humble opinion perfectly correct; for if improvements had been made, it could no longer have been esteemed as a production of Nollekens' mind. . . . Mr. Williams, who carved this figure under the superintendence of Mr. Rossi, assured me that in no instance could he have been engaged upon a more difficult task especially in carving parts that were so intricately undercut . . . he had to invent tools of the most singular shapes to enable him to cut and file away the stone.'[2]

[1] The system of scale stones, with the ball-and-socket apparatus, which followed the old systems of 'pointing' (apparently from about the middle of the eighteenth century) has now been superseded by procedures which achieve mechanically accurate results.

[2] *Nollekens and his Times*, J. T. Smith.

There can be small doubt that, if his lordship had not given such precise instructions, Mr. Rossi's mate would have turned out the usual hybrid production by indulging in a good deal of 'improvement', partly to save himself the trouble of making special tools, and partly to correct the sculptor's deviations from what was then regarded as 'the perfect standard of the Greeks', *i.e.* the *Medici Venus*.

Indeed we know from the biographer himself the lines on which the 'improvements' would have been made:

'It was the opinion of most artists that many parts of this figure could have been improved: they thought the ankles unquestionably too thick; and that, to have given it an air of the antique, the right thigh wanted flesh to fill up the ill-formed nature which Nollekens had strictly copied. The abdomen was far from good; and the face was too old, and of a common character.'

Mr. Rossi's mate must have felt sad indeed at losing the opportunity of putting these matters right. What fun he would have had with Rodin's *La Vieille Heaulmière* (Pl. 3b).

We must also remember that in these marble translations supports had invariably to be added which were not necessary in the original clay model (supported everywhere from within by the armature) and which also were not necessary when the figure was cast in bronze. These supports always modified the composition and sometimes completely changed it. We have to bear this in mind when reading the propagandists' twaddle about the composition of the marble ninepins in the Vatican, the Lansdowne, the Townley and other collections.[1]

e. Mechanical marble copies

In the case of a clay model mechanically copied by modern scientific procedures the result is not hybrid.

But the marble remains, in character, a modelled work because the results of the sculptor's 'putting on' concept have been accurately imitated in the marble.

A marble copy of this kind is as much a modelled work in character as a plaster or a bronze cast, both of which are frankly mechanical reproductions of the original clay; it is quite

[1] Cf. II. 9. vii. *f.* 13 to 24.

different in character from a marble carved directly by the sculptor himself without the aid of a full-sized clay model; it also differs from carvings by stone-masons from a sculptor's drawings or small sketches in clay.

Most popular sculpture at the present time (both statues in the round and sculpture on buildings), is clay modelling mechanically copied in marble or stone by artisans.

All such marble copies, in the eyes of the modern sculptors, are clay works in character, and, in a sense, fakes—because they pretend to be the result of stone or marble concepts when they are really the result of concepts in clay; and the same view is taken of the marble versions of Rodin's clay models and of the sculpture stuck on to their buildings by the Greeks.[1]

f. Collaboration

When the modern sculptors speak of carving they thus mean direct carving by the sculptor himself; and they regard direct carving as a kind of *collaboration between the sculptor and the substance*.

In their first definition, it will be remembered, they thought of sculpture as the conversion of a mass without formal meaning into a mass that had been given such meaning by the sculptor; this contains the idea of collaboration; Michelangelo's notion of the statue imprisoned within the stone and released by the sculptor contains it also.

This notion in itself to some extent explains the modern sculptors' decided preference for carving as distinguished from modelling; because there can really be no collaboration between clay and the sculptor. Modelling, as Epstein has said, 'is creating something out of nothing'.[2] The modeller begins with nothing beneath his hand. He has an idea and makes an armature, with wood and pliant metal, and on to that he sticks a series of lumps and worms and pellets of clay until the idea has been given form. From the wood, the pliant metal, and the pail of clay, he can get no inspiration at all.

Clay is not a substance with a permanent character. It is mud in process of becoming dust. If the form fashioned by the

[1] Cf. II. 7. vi., and IV. 2. iv. *c*.
[2] *The Sculptor Speaks*, p. 61.

sculptor is to have a lasting habitation the clay must be converted to another substance by baking or it must be reproduced in plaster or bronze—all processes which take place after the sculptor's fashioning of the clay is *finished*.

The carver, on the other hand, starts with a block of stone or marble or wood beneath his hand which has (*a*) a fixed character as a substance and (*b*) an incidental character as form.

a. The carver who takes account of the character of his substance starts with the assumption that his idea is, as Michelangelo said, already within the substance; and that in fashioning the substance he is revealing a formal meaning inherent in that substance and in no other.

His idea is thus incomplete until it achieves contact with the particular substance; and the completion will be different in the case of each different substance.

A carving produced in this spirit is thus literally the result of a collaboration; and the more respect the sculptor has for his partner the more that partner will contribute to the task.

b. The carver may also receive assistance from the *form* of the block before he begins to alter it. To quote Epstein again, 'In carving, the suggestion for the form of the work often comes from the shape of the block'. But the collaboration here is more incidental in its nature because the character of the particular block's form is a particular and not a general and permanently established character like the character of its substance. The shape of a block of stone or marble in the artist's studio is either the result of accident, in the sense that it happened to be quarried to that shape or to have become that shape from the action of time, or else it is a shape already determined by the sculptor himself in the sense that he gave an order for a block of that shape to be quarried. Moreover, as soon as the carver gets to work, the form of the block ceases to exist in its integrity and becomes another form, while the substance, if allowed to do so, collaborates from start to finish. Nevertheless some modern sculptors treat the initial form of the block with very great respect and invite that form to the maximum collaboration with themselves and the substance.

It is partly owing to this idea of collaboration that the modern sculptors assimilate the mechanical marble copies of clay

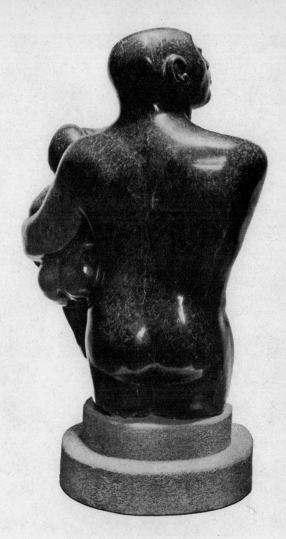

9. LAMBERT: *Father and Son*
Cf. IV. 2. iv. *d.*

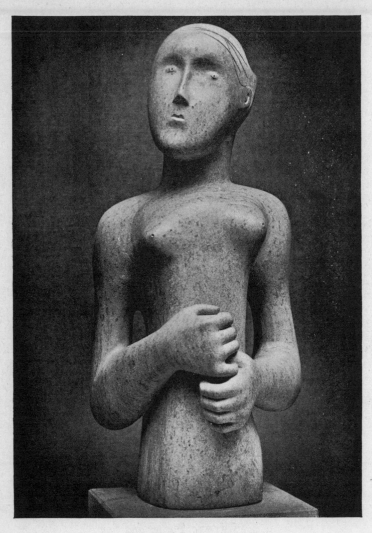

10. MOORE: *Girl*
Cf. V. 9.

models to modelling. They argue that the substance of the marble in such copies has not been invited to collaborate in fashioning the form idea because that fashioning was already completed in clay before the marble came upon the scene.

g. Sculpture and painting

Michelangelo, it will be recalled, assimilated modelling to painting. The modern sculptors go further and assimilate to painting all modelled or carved works when the formal concept which created them was really of a pictorial kind. They assimilate such works to painting whether they are sculptures on buildings or free sculptures in the round, and whether they are bronzes, casts or marble translations or marble copies. They hold that if the sculptor, when he began, had in his mind formal images derived from or appropriate to paintings, then the result must be described not as sculpture but as painting executed in marble or bronze.

We shall encounter these assimilations of marble works to clay modelling and bronze and marble works to painting when we glance at the modern sculptors' studies of nineteenth-century, Renaissance, mediaeval and Greek sculpture.[1]

h. The exigencies of direct carving

Michelangelo, it will be remembered, conceded the possibility that carving should rank higher than painting and modelling because of its 'greater judgement and difficulty, obstacles and toil'. The modern sculptors' preference for carving is also partly based on this idea.

The direct carver has need of the most deliberate judgement. He can never replace what he has carved away; he can make no alterations; he cannot indulge in second thoughts or begin in a vague way in the hope that inspiration will turn up; whereas the modeller can alter and alter again because he can both add and take away.

The substances, moreover, which the carver fashions do not collaborate of their own volition. On the contrary they offer a definite resistance, and the scale of resistance advances from wood to marble and from marble to hard stone. Clay, which provides no assistance, also offers no opposition. All it asks for

[1] Cf. IV. 2. and 3. i.

is an occasional drink to delay the moment when it turns to dust.

i. The effects of discipline

But the modern sculptors prefer direct carving, not only because its exigencies may entitle it to higher rank, but also because those exigencies seem to stimulate their will and energy and to support their sculptural aims.

In practice they find that the discipline, to which they subject themselves in this collaboration with resistant substances, seems to affect the formal and emotional quality of their sculptural ideas. Since in direct carving they cannot work rapidly, they tend to think of the substance as collaborating with themselves in the expression of deliberate and considered concepts of permanent and universal significance; as they work with substances which are permanent in character, and as they cannot improvise in carving, they find themselves concerned with concepts that in emotional quality tend to be grave, impersonal, controlled and sustained; and these tendencies seem to increase as the scale of resistance advances from wood to marble and from marble to the hardest stone.

Clay modelling, on the other hand, seems in practice to lead the sculptor to improvisation and spontaneity, to empirical recording of casual impressions and satisfactions, and to romantic recording of sudden transitory emotional reactions.

Clay, from the standpoint of the modern sculptor, is thus the ideal material for the naturalistic sculptor who aims at fashioning a work with meaning residing in its imitation of some particular physical objects or concrete things—the pretty breasts and buttocks, for example, of some healthy young woman. From their standpoint clay is also the ideal material for the Romantic sculptor intent on fashioning a work which has meaning as a record of the *expressive peculiarity* of some particular physical fragment—the unusual length of Miss Brown's neck, for example, or the remarkable quiver in Miss Johnson's nose.[1]

But these meanings, as we have seen, the modern sculptors regard as non-sculptural; they leave them to the clay modellers

[1] Cf. V. 2.

and restrict themselves to the austere discipline imposed by collaboration with resistant substances.

j. Epstein as direct carver

The foregoing will serve, I hope, to explain the conspicuous differences in form and character between Epstein's bronzes and his direct carvings in stone and marble. Epstein is keenly conscious of the differences between the attitudes appropriate to the one process and the other, as his work bears witness.

There have, of course, been other sculptors who have both modelled and carved direct. It is possible, though not certain, that Donatello carved his own marbles in addition to his work as a clay modeller for bronze. Michelangelo carved his own marbles and also modelled one figure, and possibly more, in clay for bronze. But Donatello's carvings remained clay modelling in character; and though Michelangelo, as we have seen, was keenly conscious of the difference between the two processes, his carvings, as was perhaps inevitable in the Renaissance, all have to a large extent the character of modelled form.

Epstein encountered the modern attitude to sculpture about 1911 to 1913. He was then closely associated with the philosopher T. E. Hulme, who was killed in the war. Hulme knew that Epstein was so essentially an original sculptor of unusual powers that no sculpture he produced could ever be negligible; Epstein knew that no concept of the nature of sculpture which was taken seriously by a man with Hulme's capacity for hard thought could possibly be silly. Thus it came that Hulme worked at the theory of geometrical meaning in sculpture because Epstein was making experiments in direct carving with such meaning, and Epstein produced the carvings because Hulme said that the culture of the twentieth century was calling on the sculptors to redress the balance after Rodin and regenerate sculpture in this way.

After Hulme's death Epstein advanced upon the line of least resistance and developed his amazing powers as a Romantic modeller. But from time to time he has received commissions for carvings to be placed on buildings, and in executing them he has always carved the whole thing himself and designed and

executed it from what we may call the carver's side of the dividing line; and he has done the same in the case of free carvings in the round produced of his own volition in his studio —like the *Genesis*.[1]

Epstein's carvings contain many of the essential elements of sculpture as the modern sculptors understand them. His *Rima* relief in Hyde Park (which is a sort of fragment of a carved sarcophagus) is essentially sculptural in handling from the modern standpoint. But it would be a mistake to regard his carvings as a typical expression of the modern sculptors' creed. They are not the result of an attitude based on the conviction that the essential meaning of a work of sculpture is the meaning of its formal relations. It is true that in his carvings Epstein is much more concerned with that kind of meaning than he is in his bronzes; his *Day* and *Night* (Pl. 7) and *Genesis* (to which I shall refer again later [2]) have formal meaning; but in all these works that meaning is made to serve another which dominates it. Epstein's carvings are heroic attempts to *fuse two types of intense meaning without lessening the intensity of either*.[3]

If we are to see things clearly we must realise that though Epstein is a tremendous figure and though he has contributed to the development of the modern sculptors' creed, he is fundamentally individualist and Romantic and so impatient of the discipline which the modern concept imposes on its devotees.

We must also realise that his contribution to *modern* sculpture consists entirely in his carvings. His bronzes, magnificent though they are, represent, as already noted, the climax of the Romantic sculpture of the nineteenth century.[4]

[1] Cf. IV. 3. v. *e*. 2.
[2] Cf. IV. 3. iii. *c*., and IV. 3. v. *e*. 2.
[3] For negro achievements in such fusion cf. IV. 3. v.
[4] Cf. II. 7. iv.

PART IV
THE MODERN SCULPTORS' EDUCATION

PART IV

THE MODERN SCULPTORS' EDUCATION

1. The extended range

In the course of their studies the modern sculptors turned to the world's content of sculpture for assistance in their technical problems and for reinforcement of their morale by contact with other sculptors whose attitudes were similar to their own. Somewhere, they were certain, they would find sculptors who had thought of sculpture as they were thinking of it and produced something comparable with their own experiments.

There was, of course, a much larger range of sculpture available for their experience than had ever been available for sculptors before. The museums, established all over Europe and America during the nineteenth century, had assembled a great variety of sculpture, and modern facilities for travel had made those museums accessible. It was relatively easy to get into a train or car and study the sculptured monuments of distant lands. Moreover the continuous publication, in books and periodicals, and, as separate sheets, of countless photographs of sculpture of all times and places had made it easy for every student to obtain some contact with a hundred kinds of sculpture in an afternoon; and we must not forget that, in the case of sculpture, photographs can say more about the objects than they can say about paintings, especially paintings in which colour plays an essential or dominant part.

With these facilities the modern sculptors have ranged over the whole field of extant sculpture. But they have not been concerned with formulating a history of past achievements in their art. They were not out to concoct a finality-form. They have made assessments of values as they went along. But those assessments have not been made, as the Jack Horners'

assessments are made, on the assumption that all sculptors everywhere would always have made sculptures resembling the 'Graeco-Roman' ninepins, the Parthenon fragments, the Olympia fragments, Renaissance sculptures or the sculptures by Rodin *if they had been able to do so*. The modern sculptors' assessments have not been made on the Jack Horner assumption that all sculptors outside the prejudice-pie have been 'struggling with imperfect knowledge and incomplete mastery of the mechanical difficulties'; [1] they have been made on the assumption that all sculptors have always done what they wanted to do, and that some of them probably wanted to do much the same kind of thing as they themselves were wanting to do to-day.

Each individual sculptor moreover examined each object from his personal point of view in relation to the problem on which he happened to be working at the time. A work called 'good' (*i.e. useful to himself at the moment*) by one sculptor might be called 'bad' (*i.e. of no immediate use*) by another. Creative artists, unlike archaeologists and historians of sculpture, do not pretend to be able to assess the sculpture of the past on absolute and permanent standards. They assess it in relation to their own creed and their own endeavours. Artists notoriously derive sustenance from the most unlikely quarters; Shakespeare's use of older dramas, of Plutarch and what not, is a stock example; Reynolds said that he took the composition of an important portrait from a woodcut illustrating a halfpenny ballad which he had bought in the street; Turner said that all he knew about Ulysses and Polyphemus when he painted his celebrated picture was a rhyme beginning:

> 'We ate his mutton, drank his wine,
> And then we poked his eye out.'

Individual modern sculptors have thus derived something even from reconcocted Graeco-Roman ninepins and the miscellaneous fragments of statues and masonry generically referred to as Greek sculpture, just as the Romantics derived something from Donatello and the accidental damage to the Elgin Marbles. [2]

[1] Cf. II. 9. viii. *i.*　　　　[2] Cf. IV. 2. iii., and IV. 2. iv. 2.

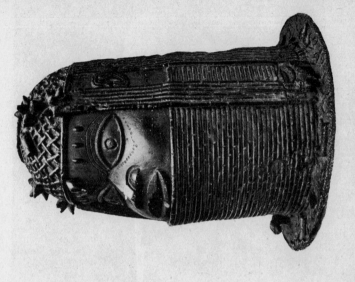

11a. Negro carving from Gabon
Sydney Burney Collection, London.
Cf. IV. 3. v. a. and b.

11b. Benin bronze
Sydney Burney Collection, London.
Cf. IV. 3. v. a. and b.

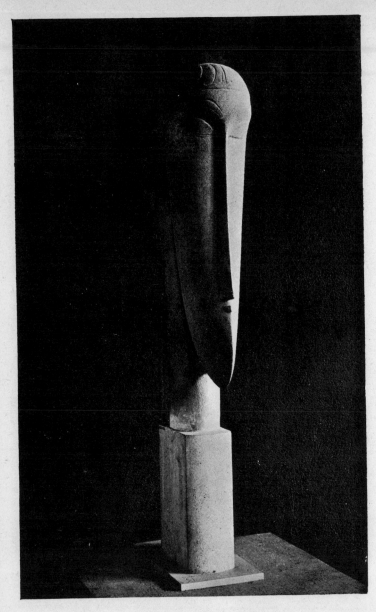

12. MODIGLIANI: *Head*
Victoria and Albert Museum, London.
Cf. IV. 3. v. *e*. 3.

The Modern Sculptors' Education

I do not, of course, pretend to know all the sculpture experienced by the modern sculptors or the character of each experience; the sculptors themselves would probably be unable to record them in detail. But, speaking generally, I think a right impression of the course of the original modern sculptors' widely extended studies will be gathered from the brief summary which now follows.

Before embarking upon it, however, the reader must once more remember that I am not concerned here with the work of popular sculptors, that is to say, with the *pastiches* produced by men who imitate some superficial characteristics of, say, mediaeval, or Chinese sculpture, because they have observed that some dilettanti are becoming weary of *pastiches* of the various kinds of sculpture generically described as 'Greek'. We must remember that the men whose creed and sculptures I am discussing are original artists who have examined the sculptures produced by distant and obsolete cultures, not in order to be able to imitate them, but in order to extract from them something of service to that enlargement of experience which they hope to compass by their own work.

2. Examining the pie

i. *The open mind*

In the beginning, as I have noted, the modern sculptors had rejected the prejudice-pie as such.[1]

But that did not prevent them from examining its ingredients for their own purposes. Creative artists never take other people's judgements on works of art for granted. They never start with the assumption that any work of sculpture is either 'good' or 'bad' from any point of view, even their own. The modern sculptors began by examining Romantic sculpture, Renaissance sculpture, and Greek sculpture, and they started with an open mind.

ii. *The study of Romantic sculpture*

a. *General impressions*

They found the Romantic sculpture of the nineteenth century of little use to them for several reasons.

1. The individualistic attitude of the Romantic artists was antipathetic to their own attitude which existed to impose order on the chaos caused by nineteenth-century individualism and empiricism.

2. The Romantic meaning of Romantic sculpture was in their eyes a non-sculptural meaning; and in typical Romantic works such as Rodin's *Balzac* (Pl. 1*a*) and *La Vieille Heaulmière* (Pl. 3*b*) they could find no other meaning.

3. The Romantic sculpture of the nineteenth century was all modelling. It was thus of no use to men who held direct carving to be the fundamental, the most characteristic and the most desirable sculptural procedure.

4. The Romantic sculpture of the nineteenth century was

[1] Cf. III. 1.

largely graphic and pictorial in concept; Rodin's statues stand closer to Romantic paintings than to sculpture with the meaning of the sphere, cube and the cylinder. The modern sculptors grouped a work like *La Vieille Heaulmière* with the Romantic genre painting of the nineteenth century which was largely influenced by Rembrandt; and as such it was obviously of no use for their own work.

5. The emotional quality in Romantic sculpture is personal and sudden; it was therefore of no use to sculptors who were seeking ways and means to imbue their work with deliberate, impersonal and sustained emotional quality.

6. The Romantic sculptors in their concern with emotive fragments had studied and recorded transitory and casual incidents —the accidental fall of a lock of hair, the casual momentary attitude of a particular model. These studies and records were of no service to sculptors exclusively concerned with the search for form that was universal and permanent in character.

b. General influence

Nineteenth-century Romantic sculpture has thus had no positive influence on modern sculpture.

But it has had a negative influence because the sculptors have tried to blot it from their minds. As I shall have occasion to note again later,[1] it is very difficult to forget at will; and the progress of modern sculpture, in my judgement, has been and still is impeded by the sculptors' inability to forget the Romantic habit of regarding the *face* as more interesting than any other part of a figure on account of its emotive character as the most potent vehicle of expression. Modern sculptors, in my judgement, frequently destroy the *unity* of their formal creations by permitting a meaning in the *faces* of their formal figures which is either not a formal meaning or else is a formal meaning of a different character from the rest of the figure. If we are good spectators we are willing to accept *any* symbols for life which the creative sculptor offers as an enlargement of experience, but we cannot apprehend a symbolic statement unless the statement is a unity within itself. In the Romantic sculpture of the nineteenth century the head is frankly the point of focus, as we have

[1] Cf. IV. 3. v. *e.*

seen in Rodin's *Balzac*, which is nothing without the head
(Pl. 1*b*). The very basis of the modern creed demands that the
whole work should be a unity as a formal concept, but the
influence of the Romantic concentration on faces is still so
strong that modern sculptors frequently elaborate the features
of a face more than the toes for example, or symbolise those
features in a different and more ' expressive' or naturalistic
way. As a result, it is often, I think, as true to say that a work
of modern sculpture gains in formal unity, and therefore in
formal meaning, by the removal of the head as it is to say that
the meaning of Rodin's *Balzac* is entirely destroyed if the head
is taken away.

c. Epstein's 'Sick Child'

The only original sculptor to whom the work of Rodin and
his contemporary Romantics has really been of service is, as I
have indicated, Epstein. His *Sick Child* is the result of a personal
reaction expressed in the language of nineteenth-century
Romantic sculpture. The modern sculptors regard the *Sick
Child* as a masterpiece but not as a work of sculpture. They
regard it as a pictorial masterpiece of the character of a genre
portrait by Rembrandt.

iii. *The study of Renaissance sculpture*

a. General impressions

Renaissance sculpture has also been of little service to the
modern movement.

1. The religious sculptures of the Renaissance, both statues
and reliefs, were mainly pictorial in concept and the modern
sculptors assimilate them accordingly to the Renaissance
paintings by which they were inspired.

2. The Renaissance sculptures which imitated the reconcocted
'antique' ninepins seem to the modern sculptors obviously
derivative productions and so popular in kind.

The more the modern sculptors have studied the Renaissance
productions the more convinced they have inevitably become
that the *original* sculptors of the Renaissance owed relatively
little to the ninepins in the papal and other collections. Ancient
Roman architecture and ancient Roman and Etruscan sarcophagi

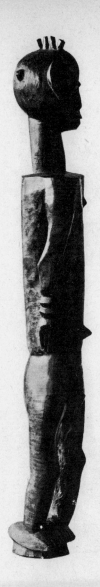

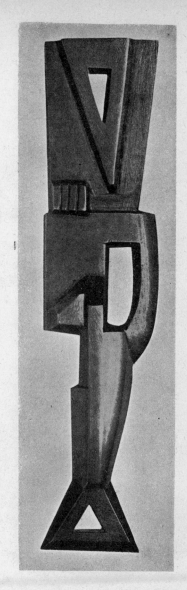

13*a*. Negro carving,
Standing Man

Richard Bedford Collection.

Cf. IV. 3. v. *a*. and *b*. and *d*.

13*b*. GAUDIER: *Brass Toy*

From Ezra Pound's *Gaudier-Brzeska*

Cf. III. 2. vii. *b*. and V. 1 and 5.

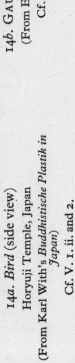

14b. GAUDIER: *Formalised Drawings*
(From Ezra Pound's *Gaudier-Brzeska*)
Cf. III. 2. vii. b. and V. I. ii.

14a. *Bird* (side view)
Horyuji Temple, Japan
(From Karl With's *Buddhistische Plastik in Japan*)
Cf. V. I. ii. and 2.

were of service to the original sculptors of the early Renaissance—notably to Donatello, but the ninepins were of service only to the *painters*.

It is indeed evident that Botticelli, Leonardo and Raphael with the aid of their creative imagination found ways and means of extracting something of value for their own purposes from the ninepins.[1] But it is equally evident that neither Donatello nor Michelangelo found them of service in any essential element of their own creative work and that both defied contemporary propagandists who extolled them as the final perfection of sculpture and as models for their imitation.[2]

3. The naturalistic portrait sculpture of the Renaissance, with its use of death-masks and casts from life,[3] has been of no service to the modern sculptors because they are not concerned with giving their work this kind of meaning. Even when Renaissance portraiture was allied with drama as in Verrocchio's *Colleone* in Venice the additional meaning, from the standpoint of the modern sculptors, is non-sculptural in character.

4. Even Donatello's work has been of small service. Its intensity and originality are of course appreciated but it is much too Romantic to serve the modern sculptors' aim. Indeed such modern sculptors properly so called who have allowed themselves to be fascinated by the expressive grimaces and psychological significance in Donatello's sculptures have derived from them, I fancy, more harm than help.[4]

5. On the other hand contact with Michelangelo's sculpture, and still more, as I have indicated, with his writings, has been found of service because Michelangelo, in spite of his Romantic temperament, had a theoretical attitude to sculpture which was very close to the attitude which the modern sculptors have adopted as their own.[5]

b. Epstein's 'Christ', 'Visitation' and 'Weeping Woman'

But here again we must realise that Epstein stands in an exceptional position. Donatello's work has been of cardinal service to Epstein as a Romantic modeller for bronze. In

[1] Just as, later, Poussin and, later still, David did.

[2] Cf. II. 8. i.-iv., and II. 9. vii. *f.* 13. [3] Cf. II. 8. ii.

[4] Cf. above, IV. 2. ii. *b.* [5] Cf. III. viii. *a, b* and *c.*

Donatello's modelling Epstein has seen technical procedures which have been of use to him, and in Donatello's temperament and psychological insight he has found a reinforcement for his own morale.

Epstein's *Christ* is fundamentally the same kind of imaginative work as Donatello's *Magdalene*; his *Visitation* has the intense emotional meaning of Donatello's *Cupid* (Florence) translated to another mood; and Donatello's grimacing Virgin in the bronze *Pietà* of the Victoria and Albert Museum has the same kind of meaning as Epstein's *Weeping Woman* in the Gallery at Leicester.

Only, of course, we must not forget that Rembrandt and Rodin and all they stand for have come between Epstein and the Renaissance.

iv. The study of Greek sculpture

a. General impressions. The modern sculptors approached Greek sculpture without prejudice. They ignored the prejudices concocted by the professors and looked at the objects which were accessible and at casts and photographs of the others.

Their interest was not aroused by the 'Graeco-Roman' ninepins, or the Elgin-Marbleish statues concocted in the nineteenth century; they knew *by looking at these things* that they were hybrid and composite concoctions.

They began to be interested when they encountered the fragments from Greek buildings and the fragments of so-called 'archaic' statues, though in the case of many of these objects also they sensed that restorers had done a good deal of sticking-together.

b. Study of the ninepins

1. General influence. Confronted with the 'Graeco-Roman' ninepins the modern sculptors knew them for what they are.

But this, we must remember, was a considerable achievement (*a*) because the sculptors like everyone else had imbibed in childhood the propaganda boosting the alleged authors of these ninepins and (*b*) because in England, at any rate, the academic sculptors, in spite of the reorganisations of the Greek propaganda, continued to imitate the Graeco-Roman ninepins right up to

the end of the last century and continue to some extent to do so to-day, and (c) because the worship of the ninepins is still encouraged in the art schools where the sculptors begin their training in youth. I myself when I began my training in a London art school was set to draw a cast of the *Apollo Belvedere* that I might learn the nature of the perfection of Greek art, and when that was done I was set to draw a cast of one of the concoctions that are described by the propagandists as 'copies' of the *Discobolus* by Myron.

Nineteenth-century imitation of the ninepins operated to a large extent *viâ* the imitations of those works by Canova and Flaxman. *Pastiches* of this kind were regularly produced by the academic sculptors in the middle of the century in spite of the propaganda for the Elgin Marbles. The statues called *Early Sorrow* by P. Macdowell, R.A., *Innocence* by J. H. Foley, A.R.A., *Cupid captive* by C. A. Fraikin, and *Psyche* by W. Theed, being mere *pastiches* are now completely forgotten, but they were much admired in the Great Exhibition of 1851; and the drapery of the *Psyche*, which in fact *is exactly copied from the tin drapery added on papal instruction to the so-called 'Cnidian Venus by Praxiteles' in the Vatican,*[1] was especially referred to as 'statuesque' by an academic critic who added: 'This work is in the possession of the Queen at Osborne House—a sufficient testimony to its merits'.[2]

Modern sculptors are not concerned with the production of such *pastiches* and the ninepins have therefore had no general influence on their work.

2. Zadkine's 'Orpheus' and 'Laocoon'. But as each modern sculptor studies everything for his own special contribution to the collective endeavour, the ninepins have nevertheless been of service here and there.

Thus the Russian sculptor Ossip Zadkine, a most brilliant virtuoso, who works in Paris, has taken the attitude of an *Apollo Citharoedus* ninepin for the carving in a tree trunk which he entitles *Orpheus* (Pl. 19); and in another highly interesting work he

[1] Cf. II. 9. vii. *f.* 24.

[2] *Art Journal* (1851), which reproduces engravings of all the statues I have mentioned.

has extracted the *linear rhythms* of the *Laocoon* and made a work of sculpture with the meaning of those rhythms divorced from the meaning of a man and boys repelling an attack of snakes.[1]

c. Study of the architectural fragments

1. General impressions. To the modern sculptors most of the fragments from buildings in Greece and the Hellenic lands seem the remains of sculptures which had no architectural connection with the buildings to which they were attached.

It is indeed obvious that no architect or sculptor with the architectural sense would have dreamed of devising a naturalistic figure composition for a pediment. To anyone with the architectural sense it must always have been evident that if this triangular shape is to be architecturally animated, the animation must consist of units which carry with them no associated notions demanding uniformity of size, because the space at the corners is so much smaller than the space in the centre. The human figure represented in a way that has meaning from its imitation of human anatomy in action (as the figures are represented in the fragments from the Greek pediments), is a unit which carries with it an associated idea demanding uniformity in size. It is the most inappropriate of all conceivable units for the architectural animation of this particular shape because if there is an upright figure as the unit in the centre all the others must either gradually approach to dwarfs or else be represented in various stages of knocking or being knocked down or falling down of their own free will. To the modern sculptors it is evident that these figures, stuck into the pediments of Greek buildings, could never have been a part of the architectural concept of the buildings.

Furthermore the fragments from the Greek pediments are fragments of masons' translations into marble (*a*) of clay models designed for bronzes (as, probably, in the case of the Aegina pediments), or (*b*) of clay models imitating drawings or paintings, or (*c*) of drawings or paintings.

The first two types, from the modern standpoint, have the meaning and character of clay modelling and not that of archi-

[1] For other references to Zadkine's works cf. IV. 2. iv. *c*. 3., and IV. 3. v. *e*. 3., and V. 9.

tectural carving appropriate to buildings, and the third type has a meaning which is also non-architectural and non-sculptural because in character it is drawing or painting imitated in stone.[1]

We may assume, I imagine, that the decision as to what should be put in the Greek pediments was made by priests or committees who had drawings and paintings in their minds and who thought that these drawings or paintings, imitated in marble, would serve some purpose if stuck into the pediments.

As not even the propagandists for the Greek prejudice can pretend that any Greek painting survives they write about Greek sculpture as though Greek painting had never existed. But we have only to consider the enormous influence of Renaissance painting on Renaissance sculpture to realise that the same influence was probably operative in ancient Greece, where, as we know from Pausanias, there were countless paintings in the public buildings.

2. Study of the Elgin Marbles.[2] If the fragments from the Parthenon pediments are examined at the back as well as the front they lead to the conclusion that they were made in the following way:

Some sculptor made a sketch in clay of a general disposition of the figures as a relief-picture to fill the awkward shape of the pediment; he put standing figures in the centre, seated and lying-down figures in the middle sections, and oddments, horses' heads and so forth, in the corners. Several sculptors then made full-size naked clay models of all the figures; *real drapery dipped in clay or covered with clay* was then disposed on the figures and the whole when dry was cast in plaster; then marble workers were called in to imitate the plasters in marble, and when their work was done the figures were hoisted into position.

The disposal of real drapery on clay figures and the casting of it together with them, was the regular procedure of the Renaissance modellers, as we know from Vasari; it is also employed in our own day by sculptors who wish to give their statues the meaning of naturalistic folds. Professor Baldwin Brown (sometime Watson-Gordon Professor in the University of Edinburgh)

[1] Cf. III. 2. viii. *a.* to *i.*

[2] Cf. II. 7. viii., and II. 9. viii. *a.-d.*

has described the procedure as 'not very artistic'.[1] He would presumably say the same of casting from life.[2]

Sculptures produced in this way have clearly no relation to the essential sculpture of the modern sculptors' creed. The meaning of these fragments from the Parthenon pediments is a meaning residing mainly in the imitation of human anatomy, gesture, and attitude, and the meaning of naturalistic disposition of drapery; it is not fundamentally the meaning of architecture or the meaning of the sphere, the cube and the cylinder which Socrates referred to as 'beauty of form'.[3]

What the modern sculptors see in the fragments of the pedimental sculpture from the Parthenon is mainly naturalism; and this is also what was mainly seen in them by the most fervent of their early artist-admirers—the English Romantic painter Benjamin Haydon who wrote pages in his Autobiography about the perfection of the anatomical imitation displayed in them; and it was possibly the non-architectural character of these sculptures which made them seem uninteresting to Ruskin.[4]

The Parthenon frieze is not a work of much interest to modern sculptors. They know it as an echo of similar patterns in Egyptian reliefs made a thousand years earlier[5]; and they naturally find it difficult to understand the meaning of the life-size veins on horses which are a third life-size, especially in the case of a frieze destined to be placed in an invisible position forty feet above the ground. Moreover the frieze, from their standpoint, is not carved work in concept but the imitation in marble of a clay version of a painting or drawing.

3. Influence of the Elgin Marbles

i. General influence. For these reasons the Elgin Marbles, which had so much influence in assisting the appreciation of Romantic sculpture, have been of little service to modern sculptors, though the richness of their naturalistic meaning as compared with the 'Graeco-Roman' ninepins or the fragments from Olympia is recognised.

But, of course, each individual sculptor may have found them

[1] *Vasari on Technique*, Baldwin Brown edition, p. 151.

[2] Cf. II. 8. ii., and IV. 2. iv. *c.* 4. [3] Cf. III. 2. v.

[4] Cf. III. 2. vi. [5] Cf. IV. 3. ii.

of service in one way or another at some particular times; and I have already drawn attention to what I take to be Epstein's reaction to their rough surface.[1]

ii. Zadkine's 'Menades'. For the same reasons the *Nereids* in the British Museum and kindred figures such as the *Victory* signed Paeonius found in 1875 and now in the Olympia Museum have been of small service to modern sculpture.

But here again individual sculptors have been able to use them. Thus Zadkine has used the Paeonius *Victory* for his *Menades* (Pl. 4). Certain photographs of this *Victory* show the found parts of the statue assembled without any attempt to fill in the gaps caused by the missing parts. Thus the front part of the head is missing and the figure therefore has no face, the front part of the right foot is missing, parts of the arm are connected by wire, the drapery is fragmentary, etc. etc. Zadkine has studied the appearance of the statue when this photograph was taken and reacted to the aesthetic meaning of the object *in this state*; and the group which he entitles *Menades* is a most interesting attempt to create a meaning of a similar kind. The aesthetic of Zadkine's *Menades* bears in fact the same relation to the aesthetic of this fragmentary Paeonius *Victory* that Rodin's torsos without limbs bear to the aesthetic of the Elgin Marbles.[2]

In so doing Zadkine shows himself a creative modern sculptor concerned with the fashioning of objects that have meaning in the relations of their forms. He has looked at the Paeonius *Victory* in its present state *as an object of a certain combination of forms;* he has not approached it, as the compilers of the histories of Greek sculpture have approached it, as an object which (*a*) is of interest because it has a name on it and so provides material for word-spinning in the Rise-and-Fall formula and (*b*) is incomplete in its meaning until it is restored or imagined as something with the meaning of a young girl running in a transparent nightgown.

Dr. Gisela Richter reproduces a 'reconstruction' of this *Victory* that is inconceivably ridiculous. Zadkine's *Menades* is *like* the *Victory* because the meaning of its form is similar in character; the 'reconstruction' reproduced by Dr. Richter is not in the least *like* it because it has no formal meaning at all.

[1] Cf. II. 7. viii. and ix. [2] Cf. II. 7. viii.

4. Study of the Olympia fragments and the 'Delphi Charioteer'
i. General impressions. When the modern sculptors turned their attention to the fragments of the metopes and pediments from the Temple of Zeus at Olympia (which are to be seen in the Louvre and the Olympia Museum as the result of excavations conducted by the French and Germans at various periods in the nineteenth century) they found them tame and academic works of small account.

These fragments are clearly the work of sculptors who were playing for safety by imitating the sculptural styles of a culture that was already obsolete in their own day. They are evidently the work of men who had no real urge to give their sculptures meaning deriving from naturalistic imitation on the one hand or meaning deriving from abstract form on the other; and who tried in a spirit of compromise to dilute the two meanings and mix them together. The result is neither black nor white nor black plus white but a miserable listless grey.

Moreover the Olympia fragments have the character of paintings or drawings because the sculptors were clearly imitating paintings or drawings.

In studying the *Delphi Charioteer* the modern sculptors set aside all the propagandists' word-spinning. They know that the hand and feet are bronze versions of plaster casts from life, and that the drapery also was almost certainly cast from real drapery like the drapery in the pedimental fragments of the Parthenon and the naturalistic statues at Toulouse.[1] As for the face with its enamel eyes and eyelashes with blobs on the end, like the eyelashes of a film-star, this, clearly, was the fashionable convention for a handsome face at the time and place when this figure was made.

The *Delphi Charioteer*, in a word, is obviously the work of a fashionable portrait-sculptor who had a commission to make a statue of a handsome young man whose valet was good at pressing the equivalent of his trousers; and the sculptor went about his business in exactly the spirit of an English academic sculptor with a commission to make a statue of the Prince of Wales. All students are familiar with the flatter-the-face-smarten-up-

[1] Cf. II. 8. ii.

the-clothes-do-the-rest-with-naturalistic-detail-from-a-model formula for such productions.

To the professors who write in their books that the date of the statue is *circa* 470 B.C., on the evidence of a half-erased inscription on the base, the modern sculptors reply, of course, that, if the date is accurate, the statue demonstrates that a fashionable portrait sculptor who made conventional faces and cast other parts from life was working at that date; and that if this does not fit in with the Rise-and-Fall formula of the professor's invention, then the professors must remake their formula accordingly.[1]

ii. Influence of these sculptures. As noted, the propaganda for the Greek prejudice now boosts the Olympia fragments as 'the flower of Greek sculpture' and more perfect than the Elgin Marbles.[2] The propagandists have also done much boosting of the *Charioteer*. In these procedures they have been encouraged by the academic sculptors, who are now as always in league with the propagandists against contemporary creative sculpture, and who have found the Olympia fragments and the *Charioteer* (*a*) sympathetic because they were produced by timid uncreative artists of their own calibre and (*b*) easy to imitate.

As a result there has been in recent years much superficial imitation of these sculptures by academic *pasticheurs*, as we can see in any show of academic sculpture in the world to-day; and this group of sculptures is beginning to usurp the place of the 'Graeco-Roman' ninepins as the models which right-minded students in the official art schools are exhorted by their professors to admire and imitate.

But to modern sculptors the Olympia fragments and the *Delphi Charioteer* have been of no service.

iii. Maillol. A word must be said here of the work of Aristide Maillol, the transitional master between Rodin and the modern sculptors.

[1] The statue was discovered in two halves by French excavators at Delphi in 1896. The lower half was found on one day and the top half some days later (they have since of course been stuck together). Near the statue were a few miscellaneous fragments of a chariot and horses, remnants of bronze reins, a child's arm, and an inscribed block of stone which is presumed to be a fragment of a much larger block which may have formed the base.

[2] Cf. II. 9. viii. *j.*

Maillol was born in 1861 and he is thus now over seventy. He began as a student of painting in the École des Beaux Arts under Cabanel. Later he met Gauguin and later still Renoir. For some time he worked at textile and carpet designing. Then he became a pupil of Rodin and at the turn of the century he began to attract attention as a sculptor.

Maillol has made a contribution to the development of modern sculpture because he has worked in a spirit of reaction against the Romantic empirical sculptures by Rodin. He broke away from the Rodin tradition of emotive modelling and particularisation. He sought to create generic not particular form. His early concepts were to a large extent pictorial and at the end of the nineties he made reliefs which resemble the classical pictures which Renoir was painting at that period and also the sculpture which Renoir himself produced. In 1909 he went to Olympia and Mr. Casson tells us that 'it was the massive and superbly balanced statues of the Temple of Zeus that he looked at; it was their powerful restraint and their fine curves that attracted his eye'.

When Maillol was in Olympia he probably did look at the fragments from the temple sculptures; and if he did he doubtless observed the balancing done by the restorers who have stuck together the fragments of the pedimental figures and mounted them on supports and blocks of stone; with his pictorial and academic training he may have appreciated the pictorial character of these fragments and he may have regarded the timidity and compromise of the sculptors as a welcome relief after the emotive energy of Rodin. But he did not go back to Paris like a dutiful victim of the propagandists for the Greek prejudice in its present form and *spend the rest of his days making nice, neat lifeless 'pastiches' of the Olympia fragments*.

Maillol in fact has not only studied the Olympia fragments. He has studied the votive *Maidens* in Athens, the bronzes from Herculaneum in Naples, the Elgin pedimental fragments and Greek and Hellenistic terra-cotta statuettes. As a result he has become a convert to the modern sculptors' attitude to sculpture; he has spent the last twenty-five years in trying to evolve a formula for the representation of the nude female form that would have meaning as form in the round; above all, he has

sought a unification of form and a plenitude of form swelling outwards from within. This is apparent in his recumbent figures the *Cézanne Memorial*, his *Venus* that fronts the sea at Port Vendres, and the *War Memorial* on the terrace at Elne; and it is also apparent in all his later works that are known to me.[1]

d. The study of the archaic fragments

The fragments of the so-called 'archaic' Greek statues in the round (votive or funeral figures like the so-called *Apollo from Sounion* and *Apollo from Orchomenos* in Athens, the *Apollo from Tenea* in Munich, etc., are mainly of little interest to the modern sculptors because they recognise them as faint echoes of the striding Egyptian figures where the form is more compelling because it retains more of the permanent meaning of the cube. The modern sculptors are more interested in the early votive figures from the Sacred Way at Branchidae (Pl. 6a) which have the meaning of their cubic shape. But here again they recognise, of course, that the Greek works are echoes of the Egyptian.

They find formal meaning also in the so-called *Hera from Samos* (Pl. 1a) in the Louvre. This work has the meaning of the cylinder, and as such, though the head is missing, it retains a meaning when Rodin's headless *Balzac* (Pl. 1b) means nothing. But though this *Hera* seems rich in formal meaning when contrasted with a headless *Balzac* it is seen to be poor in formal meaning when contrasted with Egyptian or Sumerian work or with Gaudier's *Brass Toy* (Pl. 13b). The reason is that the sculptor of the *Hera* clearly had no intense realisation of the meaning of the form he was fashioning. If the statue is genuine we must regard it not as an original work and a contribution to the culture of the time it was produced, but as a hack *pastiche*, the backwash of a culture that was already dead.[2]

All the so-called 'archaic' Greek sculptures are evidently the

[1] Maillol's work has been continued and developed in England by Frank Dobson. In Paris, Maillol's imitators already constitute an academic school.

[2] This statue reached the Louvre from Samos some time in the nineteenth century. It bears an inscription describing it as a votive offering to Hera by one Cheramyes. The lettering of the inscription is of a character believed to be later than 550 B.C.

backwash of the Egyptian tradition. They are not, as the propagandists tell us, the work of incompetent beginners struggling to produce Graeco-Roman ninepins or *Nereids* but the work of men who did exactly what they wanted to do and did it without effort because they were working within formulae that were already centuries old.

3. Farther afield

i. *The study of mediaeval sculpture*

a. General impressions

The modern sculptors now turned their attention to a hundred other varieties of sculpture which the Jack Horners assume to be the productions of ignorant and incompetent bunglers struggling in vain to achieve the perfection of the plums within the prejudice-pie; and they found a great deal of signal interest and service.

To begin with, in mediaeval sculpture they saw evidence of cultures that believed in *sculptured buildings*.

It is clear that the cultures responsible for Romanesque and Gothic sculpture in France and Spain, and for Moorish sculpture in Spain, regarded the meaning of a building as incomplete until it had been elaborately carved into sculpture.

The Mahomedan religion, as everyone knows, restricted the sculptured meaning to the meaning which resides in abstract forms; the Christian religion, on the other hand, encouraged the sculptors to give the buildings not only the meaning of formal animation at every angle but also a number of other meanings deriving from the Church's determination to make the churches and cathedrals powerful propaganda agents for the spread of all that which it desired the people to know and to believe.

The Romanesque and Gothic sculptors were mainly relief carvers. They looked at the remains of Roman relief sculpture on the sarcophagi and triumphal arches, which still existed in their lands, and they gave the Church of *Saint Trophime* at Arles the meaning of a sculptured building; they looked at Byzantine manuscripts and made carvings at Moissac and Vezelay and Chartres; when they made figures almost in the round, as continuations of columns, as in the *Portail Royal* at Chartres, the figures are in the nature of reliefs *upon* the columns;

125

they are not properly speaking free sculptures in the round conceived with the meaning of the sphere and the cylinder.[1]

b. *Influence of mediaeval sculpture*

Moorish mediaeval sculpture has not been of much use to the creative modern sculptors because in concept it is all obviously drawing.

Nevertheless it is of interest to them (*a*) because it is direct carving and not the imitation in stone of clay modelling, and (*b*) because the sculptors were not concerned with representational or naturalistic imitation, but with formal, and largely with geometrical, composition. The ceiling, for example, of the mosque which is now *Santo Cristo de la Luz* in Toledo, has the formal meaning required by the foundation principle of the modern sculptors' creed, the kind of meaning referred to as 'beauty of form' by Socrates.[2]

The superficial characteristics of Christian mediaeval sculpture have been much imitated in the last twenty years by academic *pasticheurs*. But with those imitations we are not, of course, concerned.

To the creative modern sculptors the Christian sculptures have been of interest and use (*a*) because they are all direct carvings and (*b*) because in character they are the animation of stone and examples of that collaboration between the sculptors and their material which the modern sculptors are striving to achieve.[3]

The Romanesque and Gothic sculptors brought stones to life; they were not concerned, like clay modellers, with converting living figures into dead material; they were concerned with helping stones to symbolise life. But their influence on the creative sculpture of our day has been limited because they were not creators of free sculpture in the round. Their work is real relief carving and really part of the buildings. But conditions make the creation of such sculptured buildings impossible to-day. There is no living culture to-day which regards buildings as incomplete until they are animated with sculpture at every angle. The most that is desired is a little sculpture added to a

[1] To the Roman and Byzantine elements in Christian mediaeval sculpture we must add the Far Eastern elements that came to it through various contacts with the East.

[2] Cf. III. 2. v. [3] Cf. III. 2. viii. *f.*

building here and there at the last minute as a trimming—if funds are available. The modern sculptors are willing to embark on carving whole buildings into sculpture as the mediaeval sculptors carved them; but opportunities are not forthcoming; and they prefer the production of free sculpture in their studios to the production of last-minute additions to buildings—like the sculptures in the pediments of ancient Greece.

ii. The study of Egyptian, Assyrian and Persian sculpture

a. General impressions

The Egyptians made direct carvings in hard and soft stones; and they frequently painted their statues. We have remains of their sculpture, some of it dated approximately by inscriptions, over a period of three thousand years from 3000 B.C. At the very beginning of that period the Egyptians evolved, as part of their culture, a characteristic type of sculpture which was so impressive, and held to be of such service, that it persisted with minor modifications almost to the end. At one moment (the celebrated reign of Amenophis IV (Aknaton), about 1370 B.C.) the special character of Egyptian sculpture seemed threatened with destruction by a Romantic movement dominated by a brilliant clay modeller, whose name is unknown, though some of his works have been preserved. But the fundamental concept survived this ordeal; it was still living when the Alexandrine culture came to Egypt and destroyed it.

In the seventh century B.C. the Greek sculptors were imitating the characteristic Egyptian sculpture. Later, Pliny tells us, they learned the art of hollow casting in bronze from the same masters (who had been making hollow-cast bronzes from the eighth century); three hundred years later the Hellenic sculptors invaded Egypt with their art of stone-cutting in imitation of hollow cast bronzes with sex appeal—and by that contact the ancient carved art of Egypt perished.

In Egyptian sculpture, produced nearly four thousand years ago, the modern sculptors found one aspect of the essential sculpture that they were seeking. Confronted with the remains of this art they felt in contact with men whose concept of sculpture seemed very like their own. When they studied the granite

Seated Priest at Leyden, and the diorite *Seated Princess* at Turin (both presumed to have been carved about 2900 B.C.), the diorite *Seated Chephren* in Cairo (*c.* 2800 B.C.) the granite *Seated Scribe* in Berlin (*c.* 2700) and the sandstone *Chertihotep* (Pl. 5*a*) in Berlin they were studying sculpture which seemed to them the *animation of a cube*. The *Great Sphinx*, and those pointed cubes the *Pyramids*, made about 2800 B.C., seemed to them to have meaning of the same kind.

They realised, of course, that these objects had religious and propaganda meanings as well as formal meaning. But, these non-sculptural meanings seemed to be expressed *by means of the formal meaning*. The statue of Chephren was terrible and impressive *because* it was an animated cube; the Leyden *Priest*, the Turin *Princess*, and the *Chephren* rivet attention by the character of the formal masses organised by the sculptors to express meanings imposed upon them by wills other than their own.[1]

The religious and propaganda meanings of these objects have long perished; Egyptian religion means nothing to our culture, Pharaoh can make no man tremble in the modern world; but the meaning *of the form by means of which* the Egyptian sculptors set out to kill the Fear of Death and to instil the Fear of Pharaoh, is a meaning that remains; the *Pyramid of Chephren*, considered as a funeral monument, means no more to us to-day than the first pyramidal heap of stones to keep away jackals; but what remains is the meaning of the form on that particular scale.[2]

b. *Influence of these sculptures*

In these Egyptian sculptures in the round the modern sculptors saw that collaboration between the character and form of a resistant substance on the one hand and the human will on the other, which they themselves were hoping to achieve. In these carvings the stone, the cubic shape, and the idea of a seated man had all met on equal terms, and each had contributed to the other. The meaning of the stone cube is enriched by the symbolic meaning of its relation to a seated man; and the image of the seated man is given universal and permanent meaning by its union with the universal and permanent meaning of the stone and the cube.[3]

[1] Cf. III. 2. ii. [2] Cf. V. 5. [3] Cf. V. *passim*.

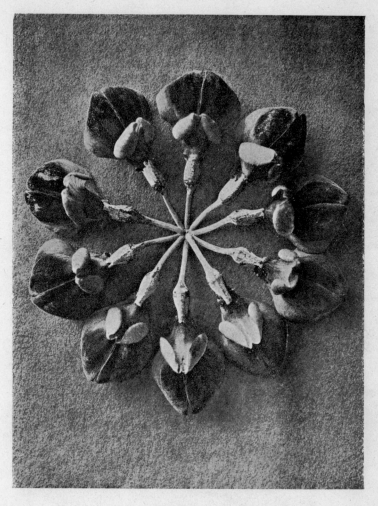

15. Flower umbel. Coronilla Coronata
(From Blossfeldt's *Art Forms in Nature, Second Series*)
Cf. V. 1. and 2.

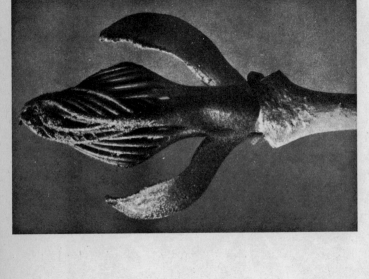

16b. Shoot of Flowering Ash
(From Blossfeldt's *Art Forms in Nature, First Series*)
Cf V. 2.

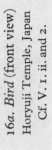

16a. *Bird* (front view)
Horyuji Temple, Japan
Cf. V. 1. ii. and 2.

Moreover from the standpoint of the modern sculptors Egyptian sculpture was really *carving*. The Egyptian monuments and figures in the round were not modelled in clay and then copied in stone; they were conceived as carved stone. The Egyptians only used clay for (*a*) minor and popular productions, (*b*) portraiture in the reign of Aknaton when some modeller of the Donatello-Epstein type was conspicuous, and (*c*) naturalistic works in the last seven hundred years of their culture when hollow casting in bronze was in common use.

Egyptian reliefs have also been found of interest and service. For here was the origin of the pattern of horses' legs in the Parthenon frieze. The modern sculptors found it in the limestone relief of the *Sailors disembarking* (in Berlin) which is presumed to have been carved about 2600 B.C. They observed too that the linear rhythm in the drawing of the row of *Dancers* doing 'high kicks' on the relief at Sakkarah resembled the rhythm in Seurat's painting *Le Chahut*[1]; and that the attitudes of the bound arms of the *Captives* on the reliefs in Berlin (ascribed to 2670 B.C.) have pathetic meaning conveyed by means of the geometrical disposition of the arms, just as pathetic meaning of another character is conveyed by the geometrical disposition of the legs both in the Sakkarah *Dancers* and in Seurat's *Le Chahut*. All this they regarded as interesting but, of course, primarily as a matter of drawing, and so really of more service to painters than to themselves.

Assyrian sculpture also is largely a matter of drawing. The Assyrians worked with the cube. But they did not, as in Michelangelo's concept, release the statue from within it, they chiselled pictures on its sides.

On the other hand, in the *Queen Napir-Asou* (Louvre), believed to be a record of the culture of Sousa about 1800 B.C., the modern sculptors found again free sculpture in the round. This work is as obviously cylindrical in form as the so-called *Hera from Samos* (Pl. 1*a*). But here again the cylindrical form is not impressive. The sculptor does not appear to have started with a concept of the meaning of cylindrical form but with a desire to imitate the cylindrical character of this particular Queen's dress.

[1] This resemblance is pointed out by Fechheimer in his *Egyptian Sculpture*.

Neither this statue nor the *Hera* would stand the test of enlargement to a colossal scale.[1]

The modern sculptors have found their studies of Egyptian, Assyrian and ancient Persian carvings of very great service.

I reproduce as an example the carving called *Musician* (Pl. 5*b*) by an English sculptress, Barbara Hepworth. This, it will be recognised, is not a *pastiche* of the Egyptian statue reproduced on the same page. It is an attempt to create sculpture with analogous meaning; an attempt to collaborate with substance and cubic form and so recapture the compelling formal meaning of the Egyptian works.

iii. *The study of Chinese and Japanese sculpture*

a. *General impressions*

When Buddhism reached China from India it created Chinese Buddhist art. By the fifth century of the Christian era the Chinese were cutting fifty-foot Buddhas into the sides of rocks and making sculptured rock temples like the Indians.[2]

The modern sculptors are acquainted with photographs of the Buddhist sculptures in the rock and cave temples at Yun Kang in the province of Shanshi, at Kung Hsien and Lung Men in the Honan province, at To Shan and Yun Men Shan in Shantung, and with photographs of the Chinese or Japanese Buddhist sculptures in the temples at Horyuji and elsewhere in Japan—all colossal works of sculpture produced in the period habitually described by the propagandists for the Greek prejudice as the 'dark ages'.

They are also acquainted with photographs of ancient Chinese and Japanese sculptured animals, and with examples of Buddhist statues and tombstones preserved in museums and collections—the Boston Museum of Fine Arts, for example, has some Chinese sculptured tombstones and figures said to date back to the sixth century; the Louvre has a Chinese gilt bronze with two seated figures of the lean character of the carvings at Lung Men which so strangely resemble the Christ in the tympanum at Vezelay; the Victoria and Albert Museum, London, has a green marble horse ascribed to the Tang period (618-906); and the British Museum, the Eumorfopoulos collection in London and

[1] Cf. V. 5. [2] Cf. IV. 3. vi.

other collections have painted wooden statues of Kuan-Yin seated with raised knee, said to be characteristic of the twelfth century.

The modern sculptors' knowledge of Chinese sculpture also includes examples of the minor naturalistic statuettes in terra-cotta that were placed in Chinese tombs from very ancient times, and of the Madame Tussaud development of that craft exemplified in the life-size coloured pottery figures of Lohans which appeared in Germany shortly before the war from the Chili province, and are now to be seen in the British Museum and the Metropolitan Museum of New York.

b. General influence

As everyone knows, pottery, porcelain and miscellaneous bric-à-brac from China have exercised a considerable influence on European applied arts from the middle of the seventeenth century to the present day. But Chinese sculpture so far has had relatively little influence, and indeed till the beginning of the present century very few sculptors knew anything about it. In recent years some academic sculptors have shown a tendency to make statues imitating Chinese porcelain statuettes; but with *pastiches* of this kind we are not of course concerned.

The creative modern sculptors have studied the Chinese Buddhist sculptures, as they have studied all sculpture, primarily with a view to understanding the sculptors' concepts of plastic form. These concepts seem to be based on spheroid, ovoid, and cylindrical forms and the flowing rhythm is accentuated by lines drawn upon these shapes. In Chinese Buddhist sculpture lines which accentuate the rhythm, symbolise, though they do not imitate, the folds of the garments which the figures wear. This is well seen in the lines of the drapery on the Chinese carving of the Tang period (618-906) which I reproduce as Pl. 6b.[1]

[1] This statue was used by Mr. Roger Fry to illustrate this aspect of Chinese sculpture in 'Chinese Art', a series of essays published by the *Burlington Magazine* in 1925. I have not seen the statue and do not know where it comes from or where it is. For the use of the photograph I am indebted to the *Burlington Magazine*. As the photograph was very faded I have reinforced the background with Chinese white, though this process and the process of 'cutting out' by the blockmaker both inevitably falsify the contour of a work of sculpture by destroying the subtleties of the receding planes, and should therefore be avoided. Neither has been employed in any other plate in this book.

The lines of the drapery in this work enhance the rhythm of the egg-form which has become the figure; the sculptor has preferred the symbolisation of the folds for this formal purpose to the imitation of the draperies. He has been concerned with the organisation of formal meaning and not with the meaning of real drapery as in the pedimental fragments of the Elgin Marbles and the naturalistic figures at Toulouse.[1]

From the modern sculptors' standpoint this Tang statue is essential sculpture in that it has the meaning of a permanent universal form—the egg; and the linear treatment of the drapery is approximated to painted decoration on the form. The modern sculptors are not concerned with the other meanings which this statue may have had a thousand years ago. From their standpoint those other meanings are of no service because they regard them (*a*) as non-sculptural and (*b*) as dead; whereas the meaning of the statue's form is still alive.

c. Epstein's 'Night' and 'Day'

Now, at this stage in our inquiry, let us make our mind a blank and then fill it (*a*) with our recollections of the cubic form of Egyptian sculpture (Pl. 5*a*) and of the Branchidae figures (Pl. 6*a*), (*b*) with our recollections of the linear rhythm of the drawing on the surface of the sculptured form in the Chinese statue (Pl. 6*b*); (*c*) with our recollections of Andrea d'Assisi's *Child sleeping in the Virgin's lap* (Palazzo dei Conservatori, Rome); and (*d*) with recollections of the *pietà motif* in Christian painting and in sculptures like Michelangelo's *Pietà* in St. Peter's and the *Pietàs* from Baden and Tegernsee in the Deutsches Museum in Berlin. If we do this, and then recall the curse of sleeplessness, we shall be in a condition to begin to study Epstein's *Night* on the Underground Building at Broadway, Westminster (Pl. 7).

I am not, of course, suggesting that the elements mentioned above constitute the *ingredients* of this work of sculpture. I am trying to indicate the kind of experience which assists in its appreciation. To judge Epstein's *Night* by the standard of the naturalistic figures at Toulouse is as ridiculous as to assess it by the standard of the anaemic pedimental fragments from Olympia or the standard of the *Apollo Belvedere*.

[1] Cf. II. 8. ii. and IV. 2. iv. *c*. 2.

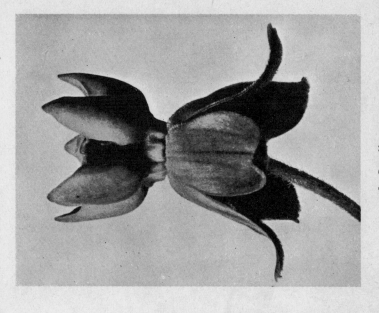

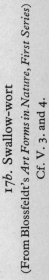

17b. Swallow-wort
(From Blossfeldt's *Art Forms in Nature, First Series*)
Cf. V. 3. and 4.

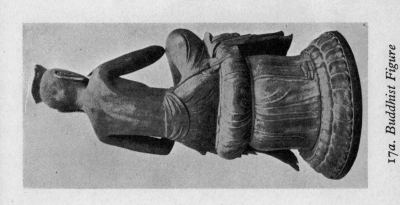

17a. *Buddhist Figure*
Horyuji Temple, Japan
(From Karl With's *Buddhistische
Plastik in Japan*)
Cf. V. 3.

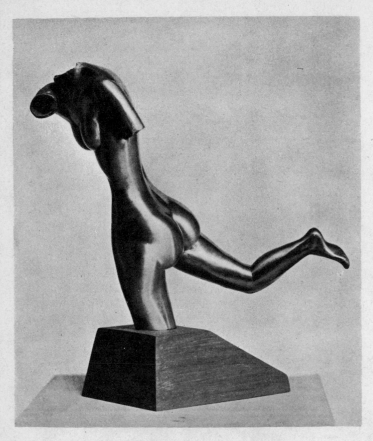

18. LEON UNDERWOOD: *Runner*
Cf. V. 4. and 9.

If we share to some extent the general range of the modern sculptors' sculptural experience and understand the attitude in which that experience has been acquired, we realise that Epstein's *Night* is an immensely interesting contribution to the sculptural movement of to-day, though we must recognise also that the form has been used as a vehicle for an idea.

For here, as in all Epstein's carving, the sculptor has not been exclusively concerned with form. No one except the creative sculptor knows the terrific difficulty of inventing new sculptural language for the symbolisation of ideas like *Night* and *Day*. Popular sculptors as we all know still take the language provided by the *tableaux vivants* in the pageants of the Middle Ages *viâ* the use made of them in the 'allegorical' paintings of the sixteenth, seventeenth, and eighteenth centuries. Michelangelo evaded the problem by making figures that could more appropriately have been labelled 'Recumbent Female' and 'Recumbent Male'—indeed Johann Fichard, a German Pausanias who travelled in Italy in 1536, described Michelangelo's *Night* and *Day* in his notebook as 'Minerva' and 'Hercules'. Epstein has made a heroic effort to invent a *new* symbol for a new concept of a Night-Goddess, and to make form and concept seem one inevitable whole. In this he has, I think, succeeded—except possibly in the face which might conceivably have been different.

The problem of the face in this work was of course extremely difficult. All Romantic particularisation had to be avoided; there could be no question of copying the face of some particular model. Epstein did not want to make a 'Greek' face, or a Chinese face, or an Indian face or an English face or a French face. He wanted to make *a* face of a form congruent with the whole sculpture and expressing nothing but his sleep-producing —protective—Night-Goddess idea. In the event he made a Mongolian face—which in the case of this work is no better and no worse than a 'Greek' face or an English face or any other. The truth was, I imagine, that the group was conceived exactly as it is except that the face had no definite features; and the group would have unity if no definite features had ever been inserted.

The *Day* group on the other hand appears to me a perfect unity of formal parts; the meaning of the face, with brows contracted against the sun, was, I imagine, an integral part of the sculptor's concept of this sculpture from the start; and in the event it has not become Mongolian or Greek or any other type that carries with it associated ideas. The sculptor by the force of his imagination has excluded all meaning extraneous to his idea.

iv. The study of Sumerian sculpture

a. General impressions

Very little is known of the ancient culture of the regions round Babylon, referred to sometimes as Chaldean, sometimes as Babylonian, and now more generally as Sumerian, as distinguished from the culture of the regions round Nineveh now generally referred to as Assyrian.

A few headless statues carved in hard stone which were excavated at Telloh by the French Consul General about fifty years ago and ascribed approximately to 2300 B.C. can be seen in the Louvre. The most imposing of these is a full-length headless figure described as a *Portrait of Gudea* who is said to have been a prince or governor in those regions about 2300 B.C. Another statue, a seated figure, has had a head wearing a turban, found at a different time, put on to it by the Louvre restorers.

b. The British Museum 'Portrait of Gudea' (Pl. 8a)

Since the war there has been a good deal of digging by tribesmen in these regions; and seven years ago various sculptured fragments were found at Lagash. A head and a body to the waist, both of very hard green dolerite stone, passed into the collection of Mr. Sydney Burney of St. James's Place, London. The head and body are believed to be part of the same figure and, like the headless Louvre figure, the statue is presumed to be a portrait of Gudea. The gesture of the clasped hands is characteristic of the Sumerian sculptures and both the body and head have the character of the Louvre examples.

Mr. Burney employed the sculptor Leon Underwood to model a neck in plaster, and the figure thus provisionally restored was studied by a number of modern sculptors in Mr. Burney's gallery.

Later, the British Museum bought the statue with the aid of a contribution from the National Art Collections Fund. The Museum authorities have re-restored it with a different neck and a wooden stand suggesting a full-length figure to resemble the full length so-called *Portrait of Gudea* in the Louvre. The photograph of this statue reproduced here (Pl. 8*a*) shows its appearance with the neck made by Underwood as it was exhibited in Mr. Burney's gallery.

c. *Influence of these sculptures.*

Modern sculptors have been much impressed by Sumerian sculpture. They set aside, of course, the archaeologists' prattle which describes these figures as 'portraits'. The Sumerian sculptors were obviously not attempting to convert the stones into likenesses of Gudea or anyone else. These statues are no more portraits than the statues of the Pharaohs or the Assyrian Kings are portraits. They are not particularised representations of individuals. If the sculptors had wanted to make lifelike likenesses they would of course have done so; whenever and where-ever sculptors have wanted to do this they have always done so. But the sculptor who had done this in ancient Egypt or Assyria or Sumeria would have been headless in ten minutes.[1] The sculptor did what he was required to do, which was to colla-borate with a block of hard stone and to convert it to form which would suggest in a symbolic way certain qualities in the prince and his office which would make men revere and respect him. These qualities were symbolised by the sculptors by means of the fundamental three-dimensional forms—the sphere, the cube and the cylinder. The formal meaning of Sumerian sculptures is the meaning of the mutual play of angular and curved forms which constitute a formal architecture peculiar to themselves. The cubic form of the clasped hands in the British Museum statue is continued in the flatness of the front of the arms and the sharply defined angle of the side planes. The gesture is given permanent meaning by the form.

Here once again is essential sculpture, and direct carving in the round; here once again are works of sculpture which have

[1] Except in Egypt under the eccentric Aknaton who allowed the Donatello-Epstein man to model a likeness (cf. IV. 3. ii.).

meaning four thousand years later because the meaning of their form is permanent in kind.

d. Moore's 'Mother and Child' and Lambert's 'Father and Son'

If we now turn to a modern English sculpture like Henry Moore's *Mother and Child* (Pl. 8b) we find, I submit, no difficulty in its comprehension. We can see at once the kind of meaning which the sculptor, collaborating with the stone, has sought to give his work.

There is no question here of a meaning deriving from the imitation of the particular shapes of some particular woman and particular child. The task in hand has been the helping of stone to grow into a piece of architecture symbolising a Mother and Child idea.

Moore has essayed this task again and again. He believes that permanent shapes in permanent materials must symbolise universal and permanent ideas. He has concentrated on the 'Mother and Child' *motif*, and made a score of interesting carvings. His attitude is the extreme antithesis of the Romantic attitude. He admits no meaning resulting from particularisation; all local and topical experience is excluded from his work. His concept of truth in sculpture is the organisation of stone-form as a symbol of life.[1]

Maurice Lambert's *Father and Son* (Pl. 8b) should also be studied at this point. This work is less metaphysical in concept than Moore's numerous sculptures on the 'Mother and Child' idea. It must be studied as a fine piece of direct carving, a brilliant example of collaboration with material, a brave attempt to help a block of Verdi Prato marble to express the kind of formal meaning which the sculptor had experienced in Sumerian sculpture.

v. The study of negro sculpture

a. General impressions

Negro sculpture was practically unknown to sculptors till about twenty years ago. Before that time a certain number of carvings produced by savages were owned by museums, but they were kept in the ethnological sections and neither considered

[1] Cf. V. 3. and 8. and 9., and Plates 10. 23. and 24.

nor displayed as works of art. But in Paris about 1907 modern painters and sculptors began to take an interest in these carvings. 'Here', they said to themselves, 'are works by savages who knew nothing of Greek or Renaissance sculpture, or the bronzes by Rodin, and who evidently had ideas of their own about sculpture, and ideas moreover which seem to bear relation to the problems which we are studying'.

As a result of this awakening interest, savage sculptures began to be imported and exhibited in dealers' galleries, the modern painters and sculptors bought some for their studios, and art critics—especially French and German critics—began to write about them. Then some rich dilettanti and museums began to buy; and in the end, of course, the fakers got to work.

No one knows much about these savage sculptures which are now generally referred to as 'negro sculpture'. The genuine objects come from the Gold Coast and the Ivory Coast, from Nigeria and the Cameroons, the Congo, Gabon and Benin, the Marquesas Islands, the Britannia Islands (formerly known as the German Archipelago) and other places. All these objects are 'antiques' in the sense that they were made at least a hundred years ago; some are doubtless of much greater age; but the exact date is always uncertain. Nothing of a character to interest modern sculptors is, I understand, produced in any of these regions at the present day.

Some of the objects are in bronze, many are in ivory, a few are in baked clay or stone, but the majority are in wood.

The bronzes all come from the Benin region in Southern Nigeria. In the sixteenth and seventeenth centuries this region was a powerful kingdom which was visited by Portuguese and Dutch traders. The craft of bronze casting, unknown in the other regions, is presumed to date back there to that time; and in character the Benin bronzes tend to show European influence. Human sacrifice on a large scale was practised by the Benin savages until the region came under British jurisdiction. The Benin bronze workers were skilled in portraiture as we can see from a *Girl's Head* in the Berlin ethnological museum. They also made bronzes of animals.

The imposing over life-size *Benin Head* (Pl. 11*b*) looks like a crusader. But the head is not represented as encased in chain

armour as it appears; the helmet, gorget and side pieces, represent part of the ceremonial costume of the Benin chiefs, which consisted almost entirely of thick chains of *coral*. The Benin ruffians must have looked supremely decorative with their black faces and bodies shining like polished bronzes, and their heads and throats encased in coral chains, their legs encased in coral, and more coral chains about their middle.

The savages of the other regions in West Africa and elsewhere made various kinds of magic and cult images and ancestor statues which were presumably supposed to bring luck to a family or tribe and to scare away evil spirits. They made objects of applied art for ceremonial purposes and carved their canoe handles and other objects in common use. They made masks which were worn in religious dances and in religious ceremonies of other kinds. One type of mask is believed to have been worn in the proceedings of a Women's Secret Society in the region of Sierra Leone; it is said to have been put on by an older member of the Society to impress and terrify the novices at some crucial moment of initiation into the mysteries of sex. The savages also made sculptured figures, mostly heads, to serve as tombstones. Some tribes seem to have buried their dead in a seated position and to have placed a sculptured head on the spot—the idea being presumably that, as the head of the departed was kept above ground in the effigy, the personality had not entirely perished, and could still exercise a helpful influence in the world.

The modern sculptors were not of course concerned with the magic-working meaning of savage sculptures. Nor were they out to concoct a Rise-and-Fall formula for negro art. Here as elsewhere they were looking for something analogous to their own concept of essential sculpture. Negro sculpture interested them (*a*) because some of the sculptors had quite evidently studied formal relations for their magic purposes and arrived thereby at formal combinations not encountered in any other sculptures, and (*b*) because the negro sculptors had looked at the naked human figure with a vision peculiarly their own.

Negro sculptures, in a word, interested the modern sculptors not only by their formal characters but also because those formal characters made the figures look amazingly alive.

b. Form in negro sculpture

Each of the various regions enumerated above seems to have produced sculptures of characteristic forms, and within these groups again there are many variations. It is thus impossible to select any one formal character as especially characteristic of negro sculpture, as we can do, for example, in the case of the carved sculpture of the Egyptians.

We do, however, observe one recurring characteristic in many negro works. We can detect, I think, that the negro sculptors often thought of, or sensed, the form of their statues as form revolving round a central axis.

A dictionary definition of an axis is: 'The straight line about which the parts of a body or a system are systematically arranged, or which passes through the centre of all the corresponding parallel sections of it, as of a cylinder, globe, or spheroid'.

Now form of this kind revolving round an axis is, of course, the fundamental characteristic of pottery. In looking at a pot we never lose sight of its imaginary axis; and we can understand the formal character of much negro sculpture if we regard it in the same way.

Pottery we must remember is the oldest of the human arts. Men doubtless made vessels to carry water while they still lived in caves. The negro sculptors mostly carved in wood, and it is quite natural that a people which has remained primitive and which, from the prevalence of forests, is equipped with an abundant supply of cylindrical blocks of wood, should set about carving with the cylindrical concept with which pottery had made them familiar.

The negro carvers started with a piece of wood, roughly in the form of a cylinder, and as they carved they seemed to have in their minds an inner cylinder to which they were cutting back; and they never lost sight of the formal relation between the outer surface and the central axis.

We can see this procedure very clearly in works of the character of the *Standing Figure* (Pl. 13*a*). The axis here runs up the centre of the cylinder; and the neck is cut back round it.

We perceive the same formal feeling in the *Gabon Head* (Pl. 11*a*); but here the line of the axis runs up just behind the surface of the front of the neck (as is apparent if the head is examined in profile) and the sculptor at this point has cut almost back to it.

In the *Benin Head* (Pl. 11*b*) the pottery character of the form is equally evident. But here of course the artist was working in clay and not cutting back to the axis but building round it. Benin sculpture is much more sophisticated than that of the other West African savages owing to European influence as I have noted above. But the first man who modelled this type of head—a type that is frequent in Benin bronzes—clearly had the same pottery concept of form in his mind that we encounter in so many of the negro carvings.

The pottery concept can also be observed in many of the negro masks. Here the sculptors seem often to have fashioned the objects as variations of circular, elliptical, and plate-like forms; and they arrived at many different combinations of convexities and concavities.

c. Life in negro sculpture

The reactions of the average sophisticated and educated members of modern society to visual phenomena are mainly second, third, or tenth or twentieth hand. We call a landscape 'beautiful' or 'picturesque' because we have seen something like it in pictures; we react to gestures and attitudes because we have experienced them in paintings and sculptures, and to effects of light and shade because we have experienced them in still and moving photographs, to forms and combinations of forms because we have experienced them in architecture or sculpture.

The original artist, on the other hand, is a man who can see phenomena as though *for the first time* and as though nobody else had ever seen them before. To be an original artist in this sense, to be able to perceive anything with a *really direct and personal reaction* has always been extremely difficult and is now—owing to the increase in education—far more difficult than ever before; and it is more difficult to perceive the naked human body in this way than anything else, because a host of experiences, mainly drawn from art, obtrude themselves between the contemplator and the object contemplated.

We must also remember that we were born at the very end of the Romantic movement and that the original sculptors of that movement established a standard of very intense emotional reaction to life; we have learned that is to say to demand from

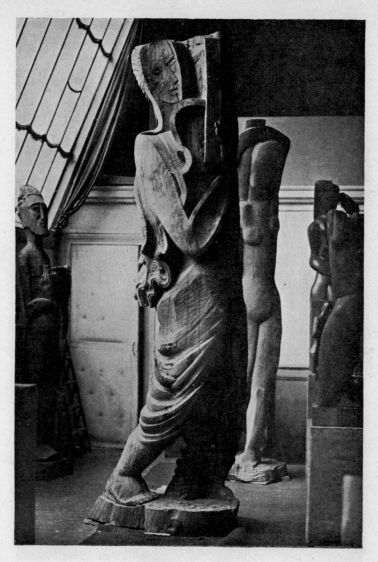

19. ZADKINE: *Orpheus*
Cf. IV. 2. iv. *b*. ii.

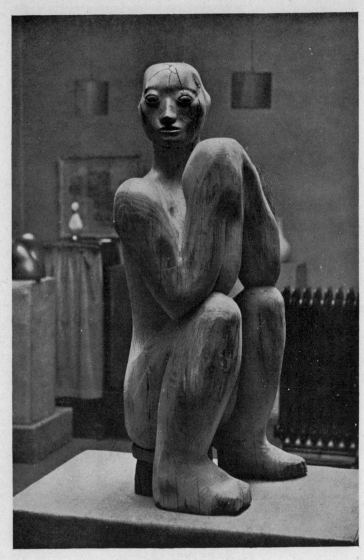

20. JOHN SKEAPING: *Akua-ba*
Cf. IV. 3. v. 3.

original artists the *degree* of intensity and emotion in personal and direct reaction to phenomena that we get in Rodin's *La Vieille Heaulmière* (Pl. 3*b*) and in Epstein's *The Sick Child* and bronze portraits (Pl. 3*a*).

The negro sculptures are the result of direct reactions to the naked human body; they were carved by men who could perceive this phenomenon as though nobody had ever perceived it before, and these perceptions equal and surpass in vividness, intensity, and sometimes in emotional quality, the perceptions of the Romantic artists who have set our standards in this field.

In the Ethnological Museum at Leipzig there is a negro carving of a man seated rather in the attitude of Rodin's *Le Penseur*. It comes from Assam, West Cameroons, and is 47 centimetres high. The anatomy in this work is fantastic, and all the forms, as forms, seem to be ordered to convey the maximum of formal meaning by their relations among themselves. But it is impossible to pretend that the terrific vitality of this little figure derives *solely* from the frank deliberate fashioning of each individual form and from the juxtapositions of those forms one against another. It is equally impossible not to realise that any alteration in this formal architecture would lessen not only the meaning of the object as form but also the meaning derived from the object's relation to the naked human body. The statue in fact compels the spectator to admit the paradox that if any alterations were made in the direction of anatomical possibility, not to say correctness, those alterations would *lessen* and not increase the statue's meaning in relation to the naked human form.

The explanation is that the vitality of this figure is dual in character—it derives partly from the artist's power to imagine and order form as such and partly from the vividness of his first-hand concept of the essential character of the naked human body.[1]

[1] This figure is reproduced as Plate II in Von Sydow's *Die Kunst der Naturvolker* (Propyläen, Berlin). I have not reproduced it because the view which best displays its character is not suitable for a book designed for a mixed English-speaking audience. The examples of negro sculpture shown in Plates 11*a*, 11*b*, and 13*a* are selected to indicate some characteristics of *form* in negro sculpture; there is no plate here which indicates its vitality of the other kind referred to in this section.

When the modern sculptors studied this and similar works they felt as Ruskin felt when after days spent in drawing the façades of Venetian palaces he saw daguerreotypes of those façades for the first time.[1]

They felt a mixture of excitement and despair—excitement at witnessing brilliant accomplishment of their own endeavours and despair that this should have been accomplished without the aid of that delicate instrument—the highly educated Western mind.

d. *The Dean and negro sculpture*

The modern sculptors' appreciation of savage sculpture is not readily comprehensible to the layman. The average student has had no call to examine the savage sculptures carefully or to study their meaning either as form or as symbols for concepts of the naked human body. He approaches these sculptures from the standpoint of the prejudice-pie.

Confronted with a work like the *Standing Man* (Pl. 13*a*) he can see nothing in it but what he assumes to be the sculptor's failure to make a statue like the Vaison *Diadumenos* or some other *Diadumenos* concoction that he happens to think of as 'by Polyclitus' as the result of his acquaintance with propaganda for the Greek prejudice. Confronted with a negro work like the Leipzig *Seated Man* his reaction is one of active resentment against an object which batters at his preconceived ideas of 'good' sculpture. As an English or American gentleman he is quite unprepared for this assault; nothing in his education has equipped him to receive either of the two meanings which are *both expressed with the maximum of intensity* in this carving.

We must remember moreover that the reactions of white men to negro figures of this kind are complicated (*a*) by the white man's instinctive prejudice in favour of the white man's physique, and (*b*) by the religious attitude of the white races which began by regarding sculpture as something to be used for ecclesiastical purposes and which was transformed in the Renaissance into an attitude that regarded sculpture as Renaissance painting in another material.

Confronted with such figures the average student thus equipped *must* say (*a*) on the basis of the Greek prejudice and

[1] Cf. *The Modern Movement in Art*, Part I. *b*. iv.

the white-physique prejudice: 'This figure is entirely lacking in caressibility' and (*b*) on the basis of the Christian and Renaissance attitudes: 'If this figure is a magic idol it has an offensive religious meaning, and if it is not an idol its meaning is obscene', and (*c*) on the basis of the prejudice-pie generally: 'the fellow who made this statue would have made statues resembling Greek, Renaissance and nineteenth-century Romantic works if he had not been a poor ignorant savage technically unable to do so'.

It is thus doubtless that Dean Inge regards these savage sculptures.

But it is not thus that they are regarded by the modern sculptors who are contributing to modern culture by their studies.

The Dean, from a dean's standpoint, may have been justified in suggesting that savage sculptures are 'atrocities'; but he was not justified in suggesting that the modern sculptors who have learned something of their own business from these sculptures, have produced works to which the word 'atrocities' applies.

We cannot blame a dean for not understanding what modern sculptors are after; but a protest is called for when he goes out of his way publicly to insult them.[1]

e The influence of negro sculpture
1. Learning and forgetting. I have said above that the modern sculptors looked at works like the negro *Seated Man* in Leipzig with a mixture of excitement and despair. What they actually said in their studios was: 'These things make all European Romantic sculpture seem formless; they make all European Classical sculpture look tame; and as for compromise-stuff like the Olympia fragments they make them look dead as mutton. The savage sculptors have succeeded where European sculptors have failed again and again. These negro sculptures contain the maximum of meaning deriving from the sculptors' direct reactions and the maximum of meaning in their form; *and these two meanings coexist in maximum intensity without destroying one another*. How can we discover the secrets of this art?'

They could not, of course, assume that the negro sculptors were aesthetic theorists like themselves. They could not assume

[1] Cf. II. 1.

that these works were produced in conditions like their own in which (*a*) creative sculpture is not generally felt to be urgently necessary or vitally useful in religious, national or personal life, and (*b*) the creative sculptors have been driven to find a justification for their work and a criterion of its value in some concept of Art as an activity which may have metaphysical value in itself.[1] On the contrary all the evidence led them to the assumption that the ideas of the negro sculptors did not include a conscious concept of Art as a distinct activity, to be pursued as an end in itself. Yet here was an art of sculpture rich in the kind of meaning which they themselves regarded as essentially sculptural. *Were they to assume that the savage sculptors' conditions were essential for its production?*

Then again they could not assume that the savage sculptors ever aimed at the meaning of the desirability of the bodies of beautiful boys and pretty girls which was aimed at by the concocters of the Graeco-Roman statues. There was sexual meaning in negro sculpture but not sensual meaning. Even making the maximum allowance for the known and presumed differences between the white man's and the black man's erotic it seemed impossible to assume that caressibility was a character that the negro sculptors were mainly concerned with in their rendering of the naked human body. It was true that in the hybrid Benin bronzes, where European influence was obvious, this character to some extent appears; but elsewhere in savage sculpture it seemed non-existent. But it was equally impossible to assume that the savage sculptors had *deliberately rejected* the caressibility ideal in sculpture as they were doing themselves. The only deduction possible was that the savage sculptors saw only sexual and not sensual meanings in the naked human body and that the expression of those meanings was not trammelled by outside prejudice or inhibited from within. *Were they to assume that this freedom was also essential for the capture of the secrets of this art?*

The conclusions at which they eventually arrived were something like this:

'As regards the possibilities of meaning in sculptural form we still have almost everything to learn; we are untutored savages

[1] Cf. *The Modern Movement in Art*, Part I, *a*, *b* and *c*.

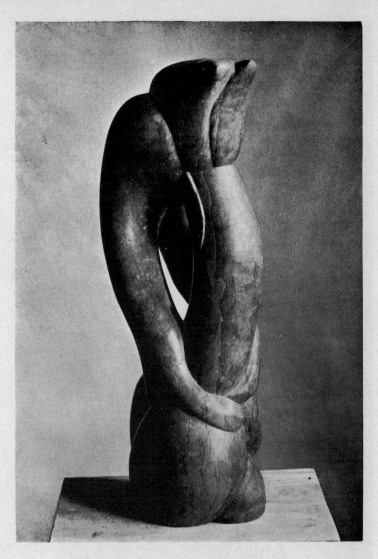

21. RICHARD BEDFORD: *Flower*
Cf. V. 9.

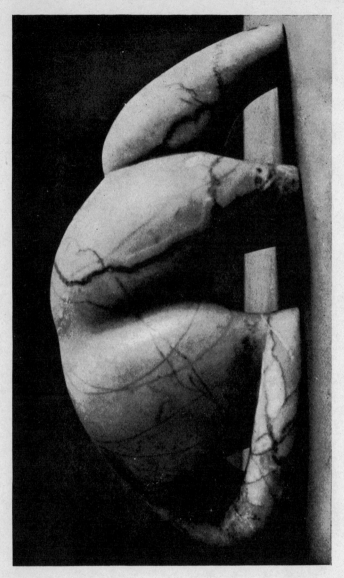

22. RICHARD BEDFORD: *Ant-Eater*
Cf. V. 9.

in this field compared with the negro sculptors. We must roll up
our shirt sleeves and *begin to learn.*

'As regards the meaning derived from a work of sculpture's
relation to the naked human body we know far more than the
negro sculptors—in the sense that we know far too many details.
Here we cannot see the wood for the trees; we know so much
about the naked figure and we have seen so many imitations of
it in pictures and sculpture that we cannot perceive it with a
fresh eye. We must throw all the knowledge in the dustbin and
begin to forget.'

In practice so far the modern sculptors have found the second
process harder than the first because man can learn in a hurry if
he works hard enough but he cannot forget at will.

The day may come when modern sculptors have forgotten
enough to enable them really to perceive the naked human
body; when they can look at a naked man without memories of
the Vatican ninepins, and at a naked old woman without mem-
ories of *La Vieille Heaulmière.* The day may come when they
know nothing of anatomy and when Romantic art has been so
gloriously forgotten that they can look at the form of a face in
exactly the same way that they look at the form of a foot. But
that day has not come yet. The modern sculptors have learned
an immense amount in the field which they set out to study;
but what they have forgotten, in spite of their efforts, is—almost
nothing.[1]

2. Epstein's 'Genesis'. Epstein's *Genesis* has been frequently
referred to as a work influenced by negro sculpture; and it is
true that the face is negroid in character and that the concave
treatment of the cheeks resembles some of the negro sculptors'
masks.

But I see nothing here of the negro principle of form revolving
round an axis and no direct new vision of the naked form.[2]

When *Genesis* was first exhibited in London it was treated as
an absurdity, an indecency and a monstrosity by the London

[1] Cf. IV. 2. ii. *b.*

[2] But of course *Genesis* would not have happened in its present
form without the sculptor's experience of negro sculpture. Epstein
has studied a great many negro works profoundly, and he has a large
collection (cf. *The Sculptor Speaks*).

press. I wrote some comments in the *Observer* which I now venture to reprint.[1]

'Mr. Jacob Epstein is one of the few contemporary artists who can still provide us with a shock. He has been before the public for more than twenty years, but he still gives us the unexpected. In other words his creative fount is not exhausted. He can still enlarge his own experience and ours also unless we are of those who think that our experience is already sufficient.

'In his new exhibition at the Leicester Galleries the shock is provided by the marble carving entitled *Genesis*. Colossal in size, staring white in colour, this mass of marble shocks us in the first place because it calls up a rush of emotive ideas with which the object before us is instantly associated. The moment we have glanced at this statue the mind registers: "Naked woman . . . half-human face . . . last stage of pregnancy . . ."; and then we can either turn away and seek elsewhere for something pretty to look at—or stay and begin to contemplate an object fashioned with hammer and chisel and a rare man's mind and spirit.

'To begin with, it is important to realise that the images associated with the words "Naked woman . . . half-human face . . . last stage of pregnancy . . ." are not irrelevancies in the contemplation of this work. Mr. Epstein's statue is called *Genesis*, and it is in fact the embodiment of a genesis idea. Mr. Frank Dobson's statue, acquired last year for the National Gallery, Millbank, was called *Truth*; but it was only called *Truth* because it had to be called something to attract the subscriptions which made its acquisition by the nation possible; it might as appropriately have been called *Duty* or *Diana* or *Sophonisba* because Mr. Dobson was not thinking of sculpture as a means for the expression of an idea that could be paralleled by any word or title. . . . But Mr. Epstein's statue could not be entitled *Duty* or *Diana* or *Sophonisba*. The word 'Genesis' here helps us to comprehension and sanctions the retention of the first incoming associated ideas.

'To appreciate this statue, therefore, we can, and must, retain our initial emotive ideas and *reconsider them* in the light of the experience provided by the statue. That the work enforces such reconsideration is a sign, of course, of its unusual merit. It is not

[1] London *Observer*, 8th February, 1931.

often that an artist can drive us to re-examine our deep-seated attitudes to the solemn facts of life and birth and death. If an explorer were to discover Mr. Epstein's *Genesis* to-morrow in an African jungle he would stand before it in respectful wonder. "Here", he would say, "is primitive man's image of the awful fact of parturition, which, in his mind, results from an act of destiny unconnected with the sexual act. Here is a pathetic being, a mind uninstructed, hardly awakened, a lean body swollen to produce another. Here is the first Mother." But when the same man discovers it instead at the Leicester Galleries he is more likely to mutter the one word "disgusting" . . .

'The truth is that we cannot begin to appreciate this *Genesis* until we have forgotten our habitual environment, until the Leicester Galleries and our rival theories of sculpture, our civilisation of steel, speed and comfort, the Prime Minister and "Miss 1931" have all faded from our minds. As sheer sculpture, in the modern sense, this carving, in my judgement, is a failure; the forms are not homogeneous, the plastic language is diverse, the flow of the lines downward suggests a falling body rather than an organisation rising upward from the ground. But this carving must not be considered as sheer sculpture. It must be considered as *Genesis*, and, thus considered, the divergencies of the forms, the contrasts of lightnesses and weight, and the downward-forward movement of the lines contribute to a significance which is undeniably primeval and profound.

'No other sculptor in England to-day could have produced this *Genesis*, because no other is mentally so removed from everyday life as to be able to arrive at this primeval conception and to rest upon it as sufficient.'

3. Gaudier, Modigliani, Zadkine and John Skeaping. Gaudier was one of the first sculptors to study negro sculpture with enthusiasm and make intelligent experiments with its characteristic forms; in his stone *Caritas* he tried to fashion formal meaning of the character of the Hawaiian wooden bowl with caryatids standing on their hands (in the British Museum) and the bowls with caryatids from the Cameroons; and when he carved his *Imp* in alabaster he had things like the bow holders from Urua (East Congo) in the Berlin Ethnological Museum in his mind.

The Italian painter and sculptor Modigliani, who worked in Paris, where he died in tragic circumstances some years ago, also essayed new types of formal meaning after the study of negro sculpture. He was attracted especially by the elegant masks from the Ivory Coasts which are much more suave in character than most negro work. His *Stone Head* (Pl. 12) in the Victoria and Albert Museum, London, is a construction of two elliptical forms, two plates, as it were, facing one another with a sheet of cardboard between. The plates form the profiles and the edge of the cardboard forms the nose. The result, unexpectedly enough, resembles the forms with which the Byzantine artists worked in the later centuries; and drawing is used as an ornament imposed upon the form as in mediaeval sculpture influenced by Byzantine manuscript, and in Chinese sculpture like the *Tang Figure* (Pl. 6*b*).

Zadkine, who has made experiments in all the fields of his wide sculptural experience, has produced some savage idols and also some elegant organisations of contrasted concavities and convexities in bronze—notably charming works called *Girl with a Bird* and *Two Friends*.

Unlike Epstein in *Genesis*, Zadkine has always avoided the negroid facial type in these experiments. He has concentrated on adapting formal organisations experienced in negro sculpture to Western sensibility. By experimenting with concavities he has been led to a concept of bronze as a substance with its own sculptural possibilities *of a metallic kind*. The Italian Renaissance sculptors and the nineteenth-century modellers thought of bronze as a skin covering and preserving their clay concepts. The Renaissance sculptors delighted in its surface and perfected each cast with care; and the Romantics delighted in its ability to reproduce their personal manipulation of clay—in its power to reproduce thumbmarks, and nervous pressure. But neither the Renaissance bronze workers nor those of the nineteenth century thought of bronze as having more than one surface; Zadkine, like Gaudier in his *Brass Toy* (Pl. 13*b*), has come to think of the metal as a pliant substance existing in itself and capable of meaning *in all its surfaces*. He has made many interesting experiments with bronze bent into forms which have the meaning of concavity on one side and convexity on

the other, and upon which sometimes he imposes a drawn ornament.

The technique of bronze sculpture has remained more or less the same for close on four thousand years. Zadkine has made most interesting attempts to enlarge experience in this technical field concurrently with the enlargement of experience in the field of abstract form. He is impelled in fact by the scientific curiosity which played so large a part in the creation of original Renaissance sculpture.[1]

John Skeaping, a young Englishman, is another modern sculptor who has made experiments in a number of fields. His carving entitled *Akua-ba* (Pl. 20) reveals his study of works like the negro *Seated Man* from Assam, to which I have already referred, and the male and female ancestor statues from the Philippines, the French Congo, and elsewhere.[2] In *Akua-ba* the sculptor has sought not only to organise form, but also to capture a direct uninhibited vision of the naked human body as the negro sculptors captured it, and to convey the meaning of this vision in maximum intensity without lessening the intensity of the formal meaning—as was done so miraculously by the Assam sculptor. He has tried, like the negro sculptors, to convey the meaning of the perception *by means of* the meaning of the form.

This statue might also be entitled *Genesis* since it is a formal symbol for the genesis idea. It has symbolic sexual meaning; but not the sensual meaning of caressibility because it is not intended to provide the substitute gratification of a pretty-girl ninepin.[3]

vi. The study of Indian sculpture

a. General impressions

Indian sculpture like mediaeval Western sculpture was the product of a culture that believed in sculptured buildings.

[1] Cf. II. 8. ii., IV. 2. iv. *b*. ii., and *c*. 3. ii.; also V. 9 and Plates 4 and 19.

[2] I saw recently a female figure in this type of attitude in the collection of Mr. Curtis Moffat, London.

[3] An *akua-ba* is a type of fetish worn by pregnant women in Ashanti. It is supposed, when worn in certain positions, to further the probability of a male child.

Before the Romans covered their triumphal arches and sarcophagi with reliefs, and before the Chinese cut their temples in the rocks, the Indians were making triumphal arches entirely composed of sculpture as doorways to shrines. The sculptures at Barhut and on the Sanchi stupa, which still partially survive, are ascribed to the second century B.C. From the fifth to the eighth century of the Christian era the Indians were making Buddhist temples that were architecturally alive with sculpture at every angle; they were attacking rocks and caves and the sides of mountains and animating the whole surface with hundreds of forms—figures, animals and so forth. The remains of this colossal sculptural production can still be seen at Ajanta, Mamallapuram and other places. In the thirteenth century the Indians made a temple in Konaraka that was even more a mass of alternating figures and ornament than the *Portail Royal* at Chartres, and at the same time they cut a ceiling in the Adinatha temple on Mount Abu with rows of figures radiating from a centre like a rose window in a Gothic church.[1]

Cultures in all parts of India continued to find a use for completely sculptured buildings right down to the eighteenth century; and from India this sculptural culture spread to China and Ceylon and Java and the whole Buddhist world.

The cult images of Buddha originated in India; and these images, which were adopted and adapted in other lands, show Indian sculpture in the round.

All this Indian work was direct carving. The Indians at various times made bronzes, but their form was influenced by the carvings, whereas in Greece the influence, as noted, was the other way about.

At one moment in the North of India the Indian sculptors came in contact with Hellenic sculpture brought eastwards by Alexander; these Gandhara sculptures are a hybrid product which seem to have had little or no influence on the main developments of Indian art.

b. Influence of these sculptures

The modern sculptors so far have been mainly interested in the Indian Buddhist statues in the round—of which the

[1] Cf. V. 3 and Pl. 15.

Buddha in Meditation from Anuradhapura, now in the Museum at Colombo, is a type. This stone figure (which is ascribed to the period between the beginning of the third and the end of the fifth century) is in the cross-legged seated position of the Egyptian scribes; its formal character would seem to be the organisation of cylindrical forms within a cube; and the monumental stillness of this figure, its character of permanence and peace, derive from the meaning of its form. The Indian statues of Buddha had other meanings, and the form of course was partly created to express them; but those other meanings from the standpoint of the modern sculptors have perished; the meaning of the form alone survives.

The form in the sculptured buildings, rock temples and caves of the Indians has a different character. In these sculptures there is an extraordinary vitality, a flowing rhythm of a quality encountered in no other sculptured works.

All Indian sculpture has an astonishing life-quality. The figures into which the Indian shrines and temples seem to blossom have a kind of vegetable rhythm and luxuriance. The stone has been made to symbolise a tropical exuberance in growth; the animation seems to spring from a force that lies behind the corporeal envelopes, a force that vitalises the animal and the vegetable world with one and the same life. The woman in the *Two Lovers* on the Kailasanatha temple at Elura (eighth century) clings to the man like ivy to a tree; and we get this same universal rhythm in the Indian figures with several pairs of arms like the well-known bronze figures of *Siva Dancing*.

Indian sculpture, I fancy, is destined to have much more influence on creative modern sculpture than has been hitherto the case; because the recent development of the modern sculptors' creed, which I am about to examine, is especially concerned with the study of this universal rhythm in all forms of life.

c. *Epstein's 'Madonna and Child' and 'Sunita'*

It would of course be a mistake to speak of the influence of Indian art in connection with Epstein's bronze *Madonna and Child* and his bronze portraits called *Sunita* and *Anita*. The facial types here are Indian because the sculptor used Indian

models; but in character these works belong to the nineteenth-century aspect of Epstein's work, the aspect in which it constitutes the climax of nineteenth-century Romantic sculpture and of the Donatello-Rodin tradition.[1]

On the other hand some of the nude drawings which Epstein has made from these Indian models seem to me to have something of the vegetable vitality of the form in Indian sculpture— and if this is so we are led to ponder on the part played by racial physique in the development of sculpture in various places and at different times.

Maurice Lambert, whose studies of Sumerian sculpture have been already referred to, has also made some interesting essays in symbolic form on Indian lines.

[1] Cf. Preface and II. 7. ix.

PART V
THE MODERN SCULPTORS' CREED (ii)

PART V

THE MODERN SCULPTORS' CREED (ii)

1. The meaning of geometric form

i. The problem

After these extensive and intensive studies of the world's content of sculpture the modern sculptors returned to the development of their own creed.

They had begun by recognising that when we speak of 'formal meaning' we always really mean forms with the meaning of geometric forms and their mutual relations. In their studies of the sculpture symbolic of different cultures of the past they had then discovered numerous examples of sculpture which still have meaning to-day because they still have the meaning conveyed by geometric forms and their mutual relations, although any other meanings, which they may have had, have perished. Their next problem was to discover *the nature* of this meaning in geometric form, and the nature of the reactions which it calls forth in man.

There was ample evidence that men at all times, men in most distant places, and men of very different cultures, had reacted to that meaning, and that sculptors again and again had conveyed other meanings *by means* of the forms which caused the reaction. What, the modern sculptors now asked themselves, was the *cause and the character of this reaction?*

ii. Two types of geometrisation

In order to find an answer to the question they began by recognising the difference between the two types of geometrisation of form—the geometrisation of visual experience and the geometrisation of natural structure.[1]

[1] Cf. III. 2. vii. *b*. I have touched on the difference between these two types of formalisation *in painting* in *The Modern Movement in Art*, p. 166.

They began by realising that it is one thing to look at a man in a lounge suit with his hand in his pocket and geometrise the visual impression as Gaudier has done in his *Brass Toy* (Pl. 13*b*), and that it is another to study the structural formation of a cock or a fledgling and geometrise that as Gaudier has done in his *Formalised Drawings* (Pl. 14*b*); and they soon came to the conclusion that the character of the first procedure was empirical and impressionist and must accordingly be abandoned.

In the hands of an artist like Gaudier, who experimented with the other procedure as well, the first kind of geometrisation might produce an object with compelling formal meaning like the *Brass Toy*. But this, it was felt, was really an accident, and in character akin to the 'guessing' which, as Socrates said, is a poor unsatisfactory procedure, though it 'is commonly called art'.[1]

Gaudier's experiments in the geometrisation of natural structure, on the other hand, were found to be of cardinal interest and importance.

It was my privilege, after Gaudier's death, to examine the works he left behind. These consisted of a number of sculptures (including the *Brass Toy*), about one thousand six hundred drawings, some paintings and pastels and a number of sketchbooks. Many of the drawings were calligraphic sketches from nature done at the London 'Zoo', in Hyde Park, and elsewhere; a few were projects for sculptures; the most interesting of all were the drawings in the sketchbooks where we see the artist studying animal forms, bird forms, fish forms and so forth. In these sketchbooks there were often a dozen drawings in a page representing different geometrisations of a particular structure; the first would bear obvious resemblance to a horse, or bird, or whatever it might be (Pl. 14*b*) and then the geometrisations would become more and more forms in themselves until in the end the horse-meaning or the bird-meaning was no longer recognisable.

When the modern sculptors studied these sketchbook geometrisations by Gaudier (some of which were reproduced in Ezra Pound's book already referred to[2]) and then studied the sculpture called *Bird swallowing a Fish* which was made after scores of preliminary experiments in geometrisation, they began

[1] Cf. III. 2. v. [2] Cf. III. 2. vii. *b*.

to arrive at the development of their own creed which they were seeking—at the comprehension, that is to say, of the nature of geometric meaning and of the reason for man's reactions to geometric form.

But it was some time before this new stage was in fact accomplished because many of the sculptors retained at the back of their minds the notion of a wild, free, ragged undisciplined 'nature' from which the Romantic artists had selected emotive fragments and which it was the function of the classical artists to 'tidy up'.

At the back of their minds many presumed an antithesis between organic nature and geometric form, and it was some time before they were equipped (*a*) against the critics who suggested that there was something impious in geometric art, that there was neither 'life' nor 'truth' in it, that it was a kind of insult to the casual character of nature, and a kind of blasphemy against God, and (*b*) against the critics who put it another way and suggested in true nineteenth-century fashion that geometric art was a form of treachery, an alliance with the hateful uniform-attitude of the machine instead of an alliance with the glorious difference-attitude of individualised man.[1]

2. Truth to nature

But the time came when the modern sculptors knew enough about the matter to refute these critics, when they were able to remind them that man himself is a geometric composition, that geometric form abounds in the animal and vegetable world, and that there is said to be reason for presuming that the earth which we inhabit is a sphere. The time came, in other words, when they had abandoned the presumed antithesis between organic and geometric form and had begun to presume instead that geometric form is *symbolic* of organic.

On this assumption they embarked on a further series of studies. They began to seek and find analogies between the characteristic forms in life and the characteristic forms in art, between the formal principles in natural structures and formal order in geometry, architecture and sculpture.

[1] Cf. I. 4.

I can perhaps illustrate the general character of these studies by selections from my own observations in this field.

It is impossible to sustain the Romantic notion of a wild, free, ragged, 'nature' when we examine the enlarged photographs of plant forms in Professor Blossfeldt's two books *Art Forms in Nature* of which English editions have appeared in recent years.[1] These photographs transform the apparently ragged constituents of a tangled hedgerow into a series of structures informed with a most definite shape, with most evident order and most evident logic. The study of these photographs makes it quite clear that the artist who reacts to the superficial tangled appearance of nature, the painter, for example, who is content to copy the appearance of the hedgerow in a particular effect of light and give his work only the meaning residing in that imitation, is producing the kind of art which Socrates described as 'only conjecture, and the better use of the senses which is given by experience and practice, in addition to a certain power of guessing, which is commonly called art, which is perfected by attention and pains'; and that the artist who gives us truth of form is the artist who symbolises the forms contained in the hedgerow by geometric forms which Socrates *for that reason* described as 'eternally and absolutely beautiful'.[2]

Take, for example, the flower umbel (*Coronilla coronata*) which I reproduce as Pl. 15. What could be less free and ragged than its form? And how after looking at it can one describe the geometry of a rose-window in a Gothic cathedral as 'untrue to nature'?

Or take the wooden *Bird* (Pls. 14*a* and 16*a*) in the ancient Japanese temple at Horyuji. It is very unlike the kind of sculpture which academic sculptors call 'true to nature'; but how can we call the geometrical form of this sculpture impious and a blasphemy when we look at the form of a shoot of flowering ash (Pl. 16*b*)?

Studies of this kind make it clear that even the most drastically non-representational work of art, if produced by an artist who consciously or unconsciously apprehends the formal

[1] The English editions are published by Zwemmer (London)—the first volume in 1929, the second a few months ago. I am indebted to Mr. Zwemmer for permission to reproduce plates from both books (cf. Pls. 15, 16*a*, 17*b*).

[2] Cf. III. 2. v.

character of natural structures, may be 'true to nature' in this larger sense of the symbolisation of natural form. Examples could be multiplied *ad infinitum*. Set photographs of the Rajarani and Lingaraja temples in Bhuvanesvari next to Professor Blossfeldt's photographs of winter horsetail and asparagus, or Professor Blossfeldt's photographs of branched stems of Indian balsam and balsamine next to brass candelabra by a craftsman in tune with natural form, and the conclusion is bound to be the same. After such studies we are bound, I submit, to realise that the naturalistic sculptor's clay figure made to imitate the shape of Miss Jones the artist's model without her clothes, and the clay figure made to record a Romantic artist's excitement at the departures from the normal (which he will call 'the character') of Miss Jones's body, are both only 'true to nature' in a very limited and minor sense, because Miss Jones after all is only Miss Jones, and the works take no account of Miss Brown and Miss Robinson and the rest of the female species of the human race. But the sculptor who seeks to apprehend the formal laws behind particular phenomena is aiming at 'truth to nature' of a more universal and permanent kind.[1]

3. The universal analogy of form

Pursuing studies on these lines we begin to understand the meaning of the blend of human, animal and vegetable form observed in the Indian sculptors' treatment of the human figure; if we set the *Buddhist Figure* (Pl. 17*a*) in the Horyuji temple beside a swallow-wort (Pl. 17*b*) we realise that the formal meaning of the one is the same as the formal meaning of the other.

It is by such studies that the modern sculptors have arrived at the concept of the universal analogy of form, the concept of all human, animal and vegetable forms as different manifestations of common principles of architecture, of which the geometric forms in their infinity of relations are all symbols; and at the concept of the meaning of geometric relation as the symbolisation of this universal analogy of form.

As a result of such studies the modern sculptors have learned

[1] Cf. III. 2. viii. *i*.

to understand what Michelangelo meant when he said to Vasari: 'If life gives us pleasure we ought not to expect displeasure from death seeing it is made by the hand of the same master'; and they now knew what Gaudier meant when he wrote:

'Sculptural energy is the mountain'

at the head of his essay in *Blast* from which I have already quoted.[1]

4. An aesthetic doctrine

And now the modern sculptors were in a position to answer the question: 'Why do we react to relations of geometric forms?' Now they could formulate an aesthetic doctrine, and reply: 'We react to such forms because they symbolise the universal analogy in formal relations; if we find a meaning in the symmetrical structure and the articulations of the Japanese *Bird* (Pl. 16*a*) and of the shoot of flowering ash (Pl. 16*b*) and derive satisfaction from that meaning it is because in obtaining contact with each of these manifestations we are obtaining contact with the universal life behind, and if we derive satisfaction from the form and movement of the raised leg in Leon Underwood's *Running Figure* and from its relation to the torso (Pl. 18) it is because that form and movement have a universal character as we can see when we study the form and movement of the petal moving outwards and upwards from the body of the swallow-wort (Pl. 17*b*). We react with satisfaction to works of art which make us realise subconsciously that all human, animal and vegetable forms are manifestations of one life'.

5. The meaning of scale

This concept of the universal analogy of form explains, I think, the reason for the increased emotive power of geometric (or if you prefer it architectural) sculpture as it increases in scale. The meaning of such sculpture implies no reference to particular physical objects or concrete things and therefore arouses no

[1] Cf. III. 2. vii.

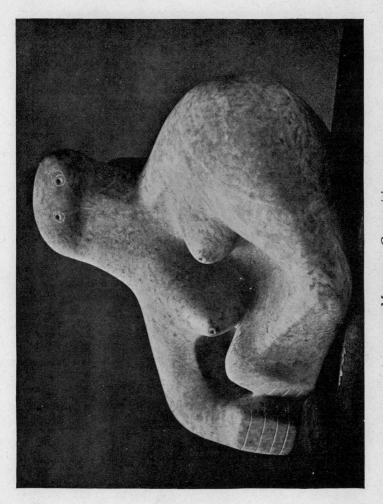

23. MOORE: *Composition*
Cf. V. 9.

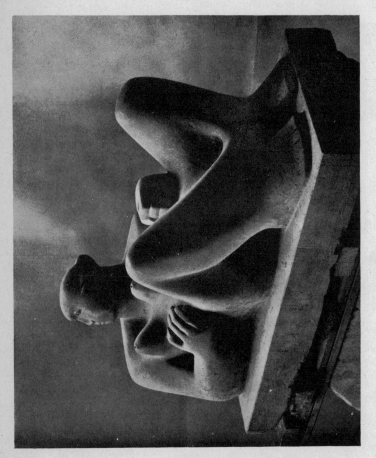

24. MOORE: *Mountains*
Cf. V. 9.

associated ideas of appropriate scale; if the sculptor has the sense of the universal analogy of form the scale most appropriate to his structure will be a universal scale and as the work approaches the tree or the mountain in dimensions its meaning will become more powerful and clear.

Gaudier's *Brass Toy* (Pl. 13*b*), as I have already suggested, would have terrible meaning if enlarged to forty feet and more terrible meaning still if enlarged to a hundred.[1] There is more meaning in a spiral by Brancusi that reaches from the studio floor to the studio ceiling than in a three-inch corkscrew. Moore's *Mountains* (Pl. 24) would have ten times the meaning if it were ten times the size. But Rodin's empirical *La Vieille Heaulmière* (Pl. 3*b*) would mean five or ten times less if it were five or ten times larger, and a headless version of his *Balzac* (Pl. 1*b*), if enlarged to the height of the loftiest sky-scraper, would still mean nothing at all.

This explains, I submit, the continued meaning of the Egyptian *Sphinx*. The *Sphinx* is not too big because the meaning is a symbol of the universal analogy of form and is thus meaning of a permanent, eternal and universal kind; but we should feel that a naturalistic imitation of a lion with a naturalistic portrait of a particular man for a head, the size of the *Sphinx*, would be not only meaningless but intolerably silly.

When we experience the form of a work of sculpture by means of a photograph we instinctively assume the scale to be the one most appropriate to the form's significance. We never imagine photographs of Egyptian geometric sculpture as small, or of Egyptian or any other genre sculpture as large; and in the case of photographs of statues with sex appeal or Romantic meaning we never assume an over-life size; the more the meaning is 'caressibility' the more likely we are to assume from a photograph that the statue was of the size that can be easily handled and caressed.

6. Sculptural imagination

The modern sculptors' concept of sculpture has thus, I submit, been developed in a most important and interesting direction.

[1] Cf. III. 2. vii. *b*.

I can perhaps explain the present attitude, as I understand it, more clearly by putting it in this way:

Many members of the so-called musical public go to hear different virtuosi playing the same works by the great composers; and they concentrate their attention on the differences between the performances. But the musician gives his attention in all the performances to the common denominator which is the music itself; for him the differences in the particular performances only have meaning in relation to that.

Now from the standpoint of the modern sculptors to-day life is the composer, the principle of universal analogy of form is the music, and the swallow-wort and the egg, the asparagus and Miss Jones, the elephant and the ant-eater, are the performers. The modern sculptor is not concerned with the differences between these performances; in his eyes their forms primarily have meaning as evidence of the universal formal principles with which they act as connecting links.

The sculptors' function thus conceived is the organisation of microcosmic symbols by means of formal imagination which is apprehension of the principles of formal analogy in the universe.

The modern sculptors, in other words, have arrived at a point when they understand what Baudelaire meant when he wrote: '*L'imagination est la plus scientifique des facultés parce que seule elle comprend l'analogie universelle*'.

And they have arrived at a point when they can add another definition to their own sculptural creed:

'*Sculptural imagination is the power to organise formal energy in symbols for the universal analogy of form.*'

Or to put it in another way they have now decided that the sculptor's business is not to imitate or dramatise fragments of nature but to symbolise the formal principles of life.

7. The creed as it now stands

The modern sculptors' creed as it now stands, if I understand it rightly, would therefore read as follows:

1. Sculpture is the conversion of any mass of matter without

*formal meaning into a mass that has been given formal meaning
as the result of human will.*

2. *Essential sculpture is sculpture which has the same kind of
 meaning as the sphere, the cube and the cylinder.*

3. *The meaning of naturalistic or romantic imitation, as Socrates
 said, is merely empirical and conjectural; and what is com-
 monly called art is merely such empirical meaning expressed by
 skilful tricks of hand; but the meaning of geometric art is
 universal and everlasting.*

4. *Sculptural feeling is the appreciation of masses in relation.*

5. *Sculptural ability is the defining of those masses by planes.*

6. *Sculptural energy is the mountain.*

7. *Sculptural imagination is the power to organise formal energy
 in symbols for the universal analogy of form.*

And to this they might add:

8. *Essential sculpture is a collaboration between the sculptor and
 the essential character of the block of resistant substance be-
 neath his hand.*

9. *Sculpture is not the imitation of clay modelling or painting
 or drawing in marble or stone. It is the creation of architec-
 ture by collaboration with a substance of permanent character.*

10. *All great sculpture is microcosmic in formal character; and
 gains in meaning when increased in size.*

8. Truth to life

Thus we arrive, I think, at the meaning of modern sculpture.

That sculpture is a symbol of the cultural effort towards col-
lective contact with universal life; and the sculptors are aiming
not at *truth to nature* in the old sense, which they regard as use-
less at the moment, but at *truth to life* in a sense that has long
been forgotten.

And thus, too, we see once again what Einstein meant when
he referred to the 'positive motive which impels men to seek
a simplified synoptic view of the world conformable to their

own nature, overcoming the world by replacing it with this picture'.[1]

Original art in the modern world obeys its own finality-complex. The modern sculptors and the Jack Horners are brothers after all.

9. Epilogue

If the reader now encounters the carvings entitled *Ant-Eater* (Pl. 21) and *Flower* (Pl. 22) by the English sculptor Richard Bedford and the carvings called *Girl* (Pl. 10), *Composition* (Pl. 23) and *Mountains* (Pl. 24) by Henry Moore, he will not, I hope, find it difficult to understand and so appreciate them.

I have done my work badly if he does not regard Bedford's *Flower* (Pl. 22), as I do, as an enlargement of experience by imaginative organisation of form symbolic of human-animal-vegetable life (Pl. 16a).[2] I have done my work badly if he does not regard Moore's *Composition* in the same way. I have done my work badly if he can re-read Gaudier's dictum 'Sculptural energy is the mountain' without thinking of Moore's *Mountains* and if he does not perceive that work as a symbol of the surge and swell of the surface of the earth itself.

For my own part, I look on the achievements of the modern sculptors with enthusiasm and a firm conviction that the men who have already given us so much are about to give us a great deal more. I await their future productions with the liveliest interest. I look on Epstein as an individualist giant; on Zadkine as the most agile-minded and technically adventurous figure in the whole field of European sculpture as I know it; on Underwood, Moore and Bedford, as poet-sculptors of a new kind.

[1] Cf. *The Modern Movement in Art*, p. 187.

[2] The student will find it instructive to compare this carving with the photographs of plant forms reproduced as Plates 86, 90, 108 and 117 in Blossfeldt's *Art Forms in Nature* (Second Series).

THE END

INDEX

Index

Index

Index

Index